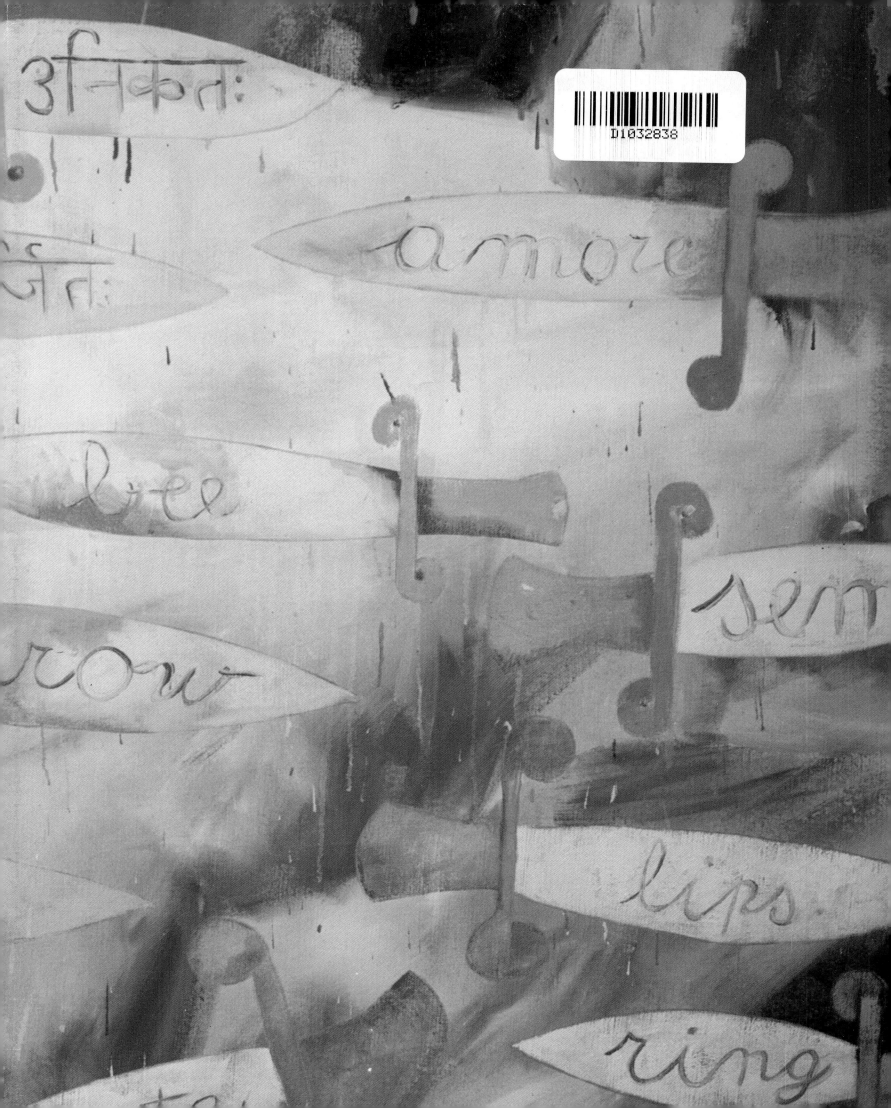

FRANCESCO CLEMENTE

A PORTRAIT

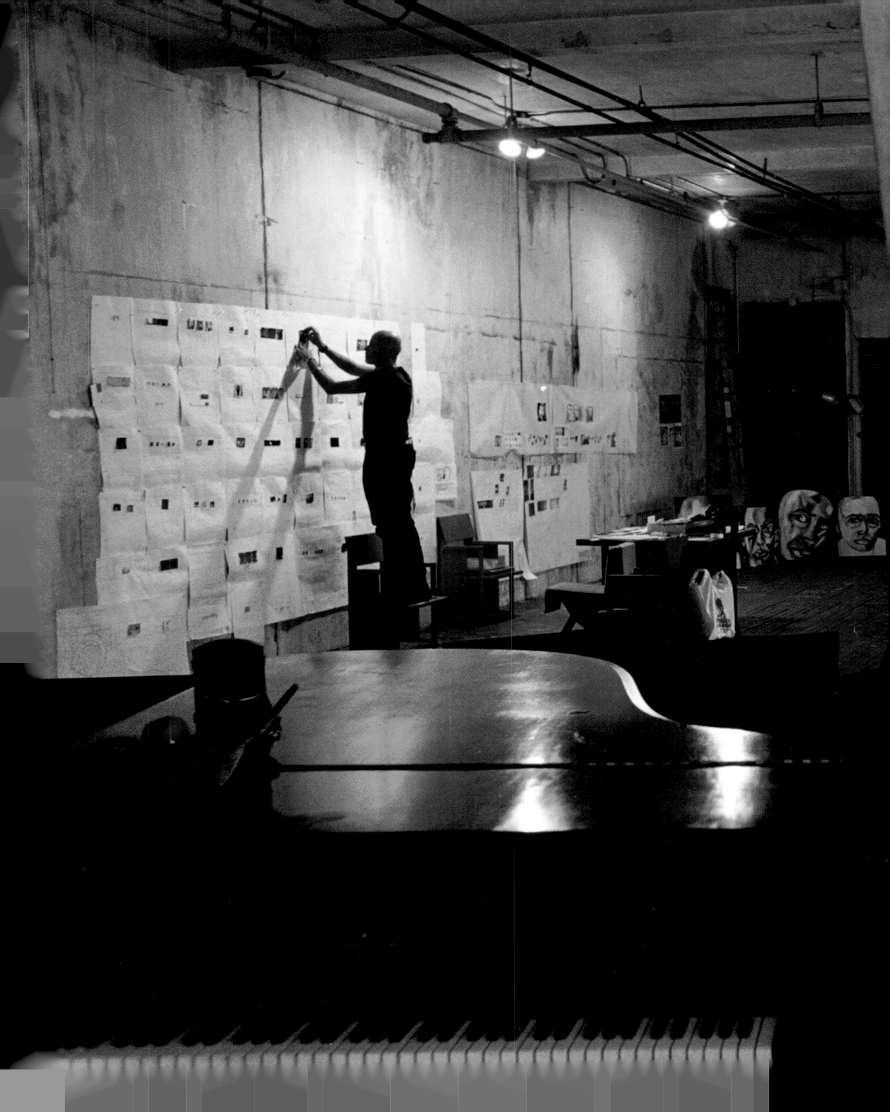

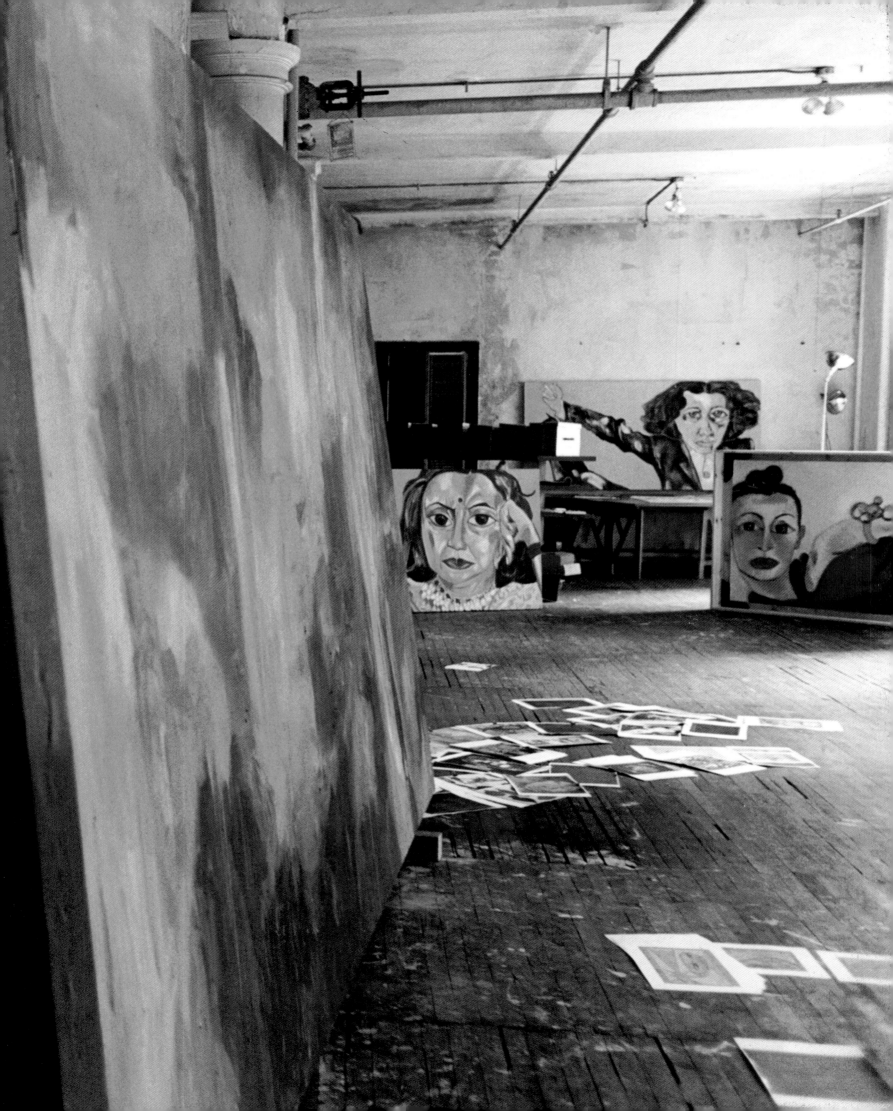

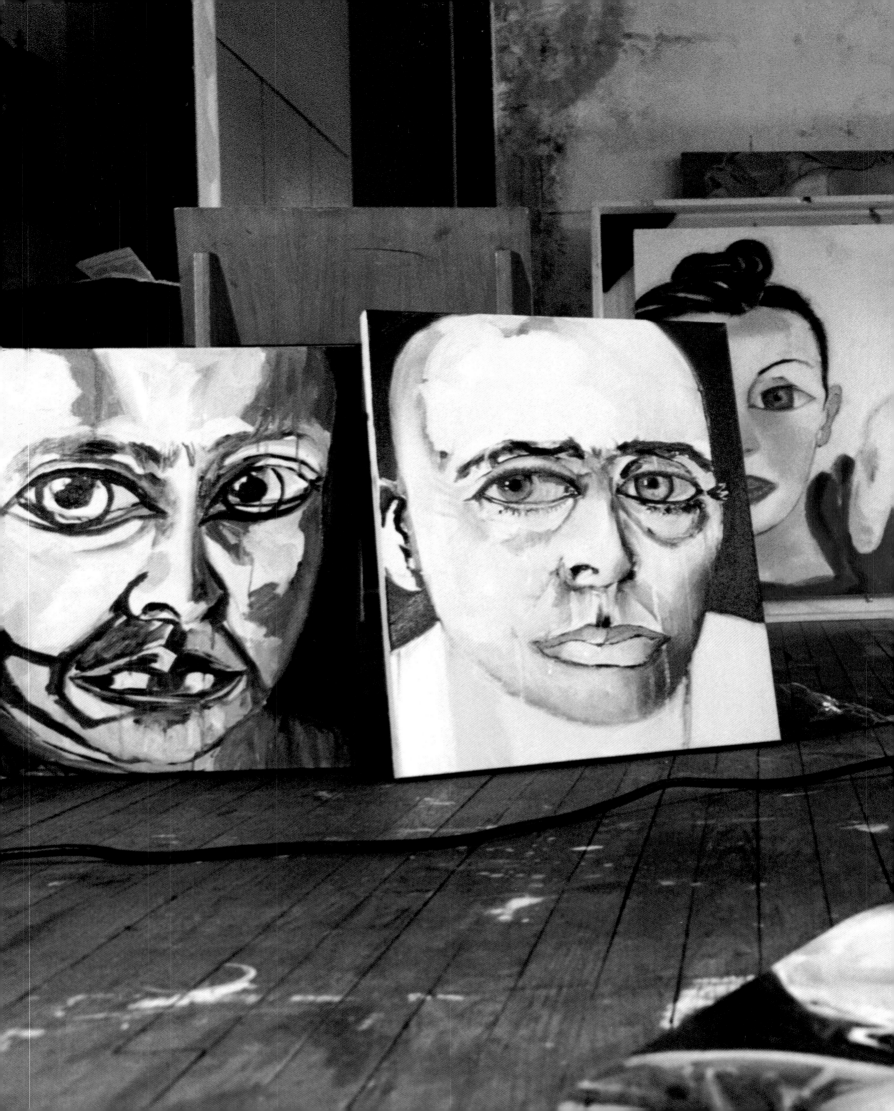

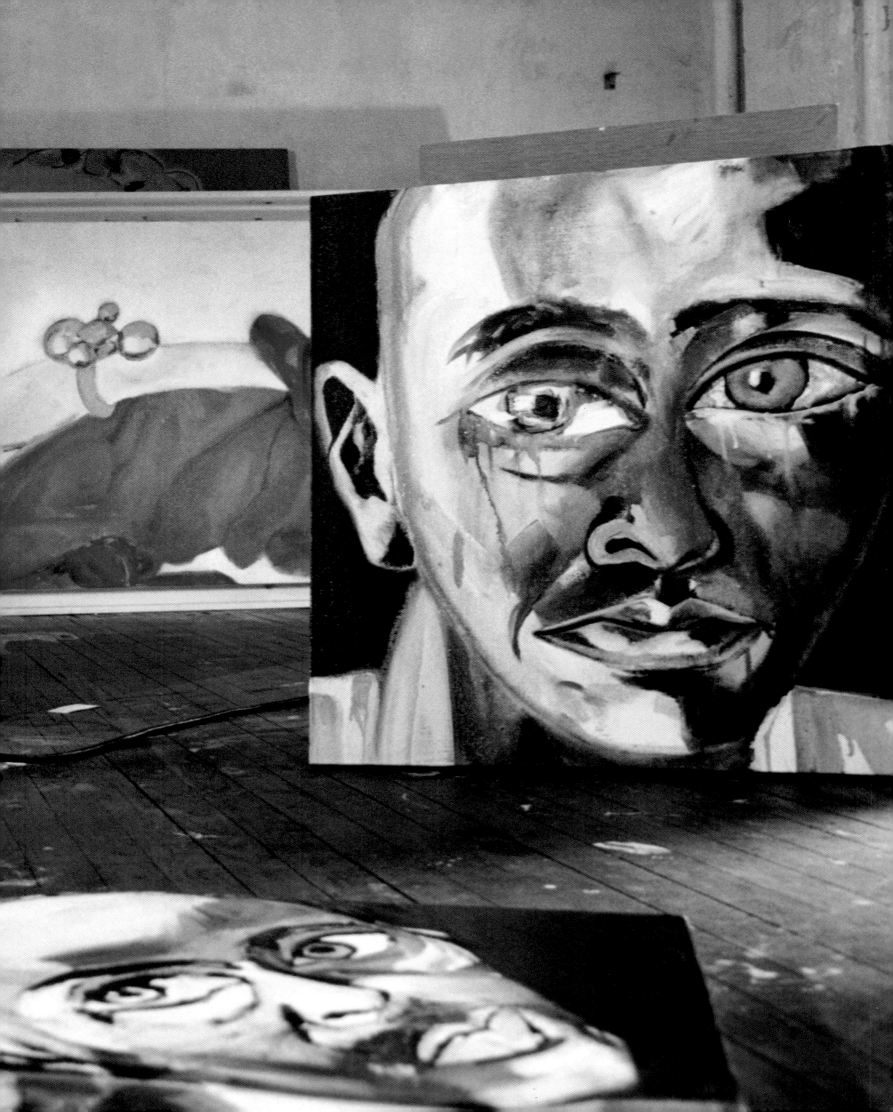

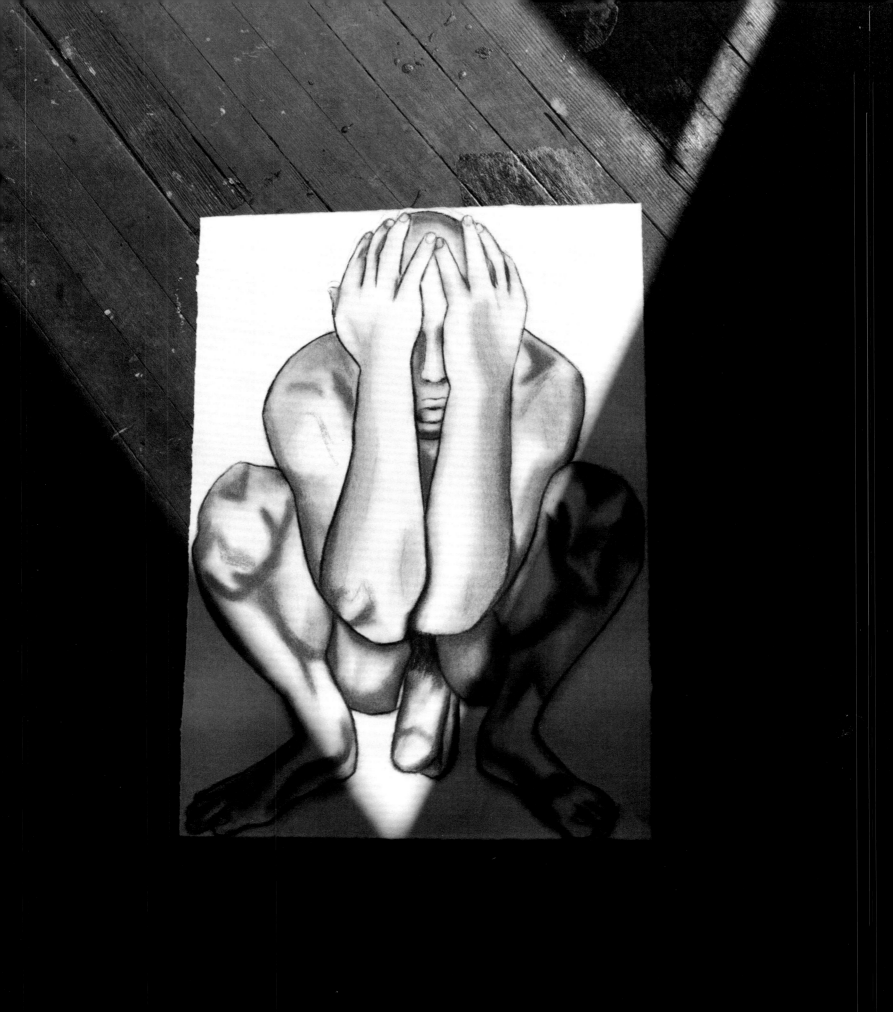

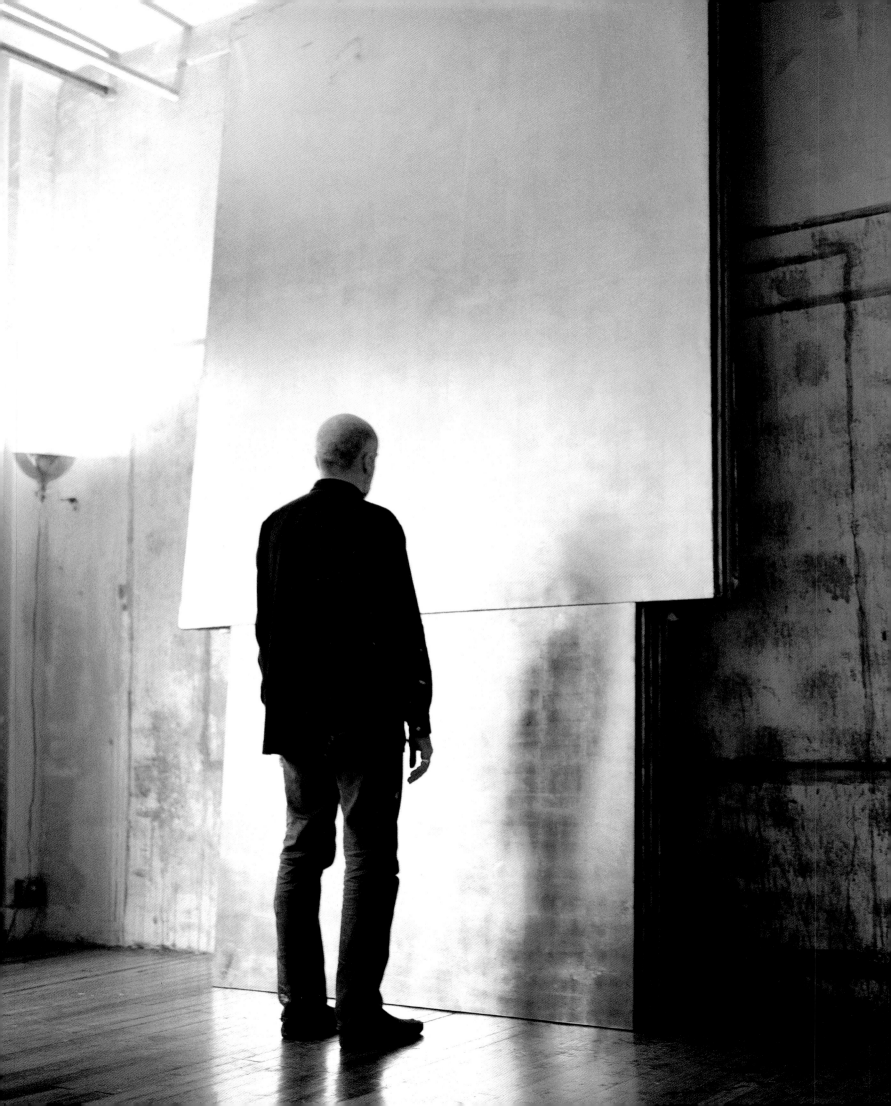

FRANCESCO CLEMENTE

A PORTRAIT

———

Photographs by Luca Babini

ESSAY BY RENE RICARD

APERTURE

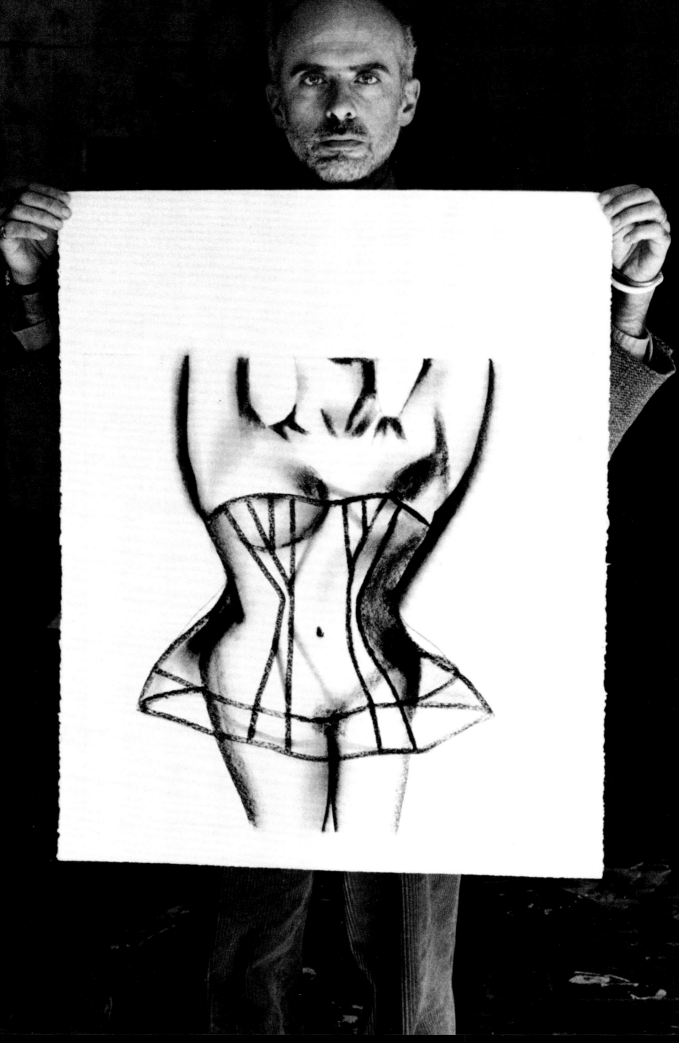

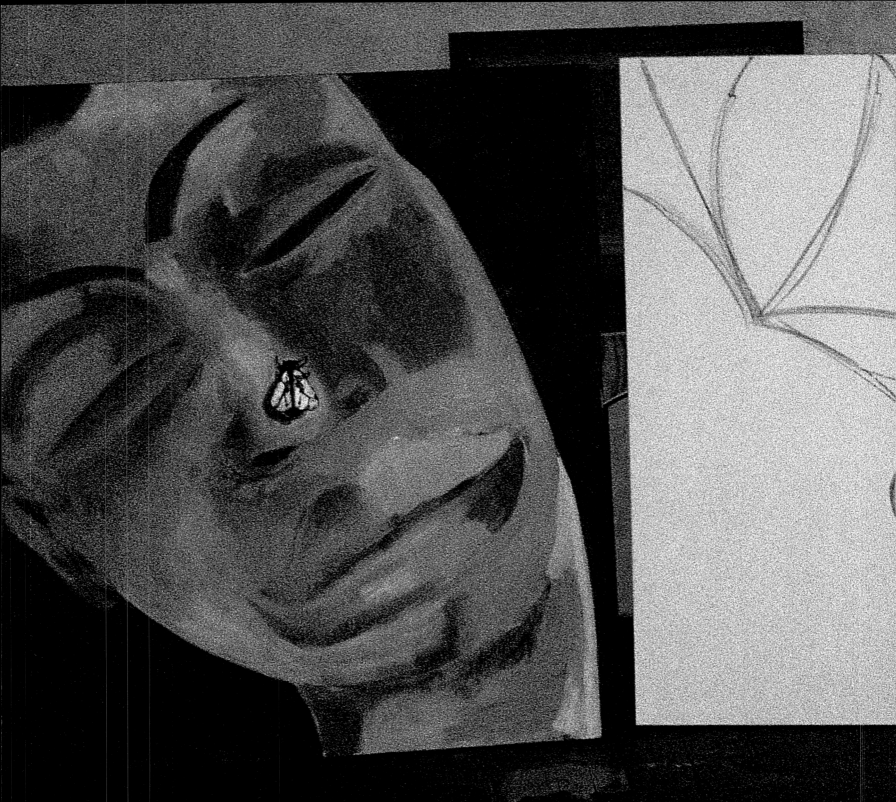

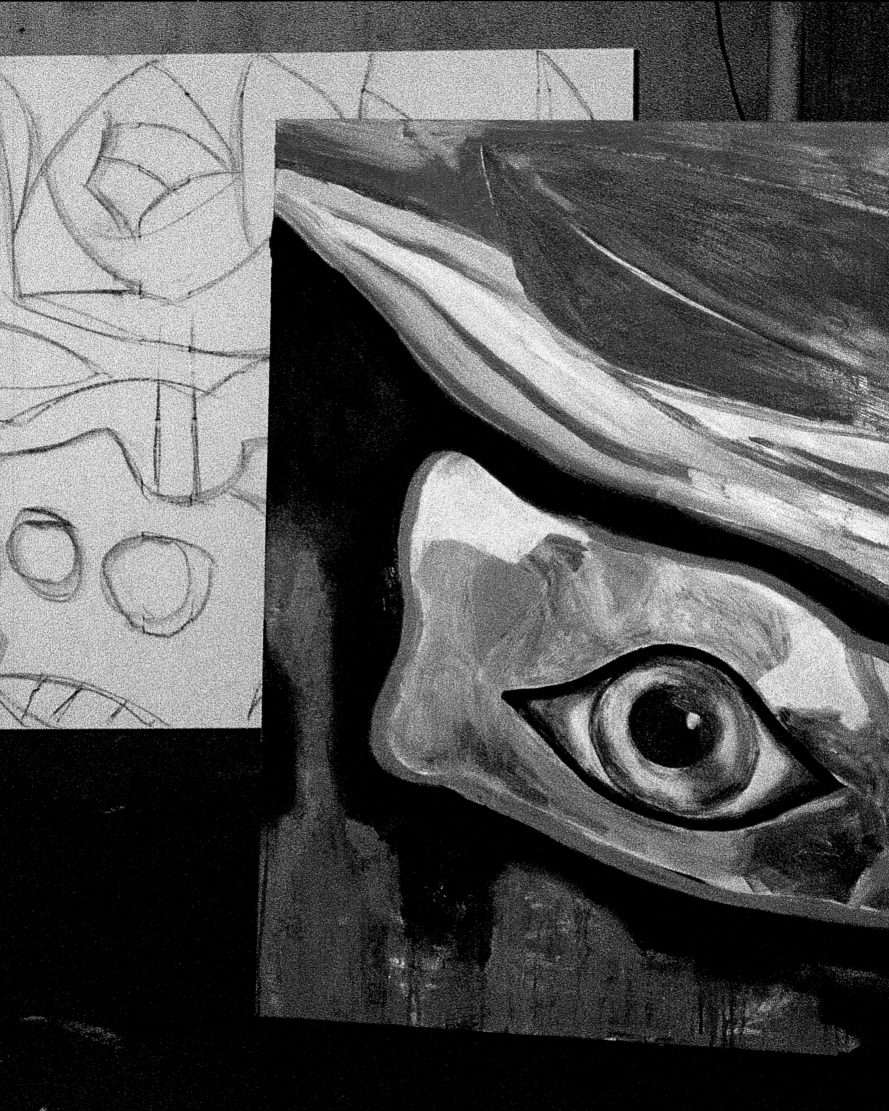

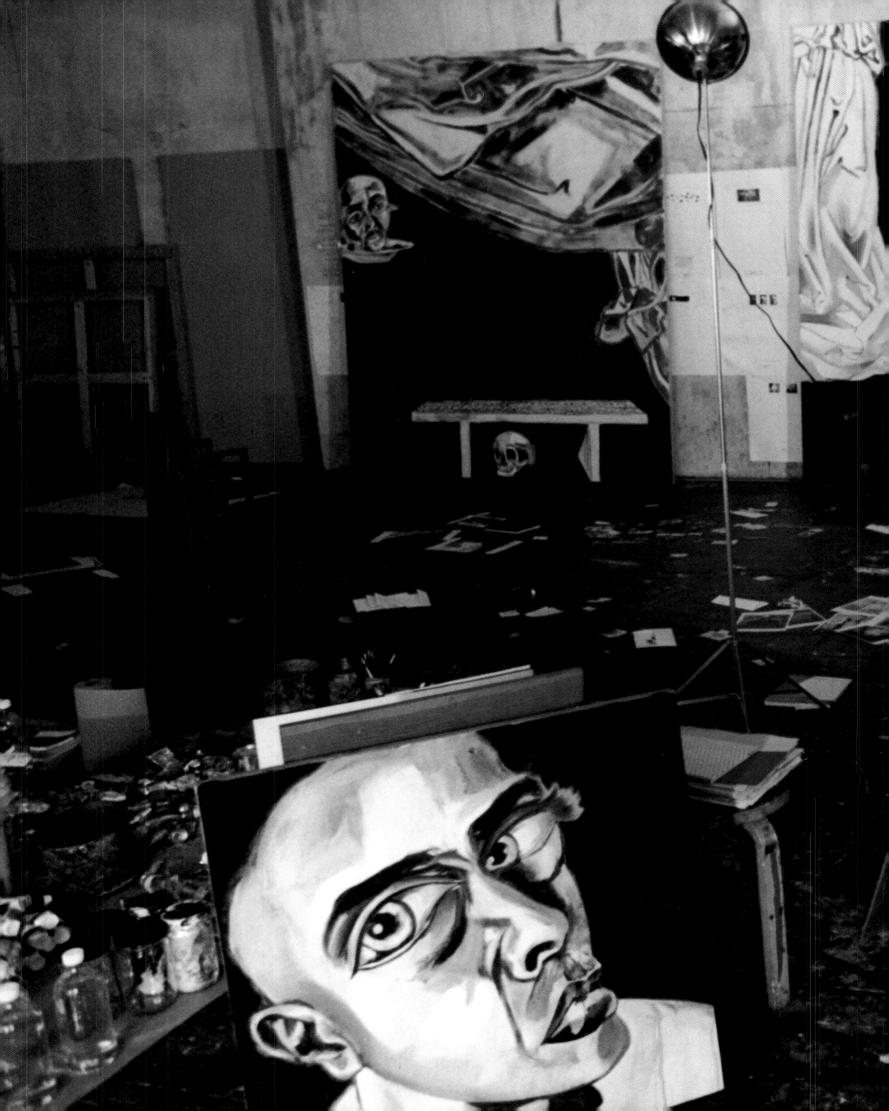

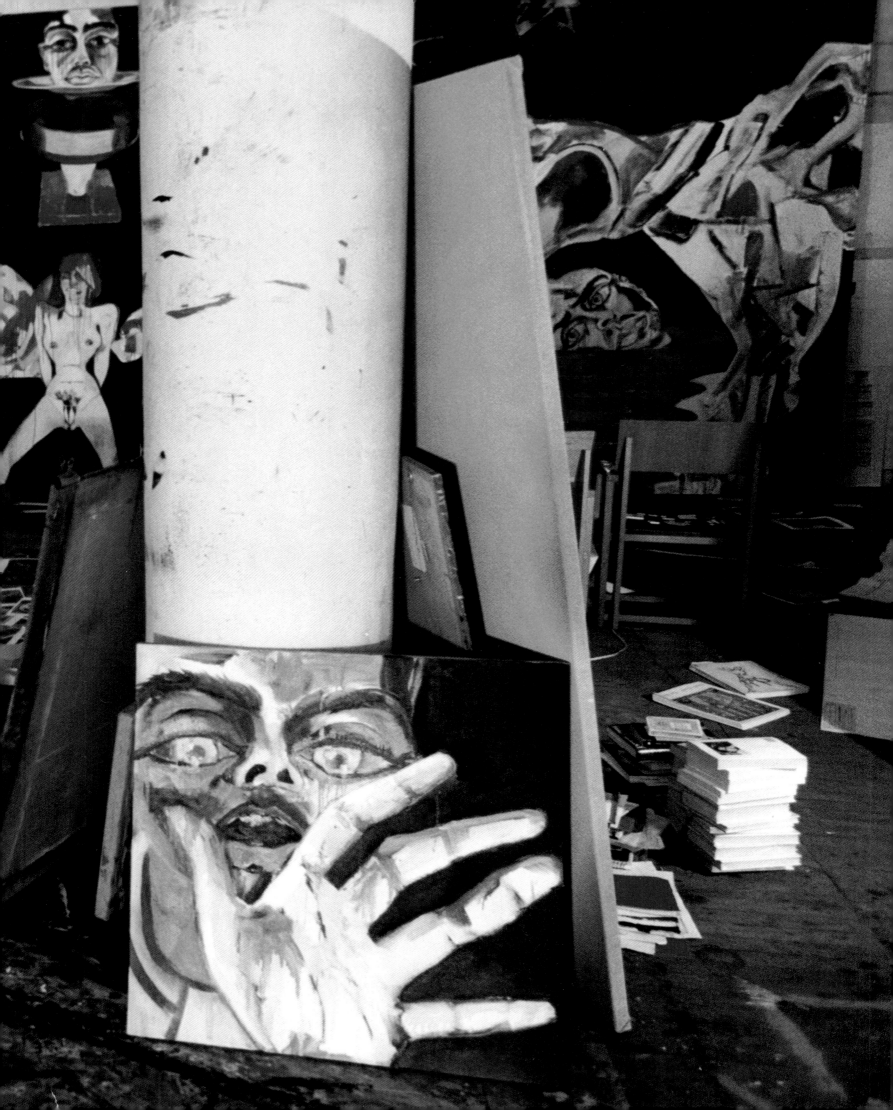

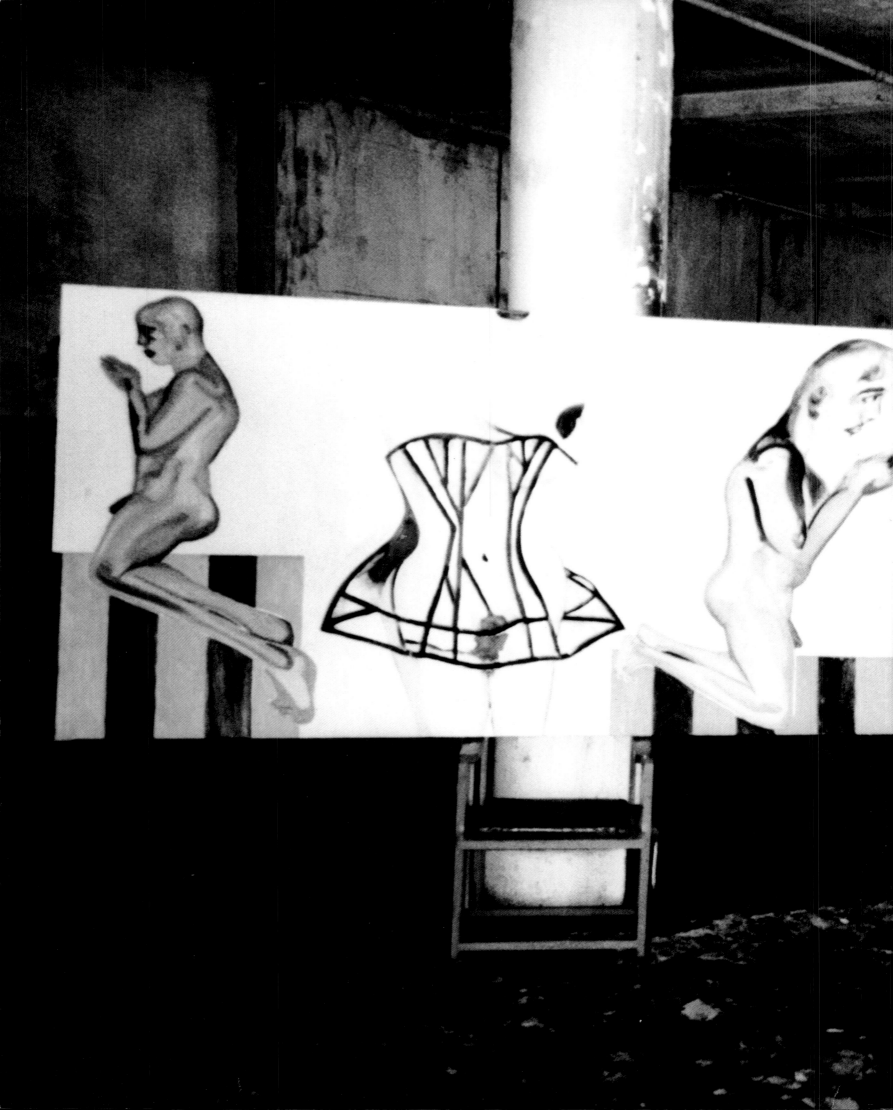

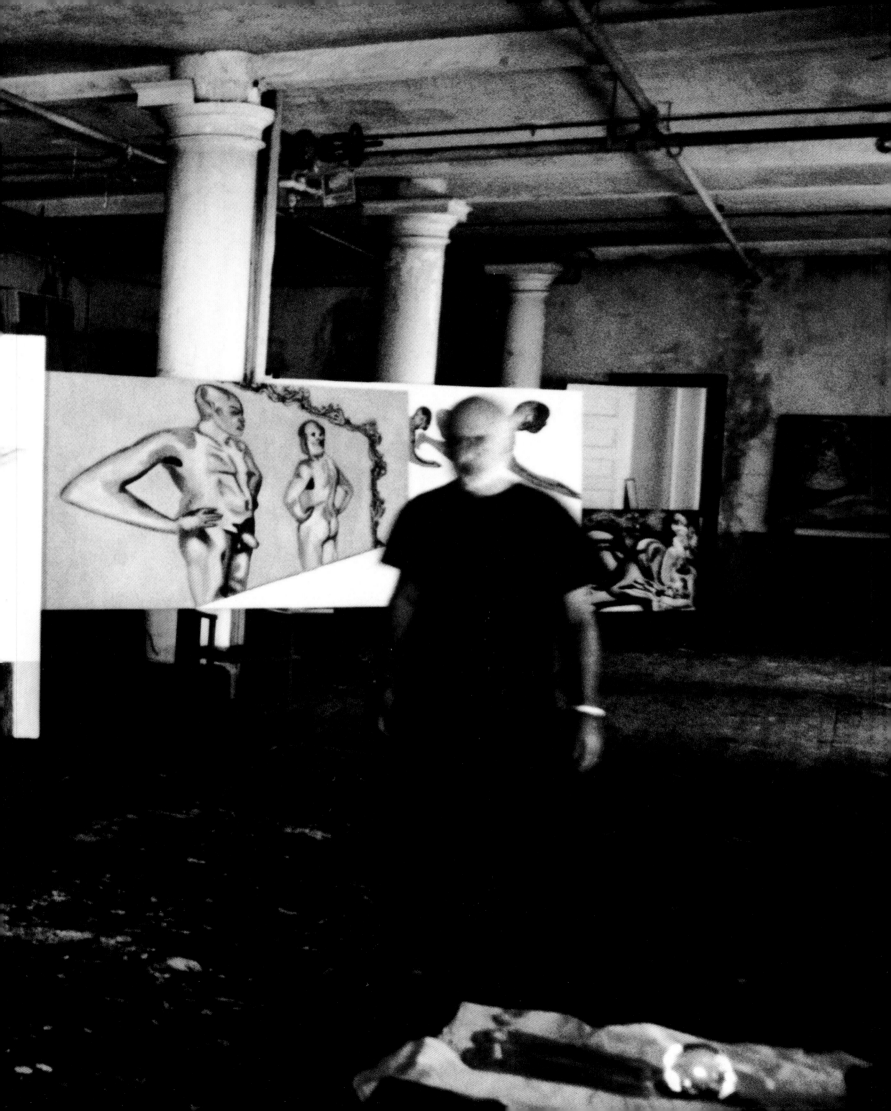

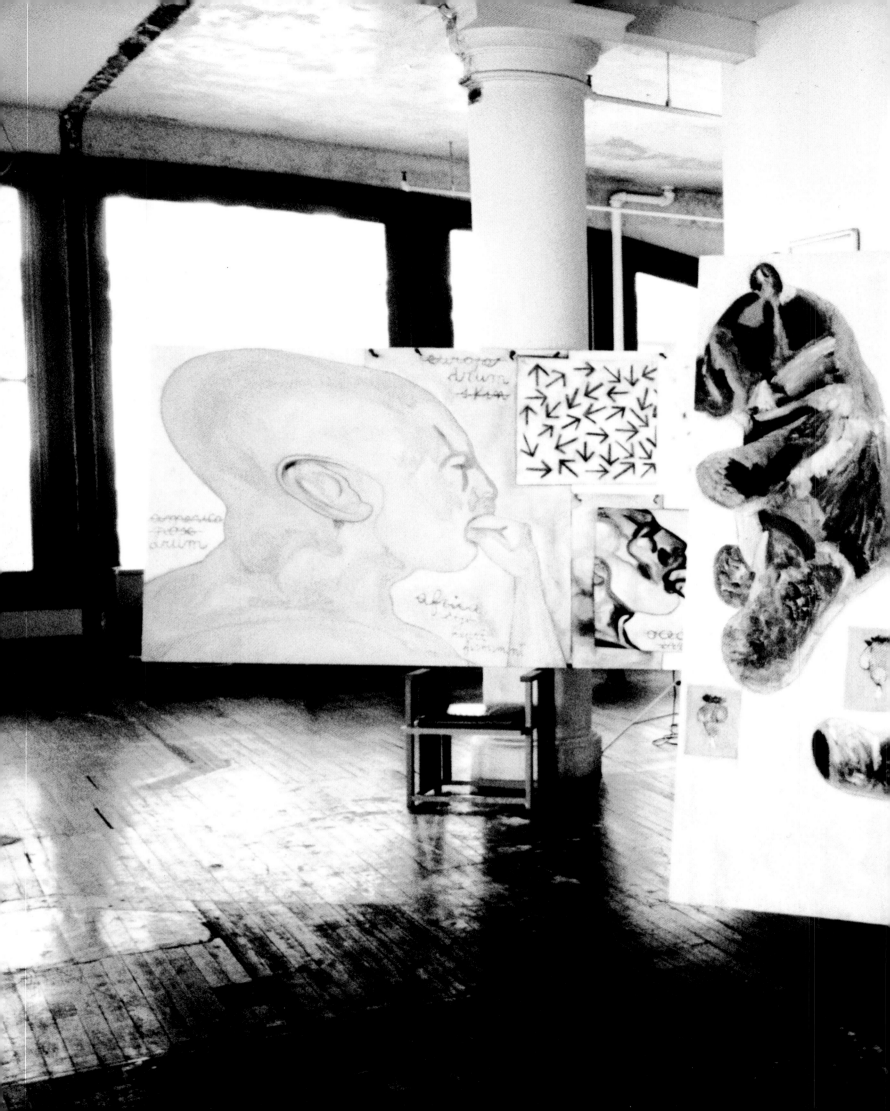

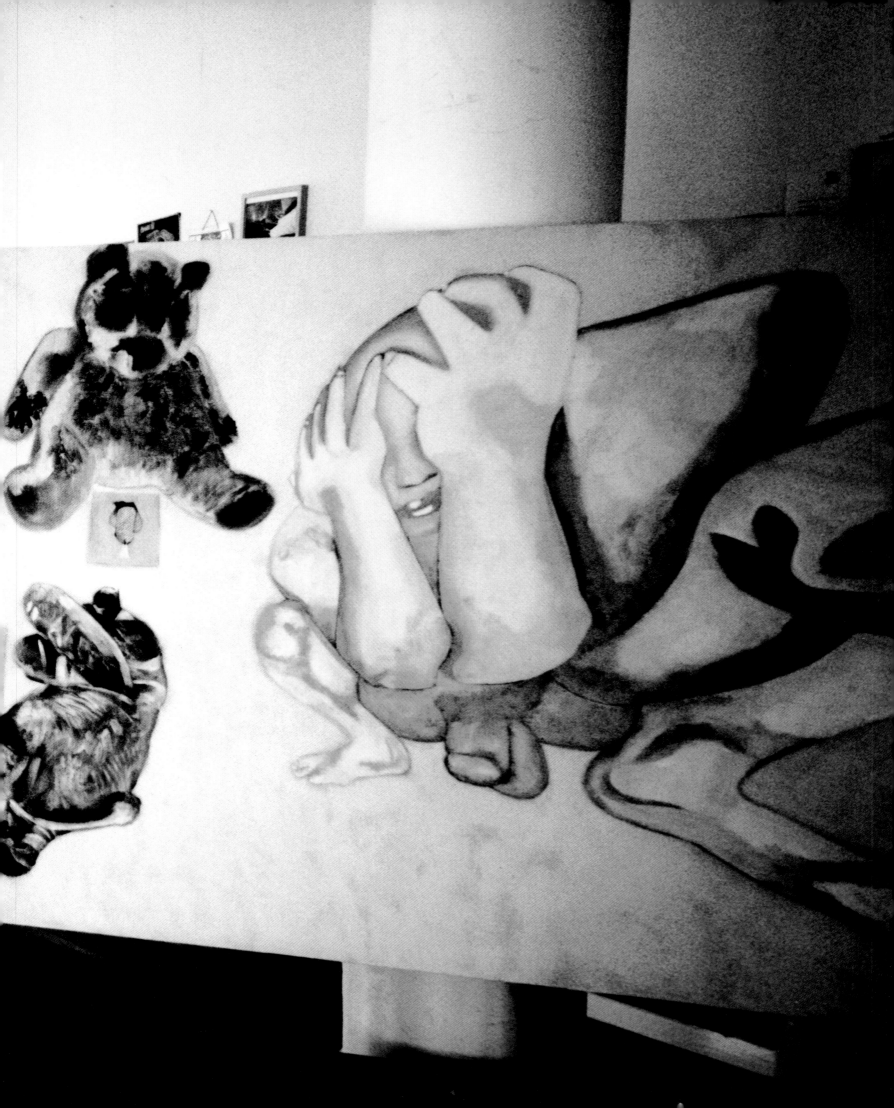

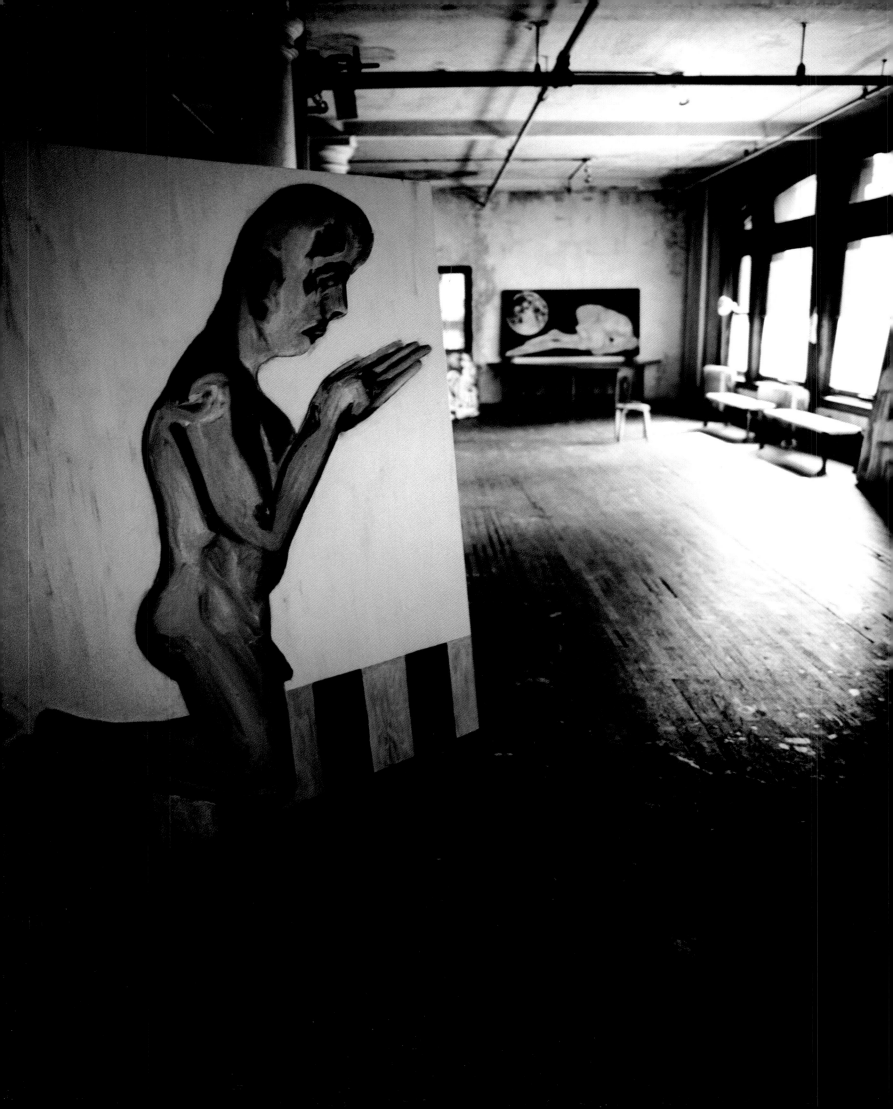

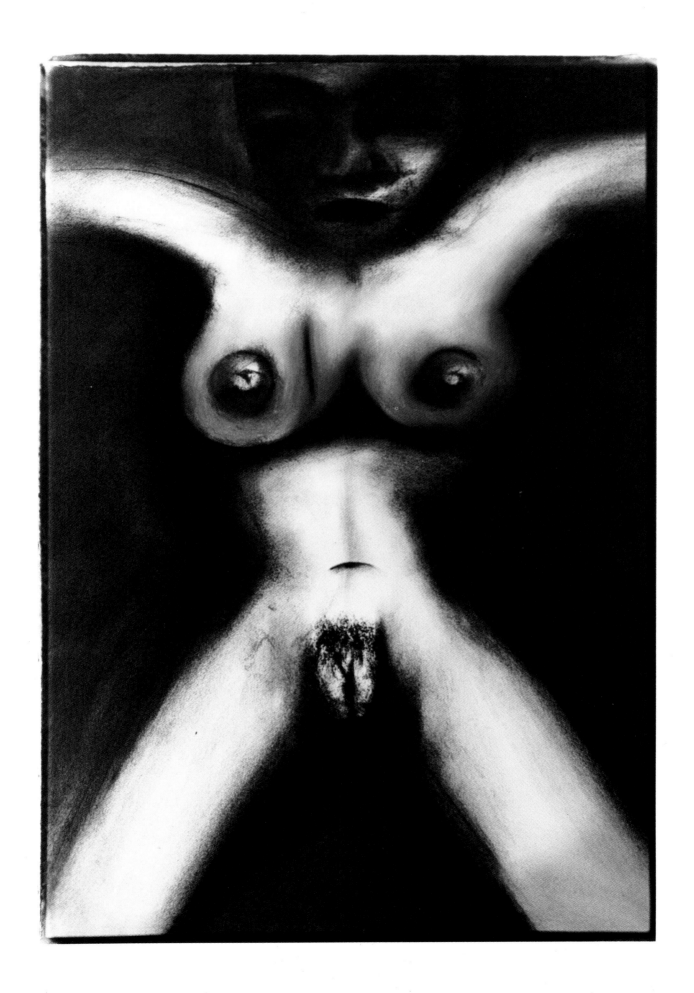

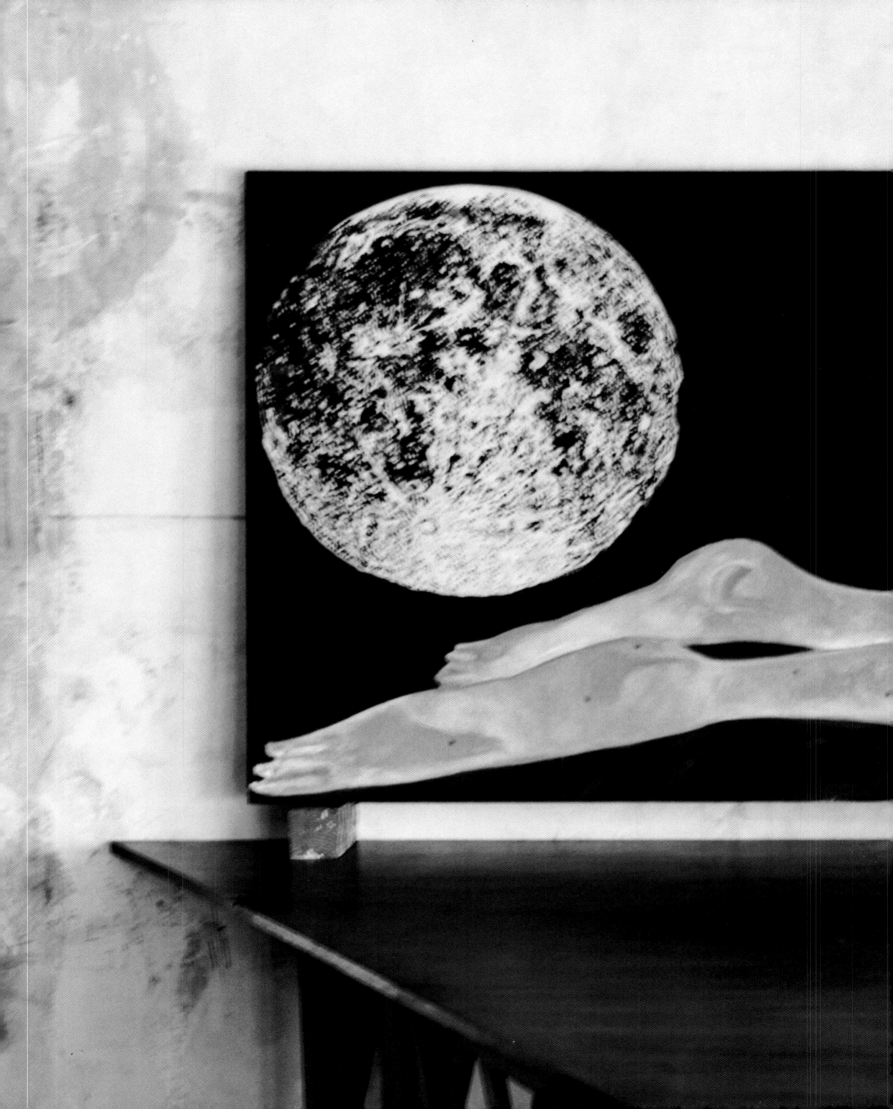

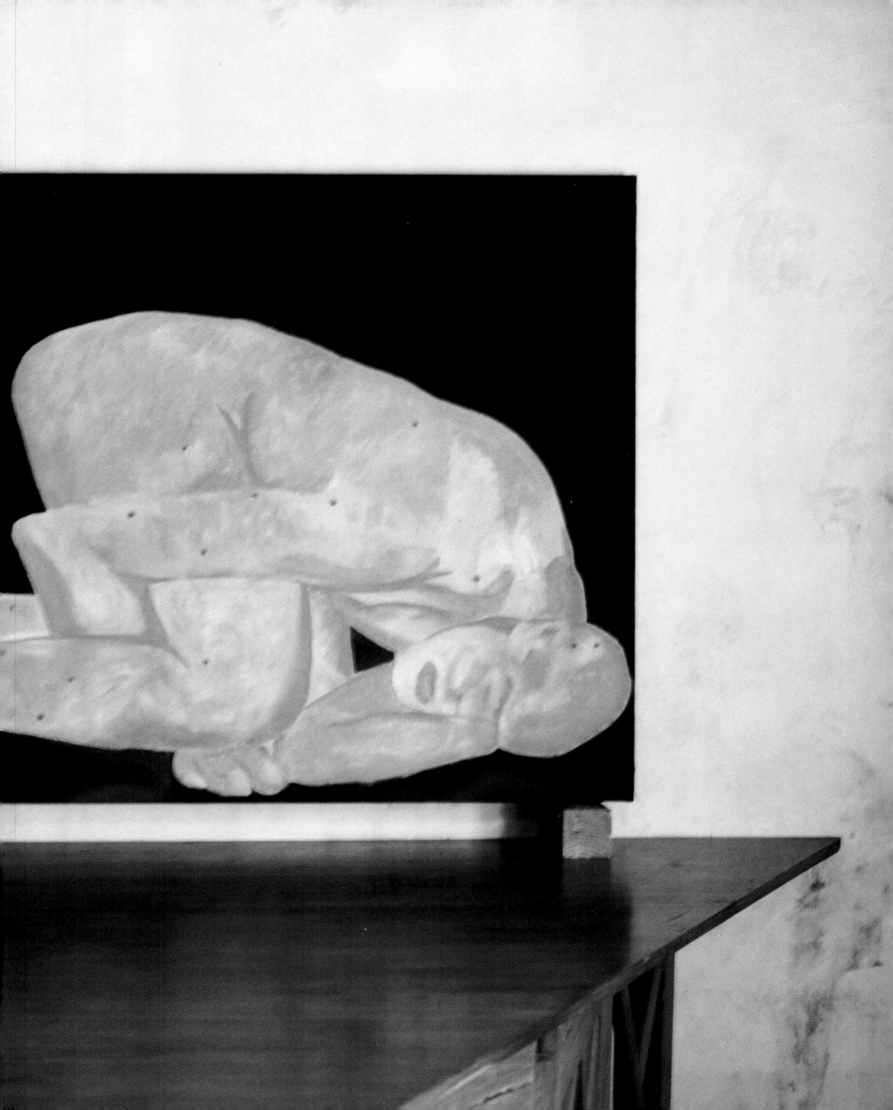

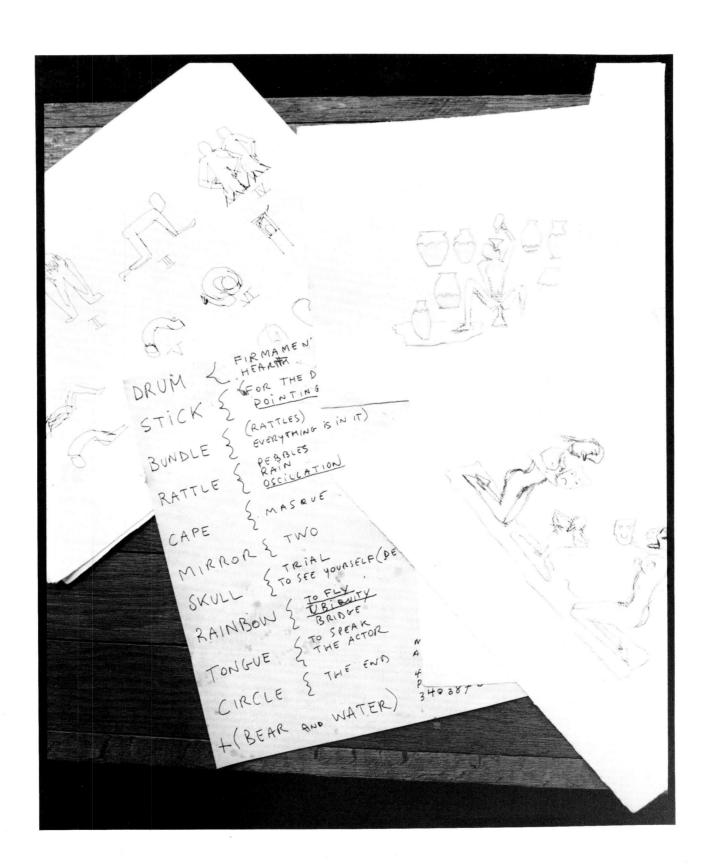

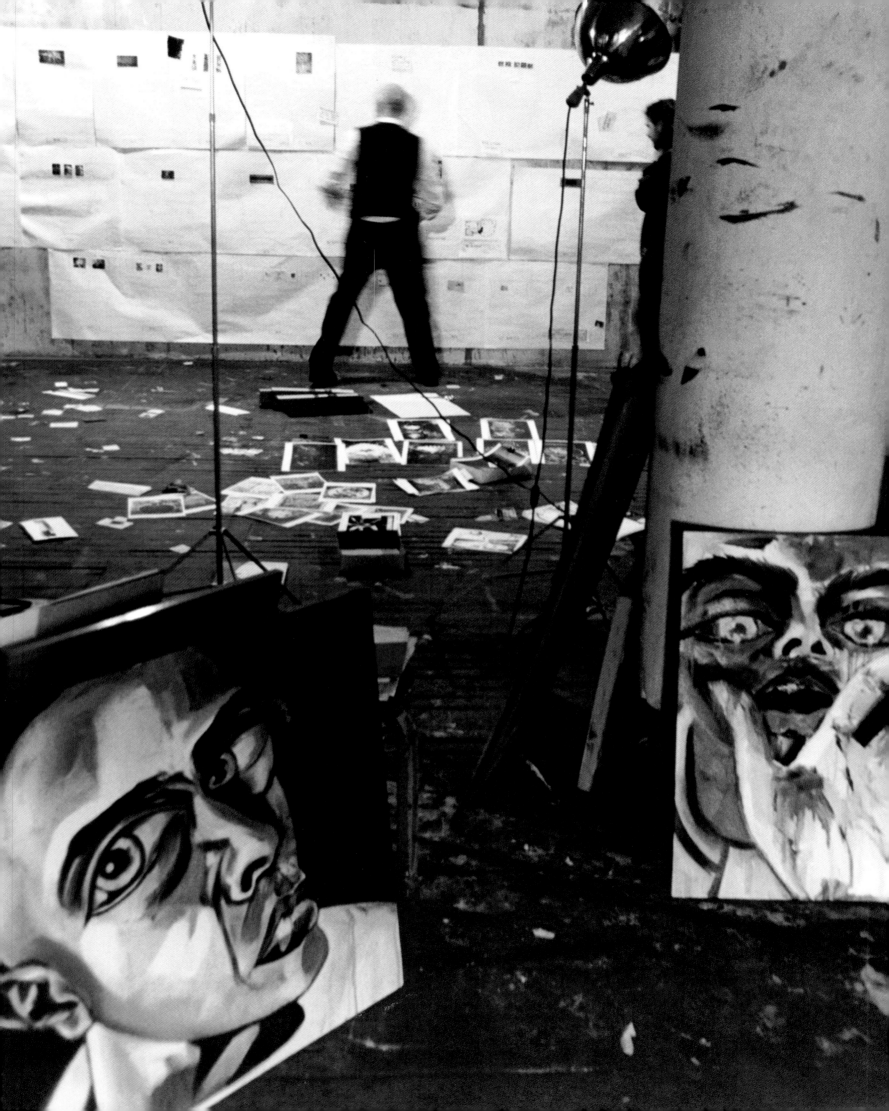

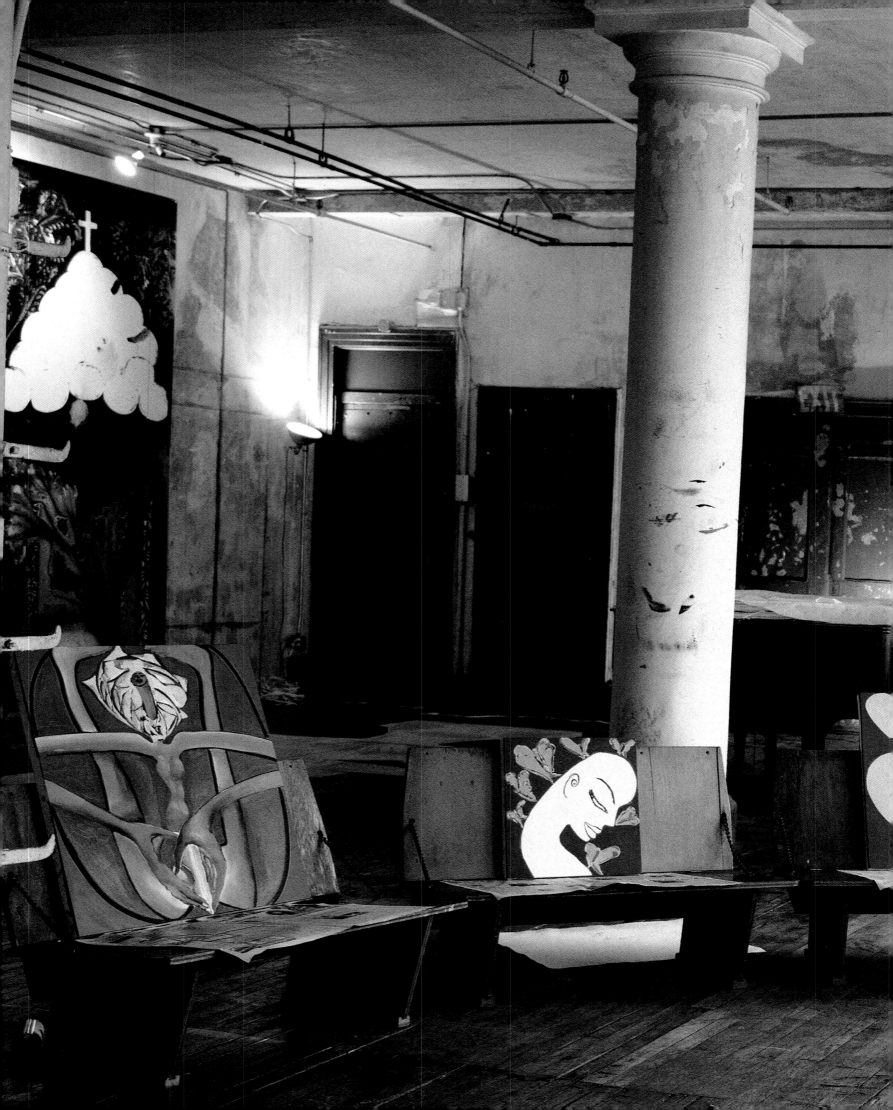

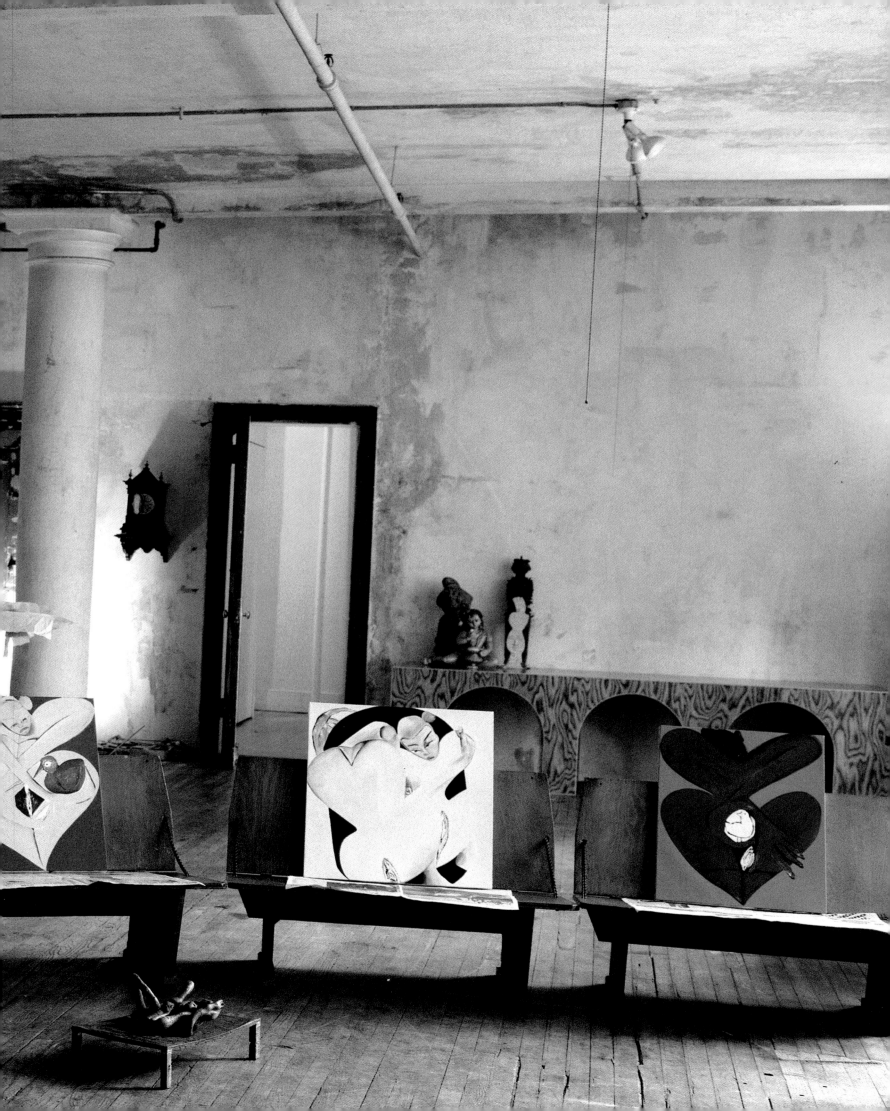

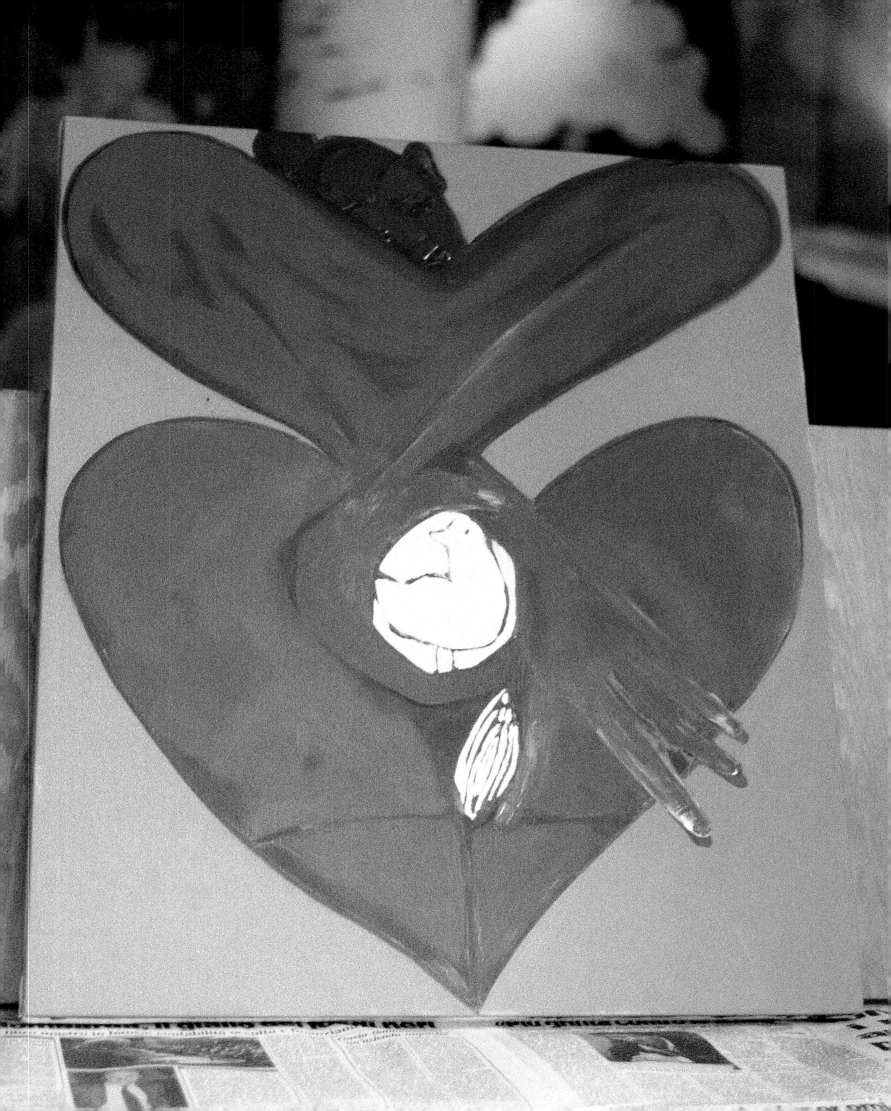

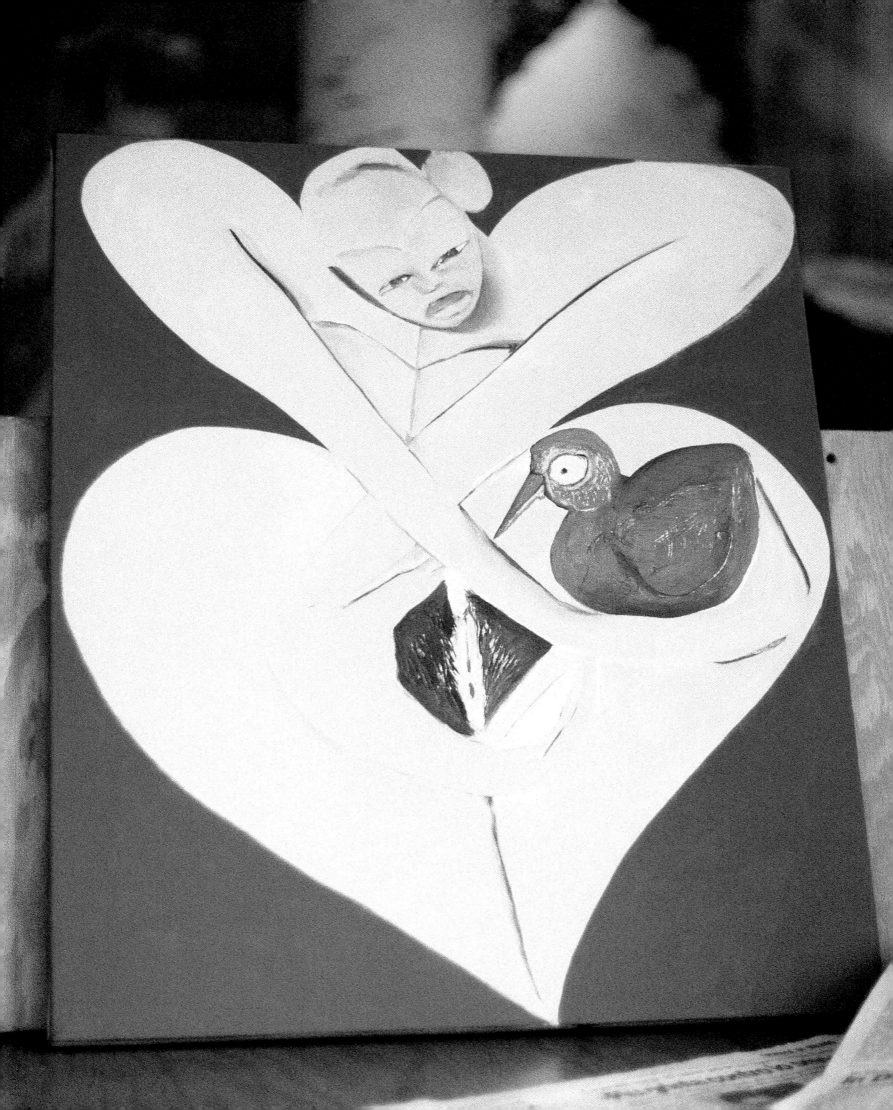

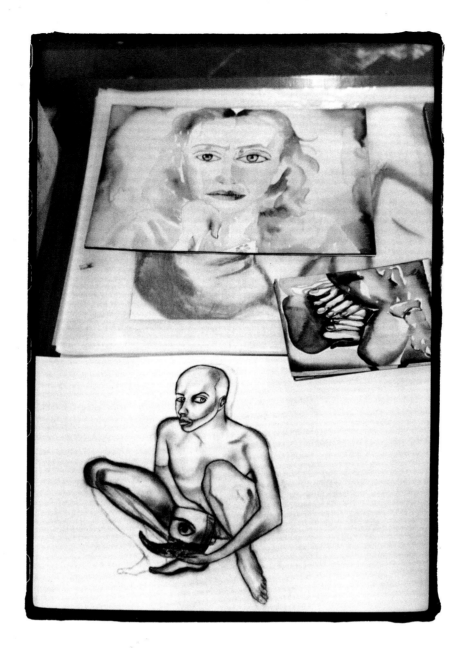

At the beginning of everything we find the voice
and before that, the breath.
I never decided to be a painter.
It has been a very gradual journey.
Through the seventies my work was like a large diary,
half written and half drawn.
Then, almost involuntarily, I began to embrace
the traditional ways of painting.

It is a way to remember, a way of thinking and knowing.
Painting relates to ways of thinking that are less common and for which
we are less trained. Generally it has to do with extreme states of consciousness,
like sickness, death, love.

Ideas divide and forms reunite.
Maybe ideas wound you and forms heal you.
Painting is what remains of a magical activity of comprehension
and acceptance of the world through forms.

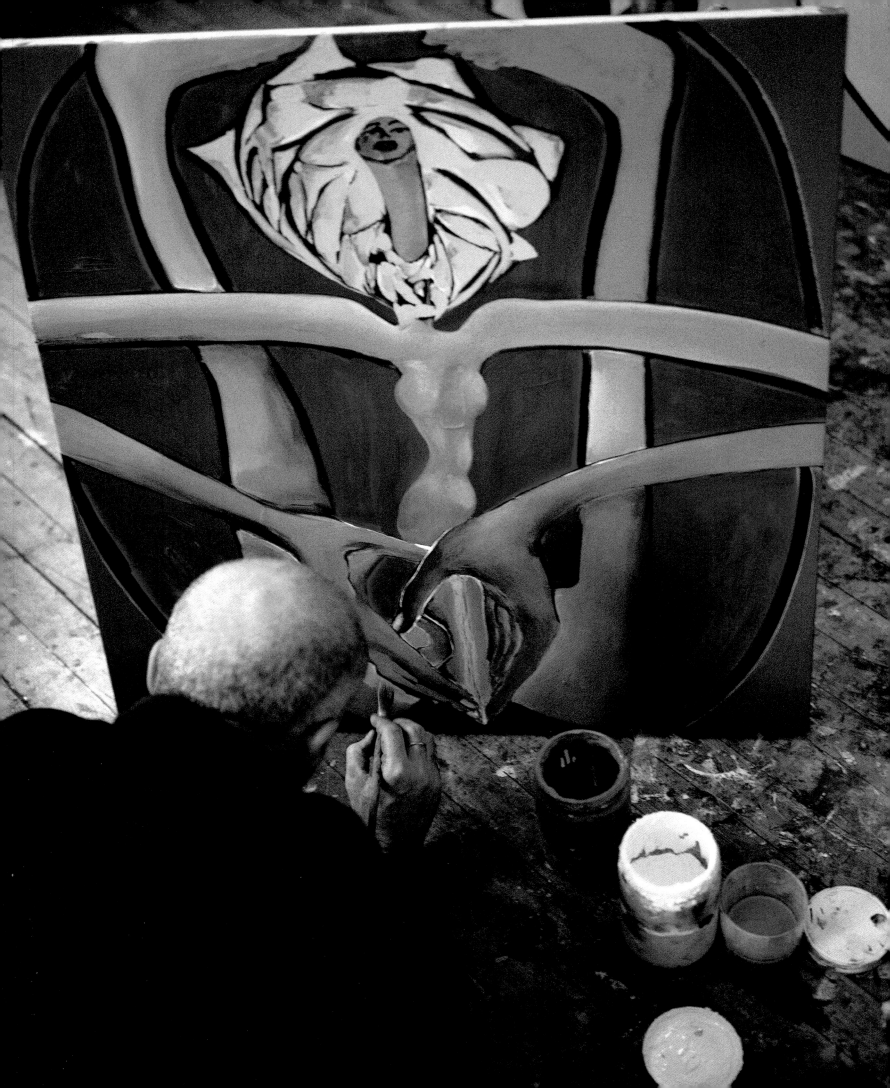

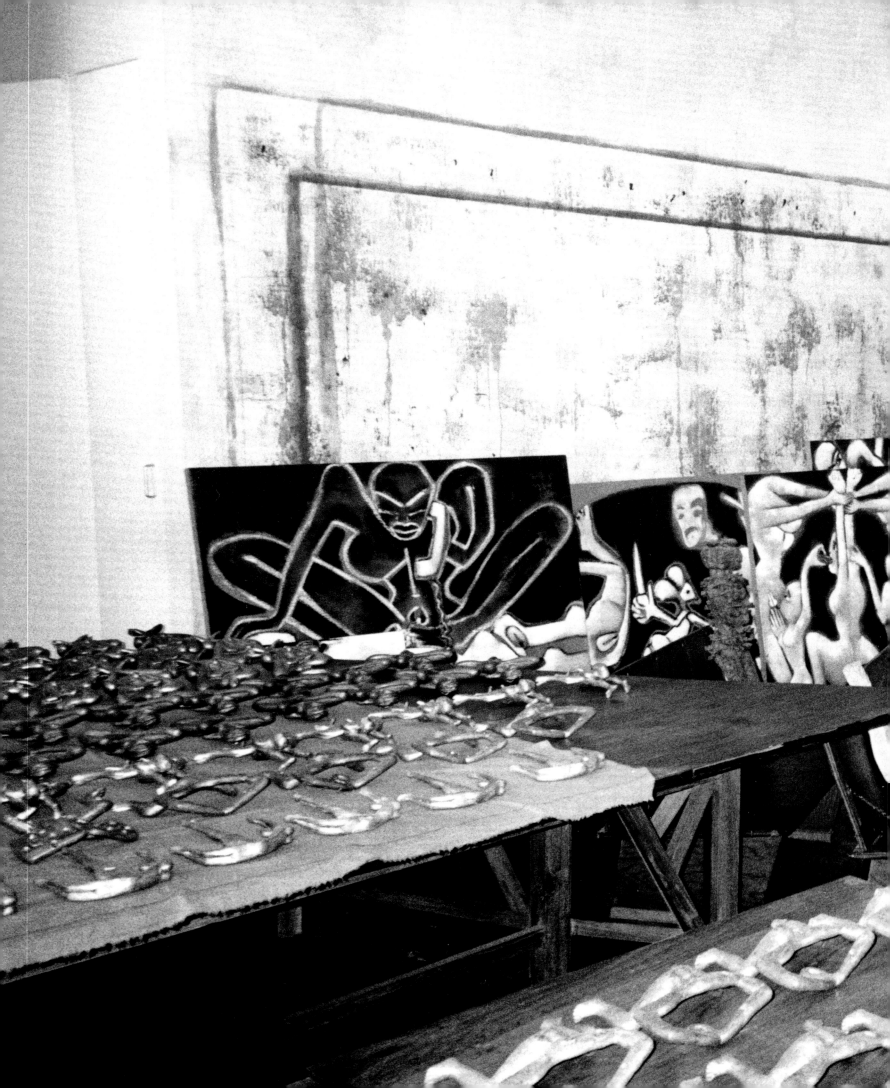

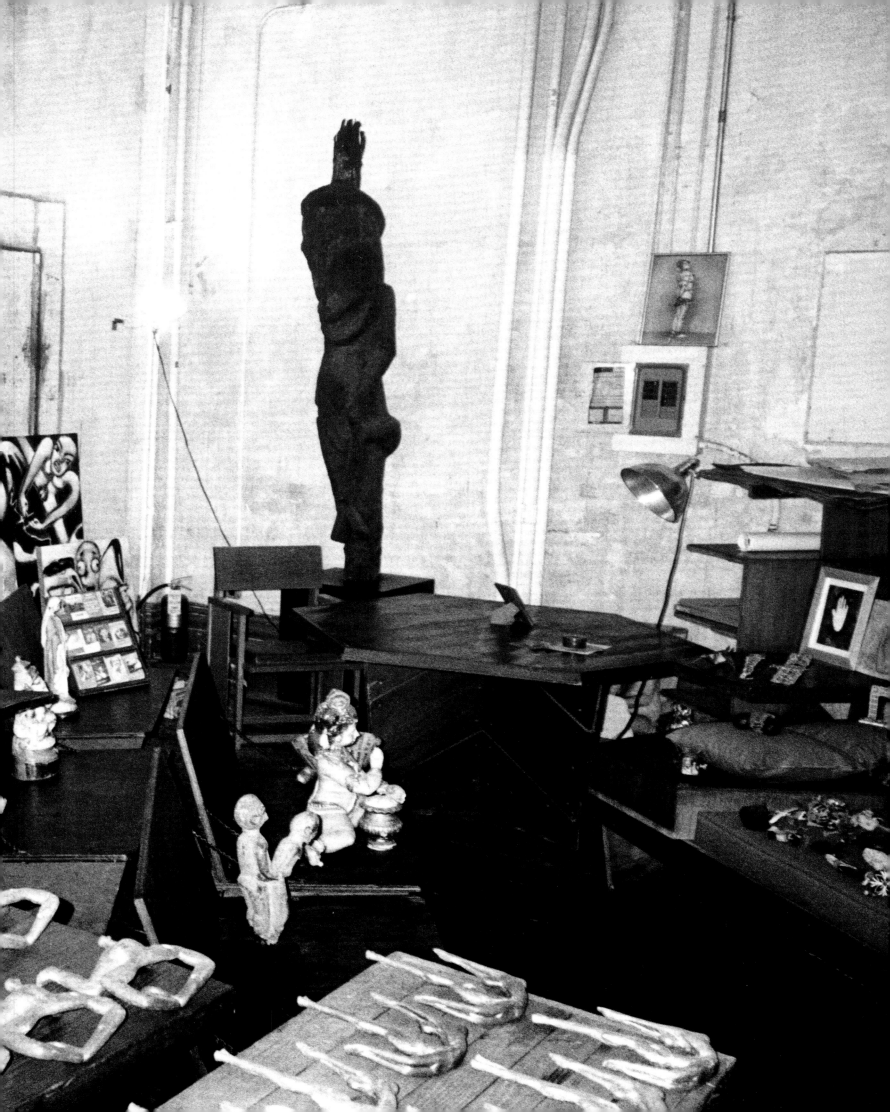

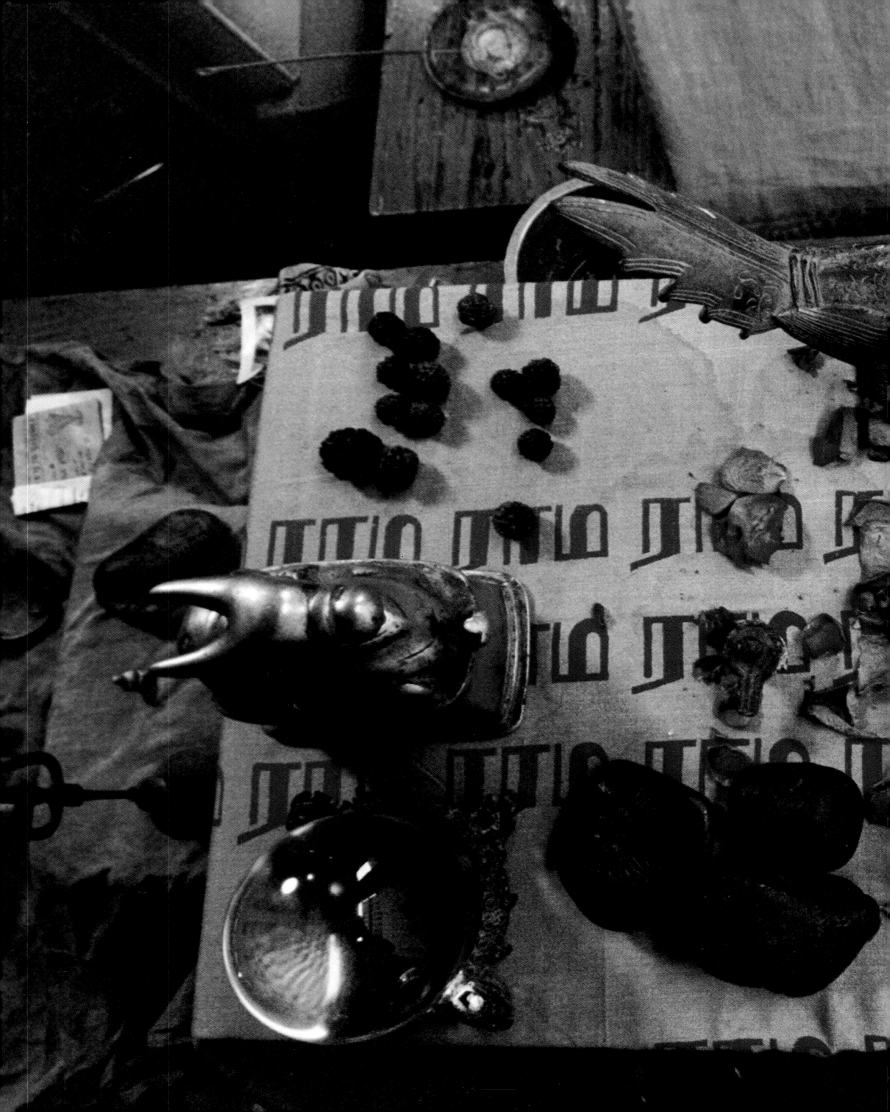

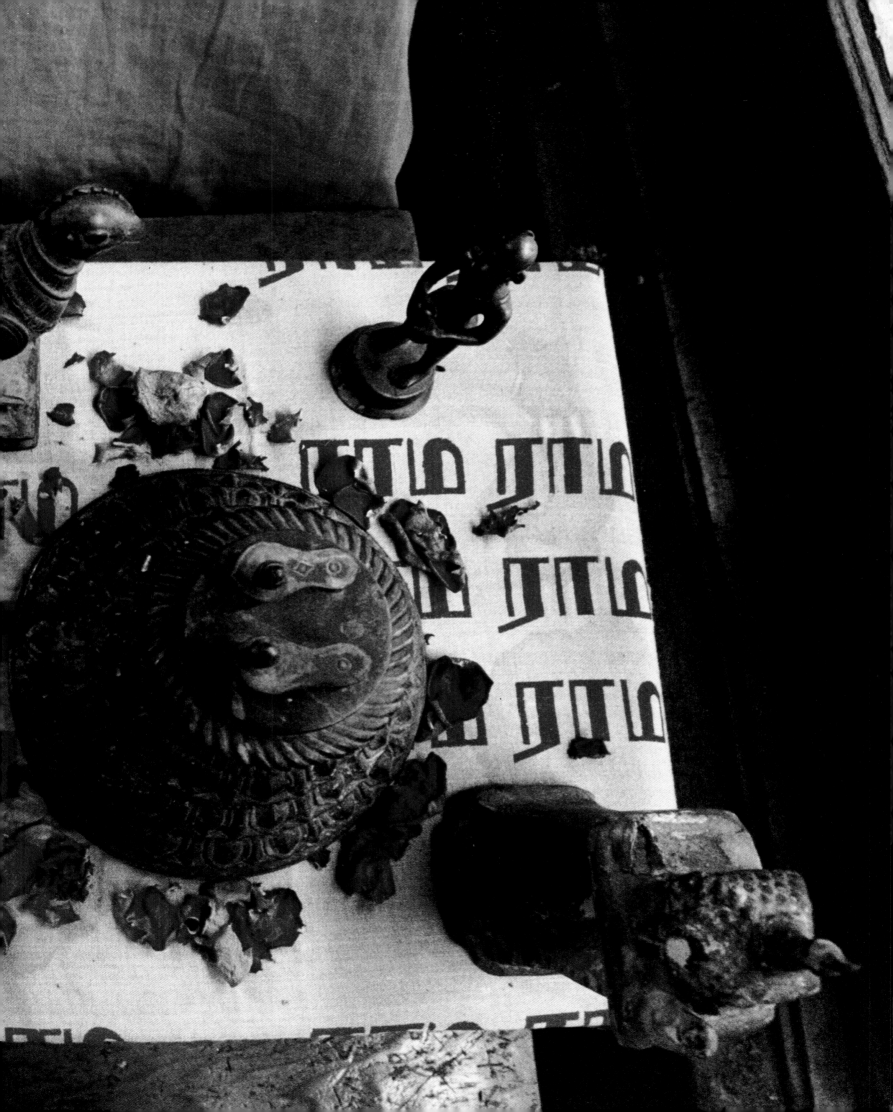

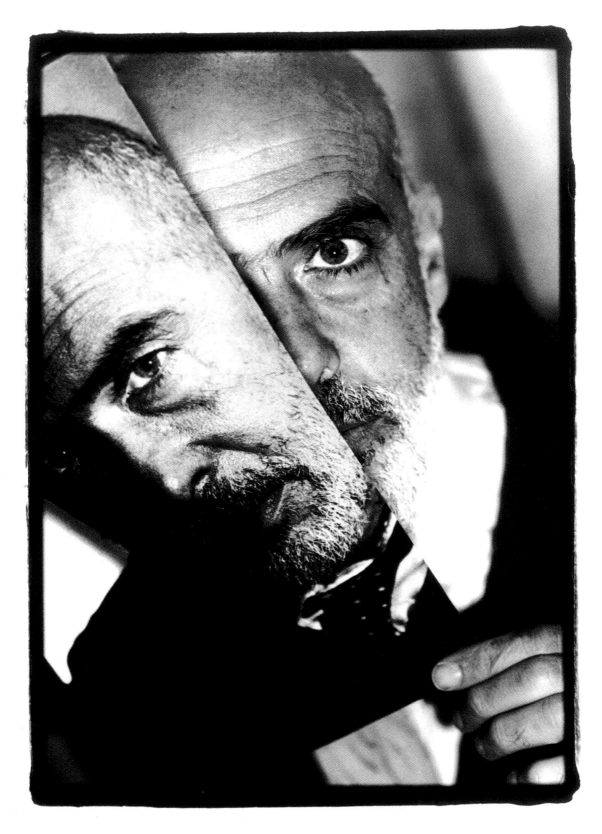

I laugh when I think about how my love for India began.
It was *Siddhartha*, which I read when I was fourteen,
and the cover of Jimi Hendrix's *Electric Ladyland* with all the Indian gods on it.
As you can see, it was the Germans and the Americans
that first took me to India!
India is like New York but between transparent walls—
the absolute fusion and segregation of all and everything.
Both places are of grand spaces,
interior in India and exterior in America.

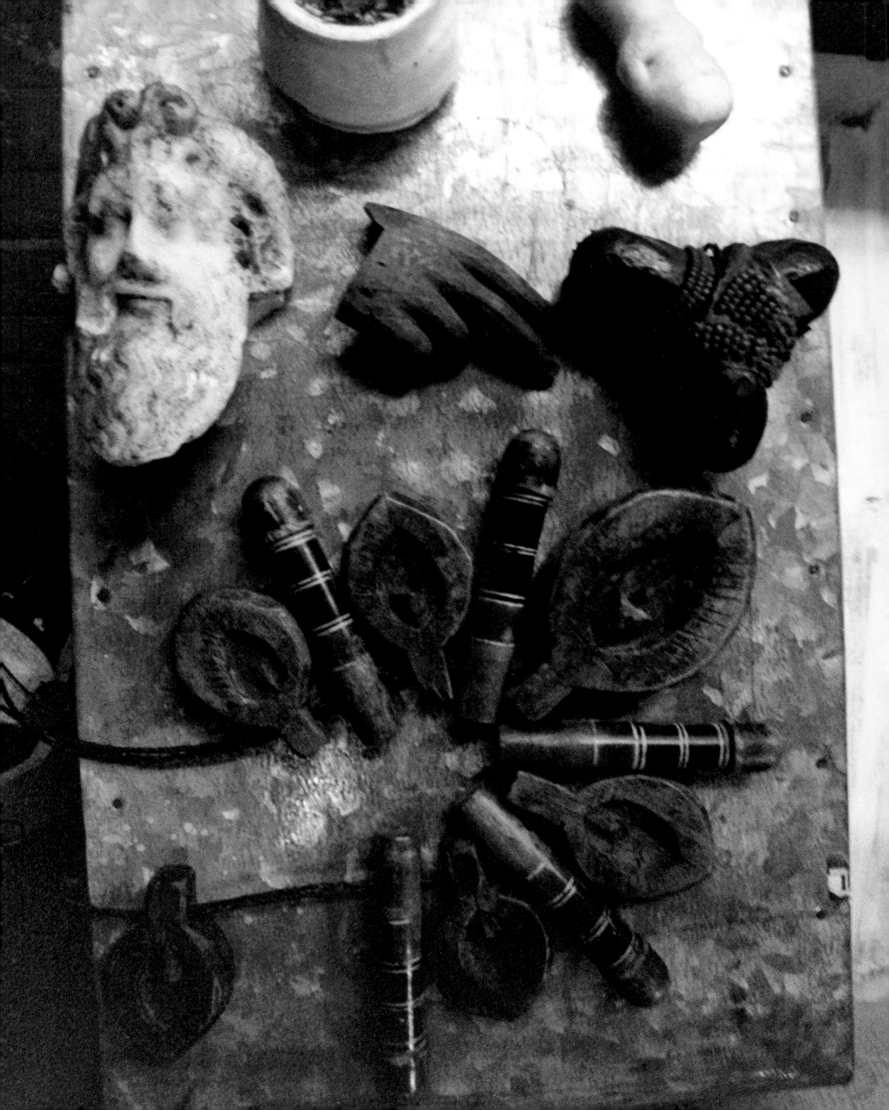

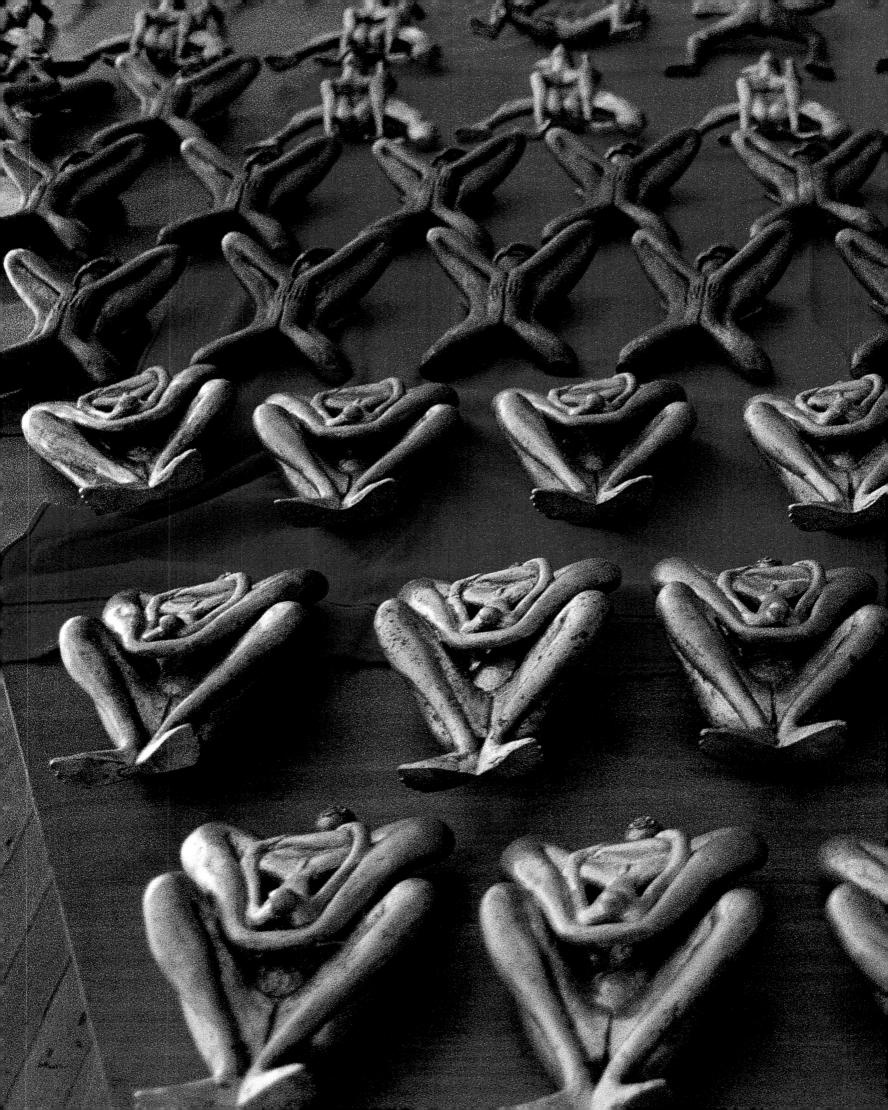

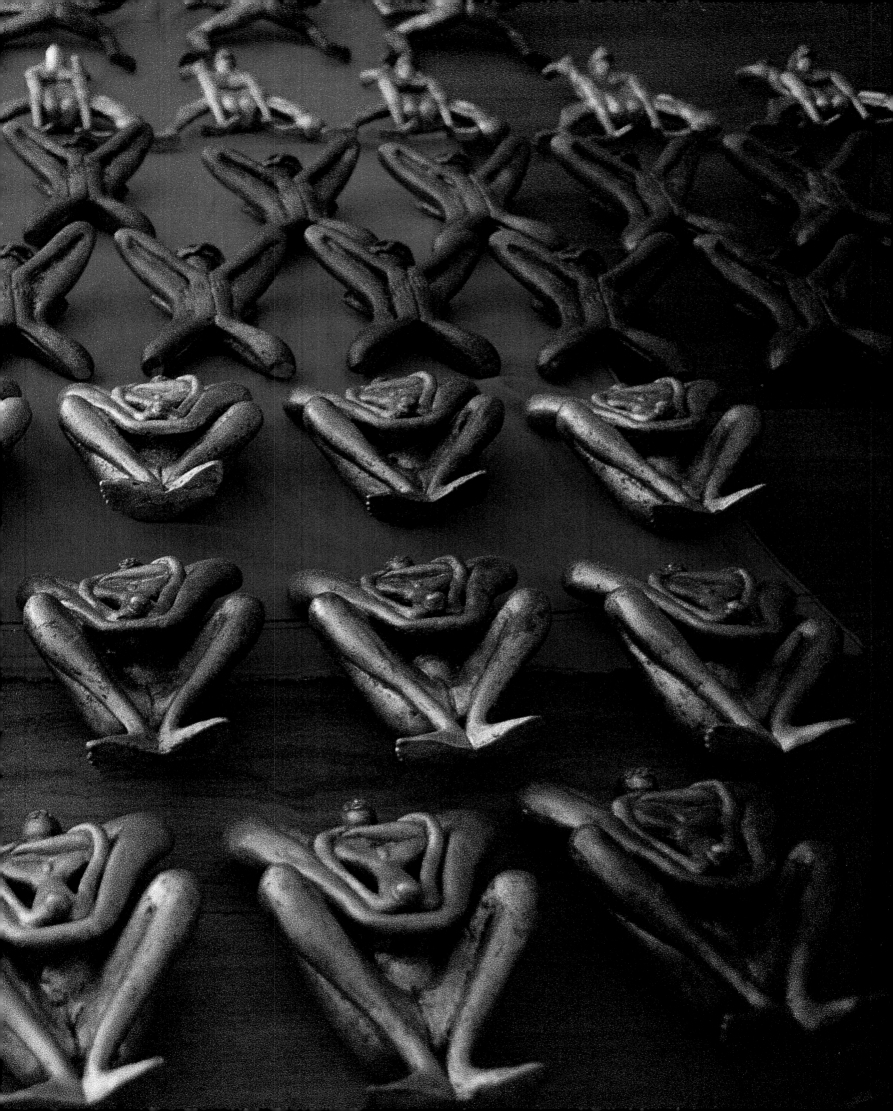

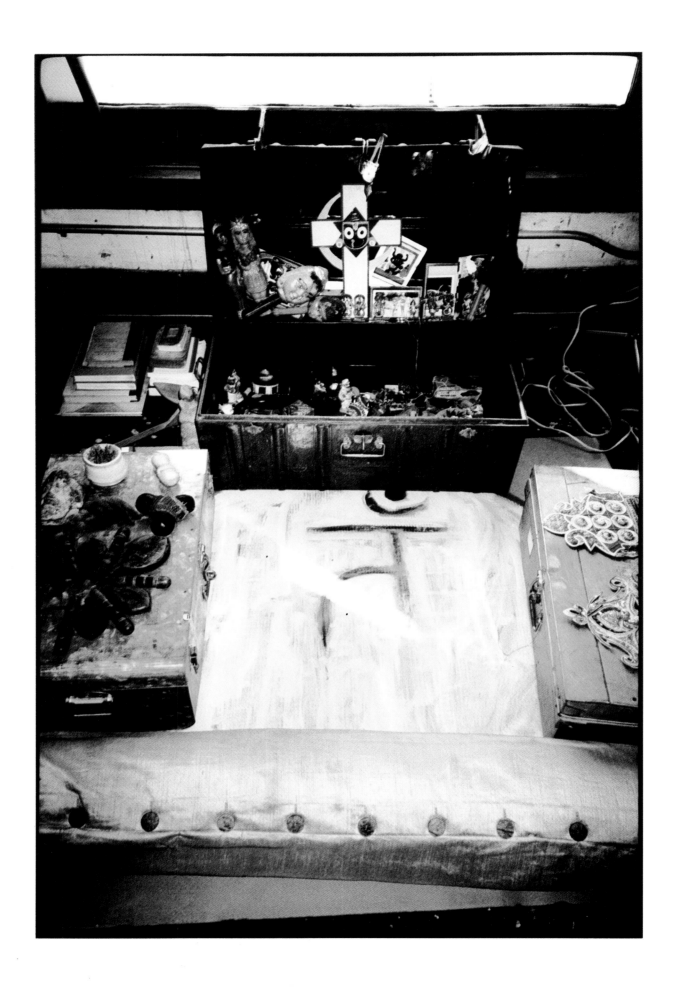

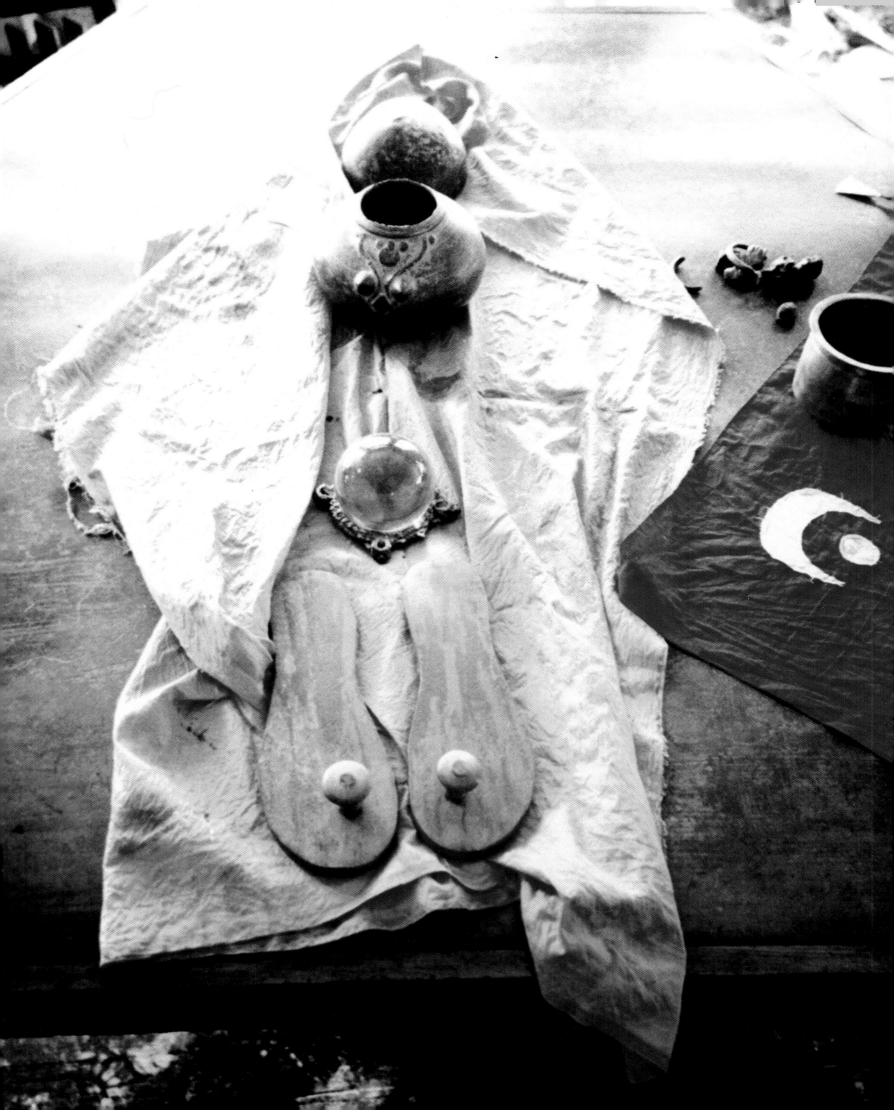

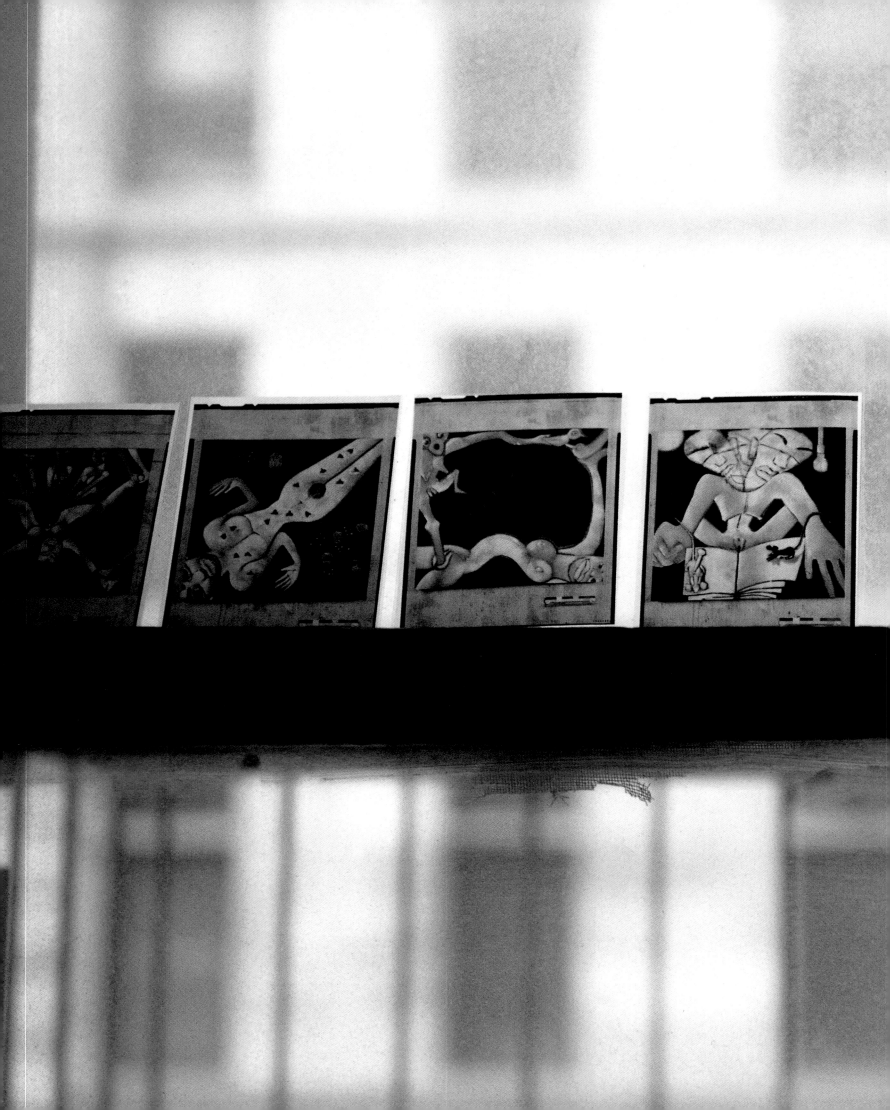

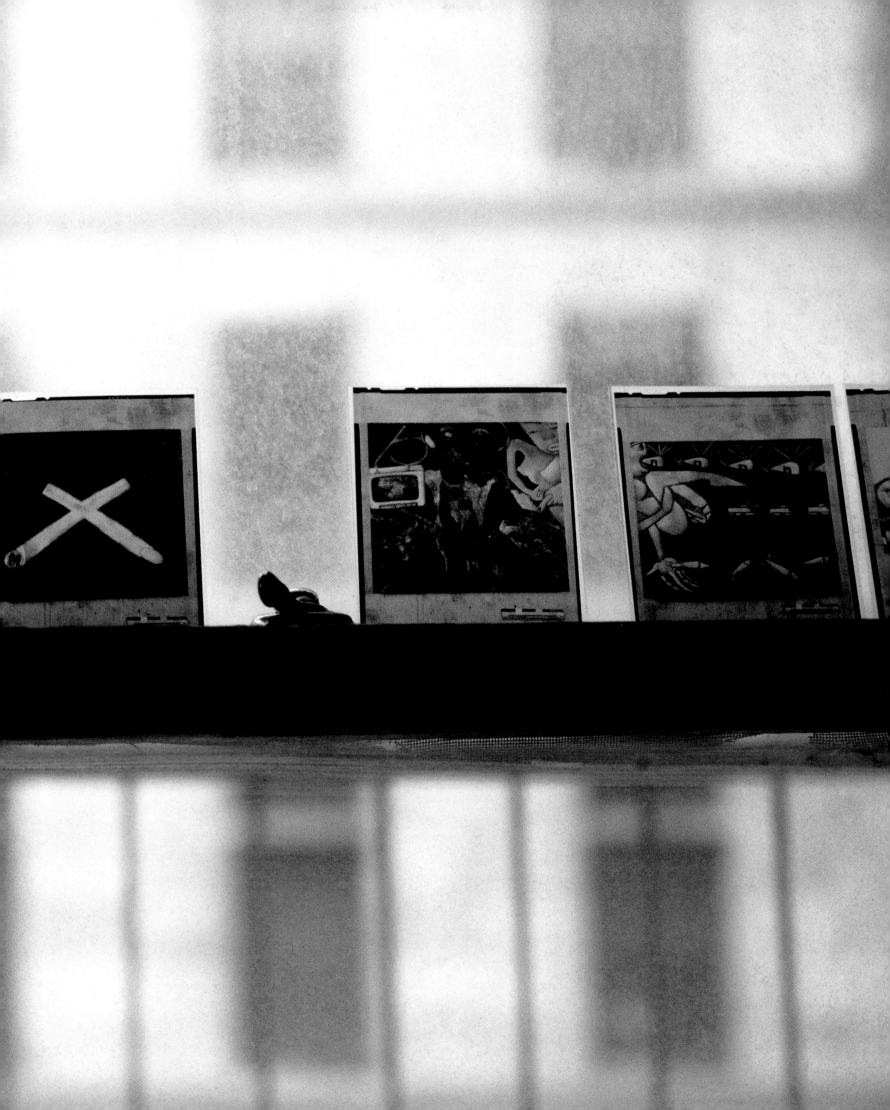

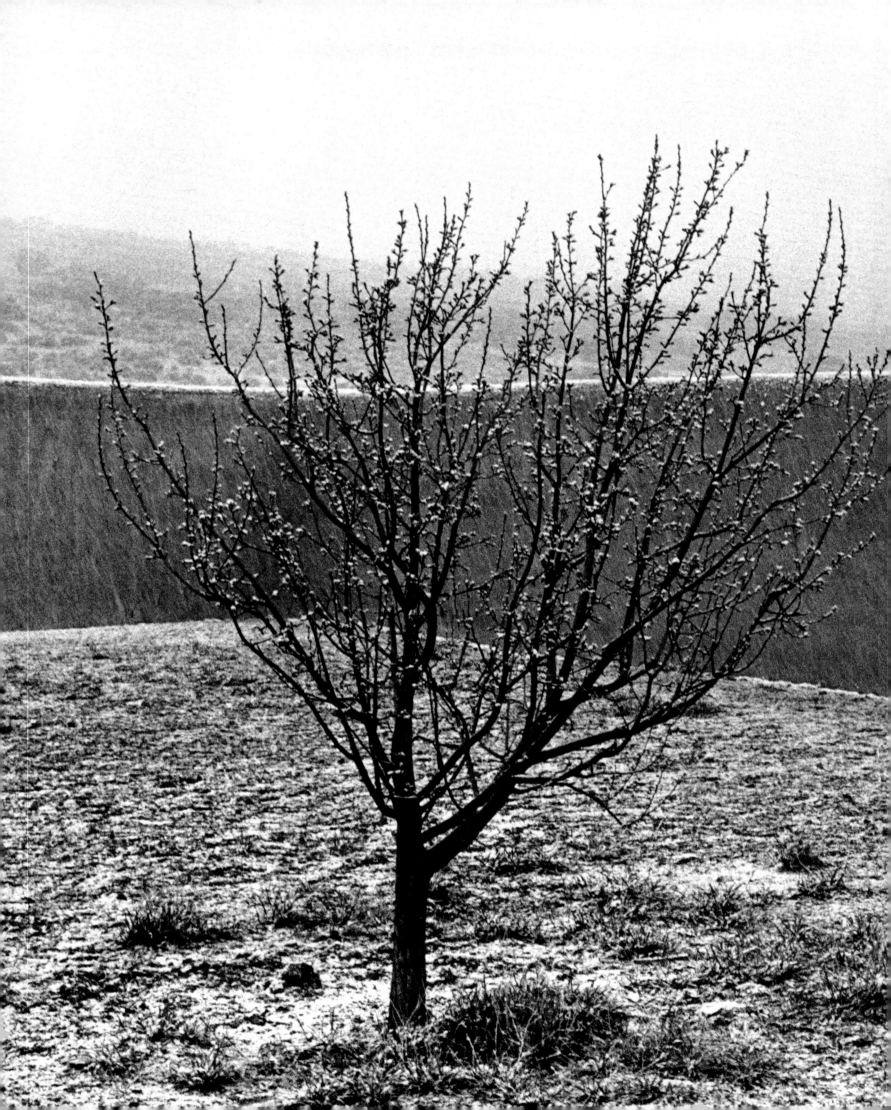

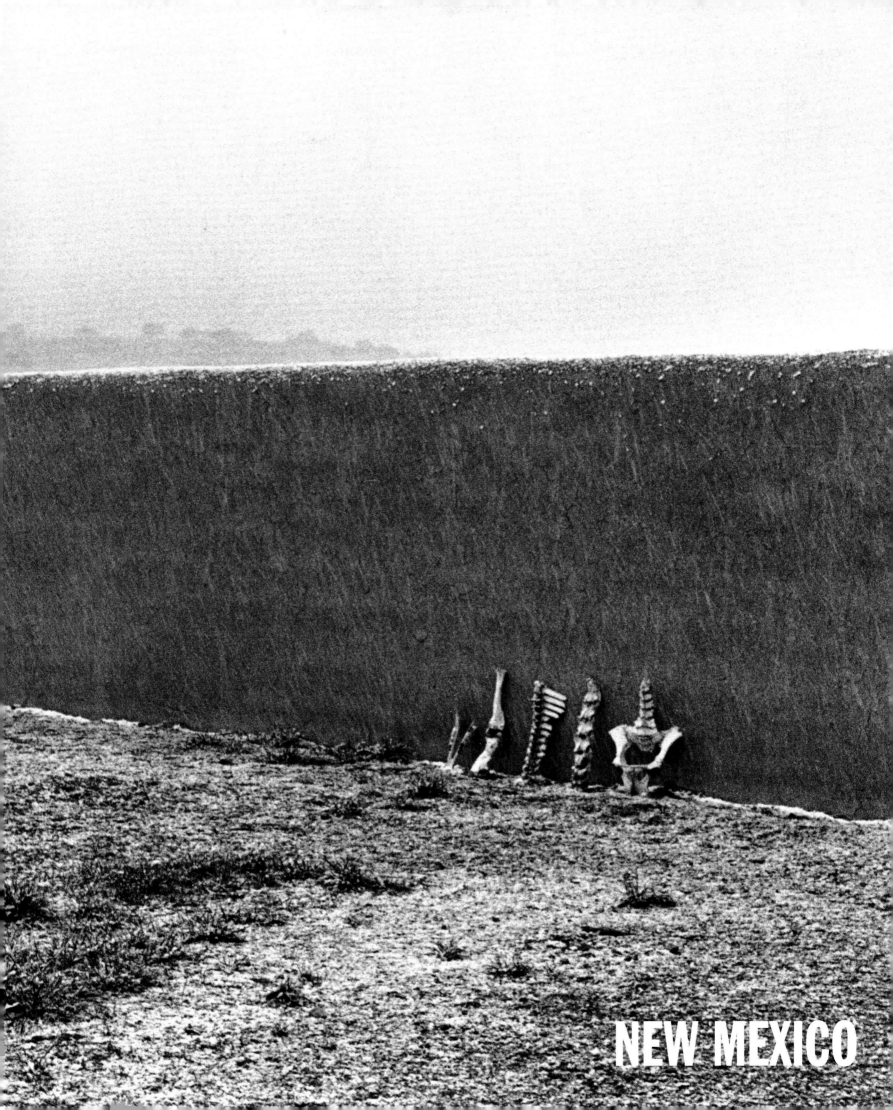

NEW MEXICO

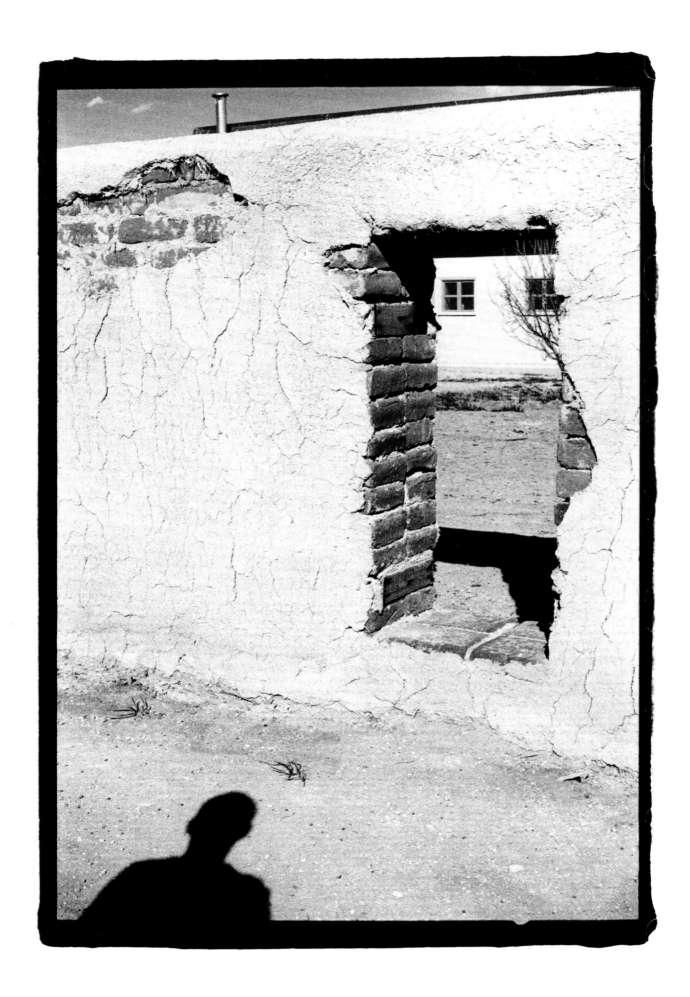

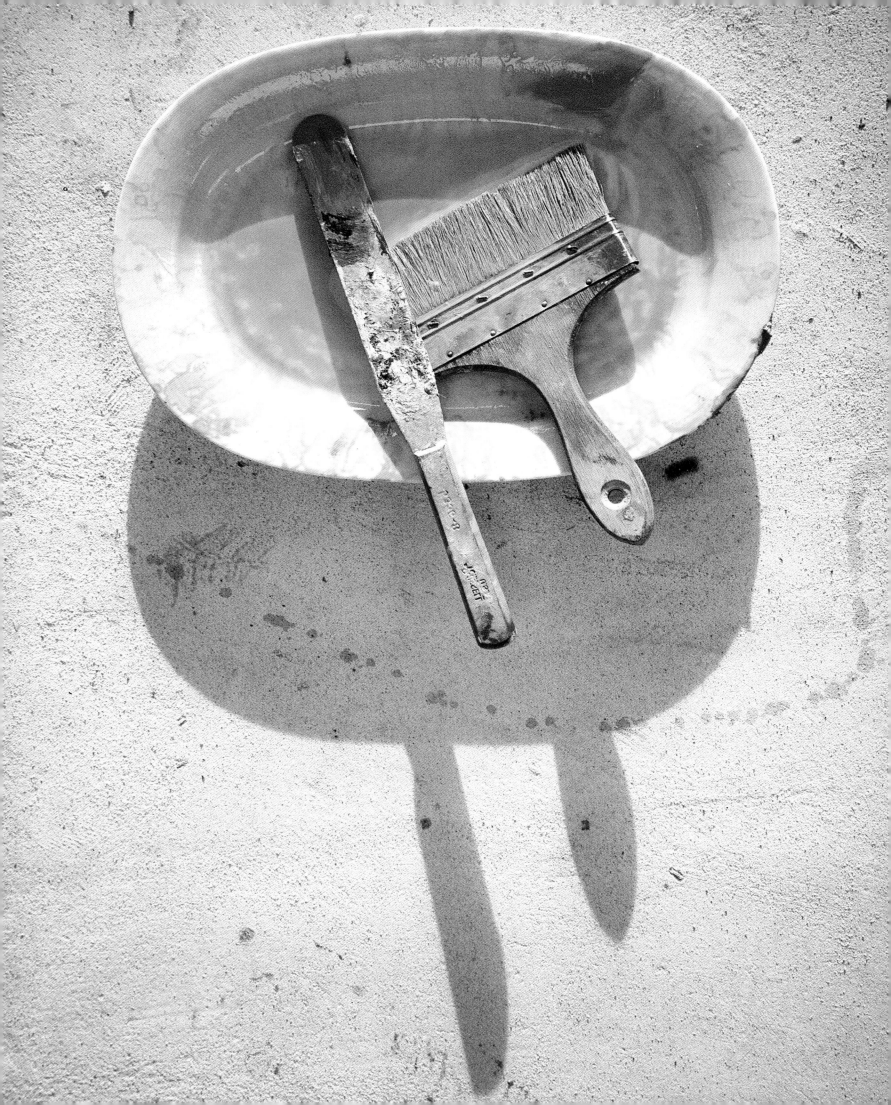

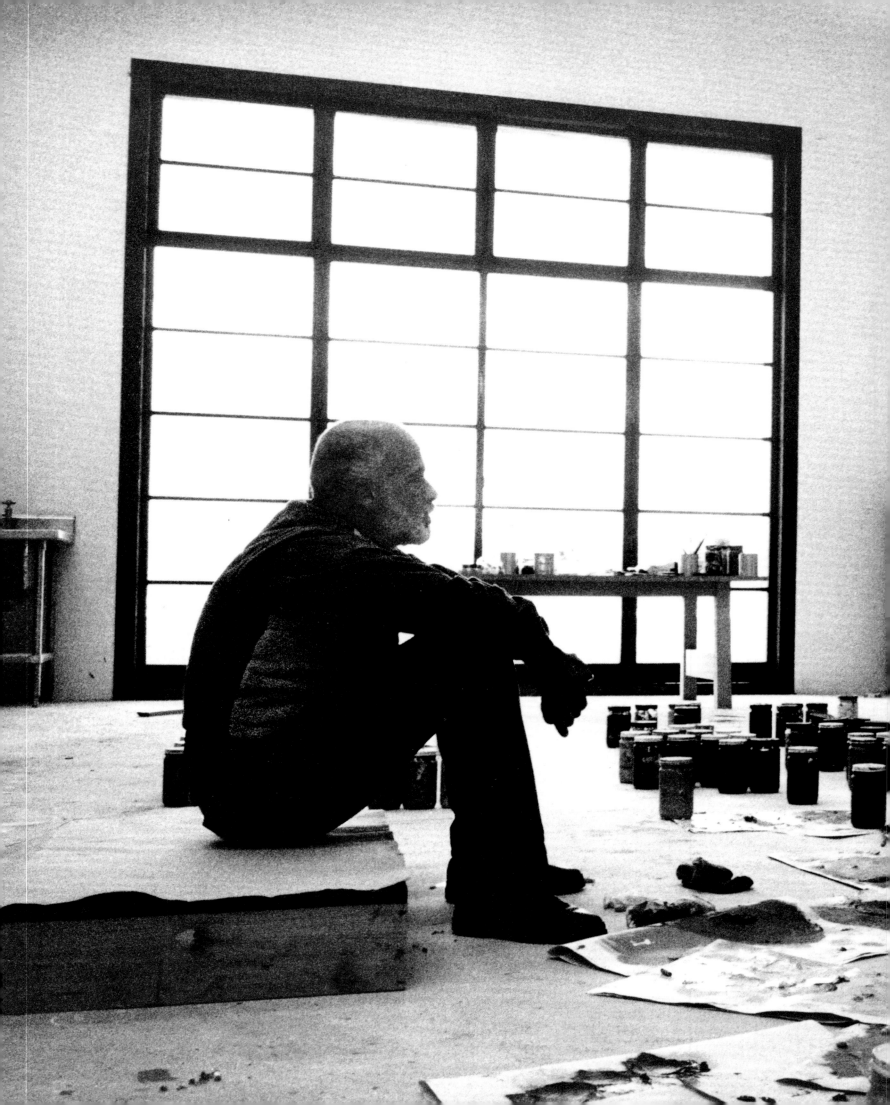

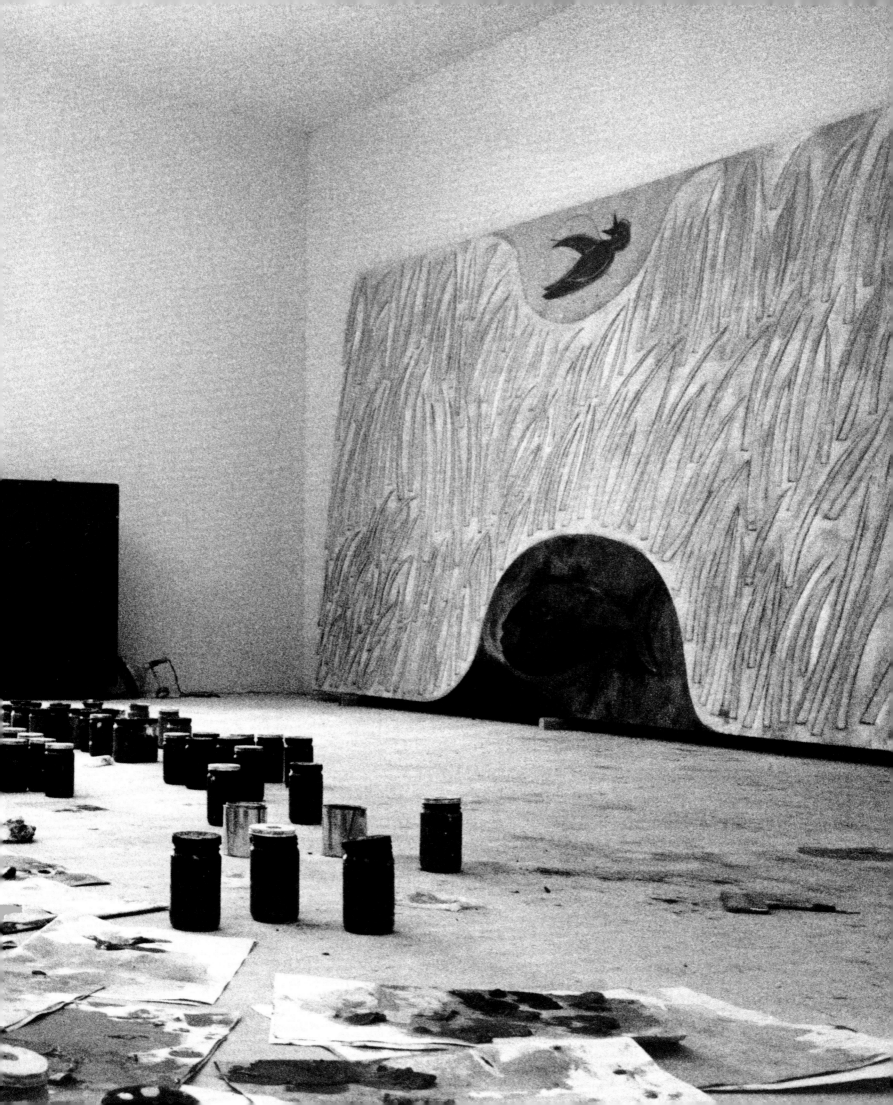

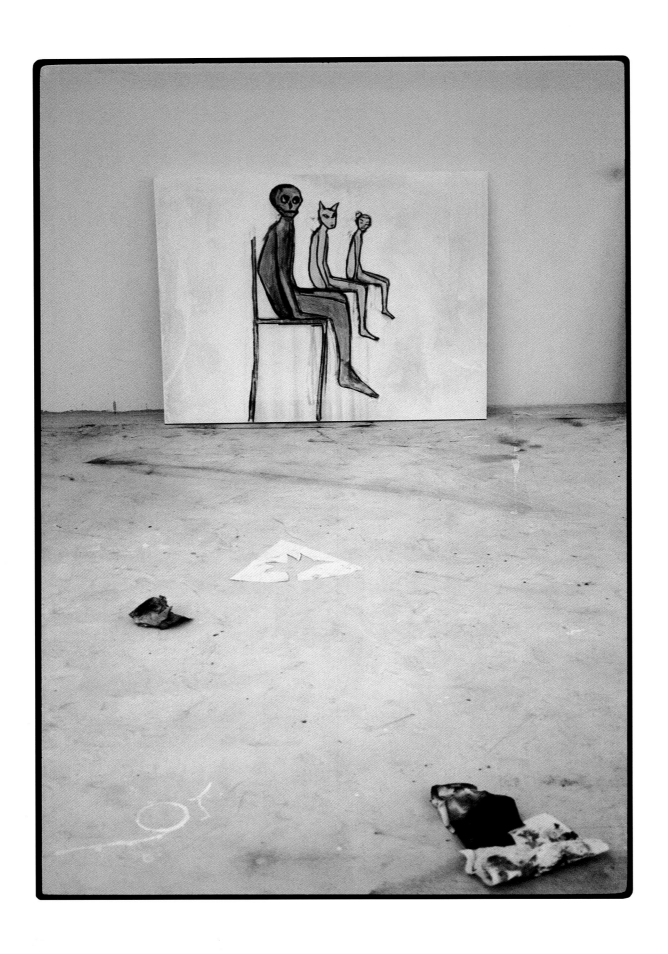

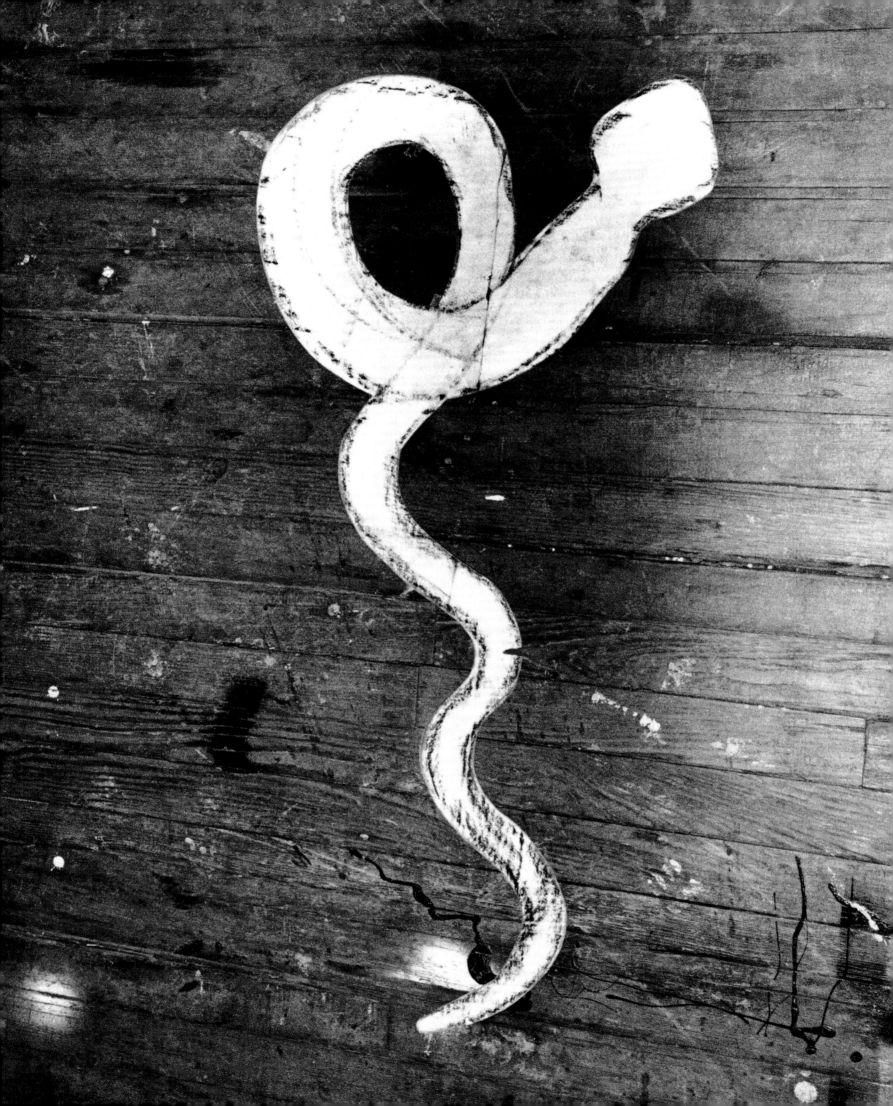

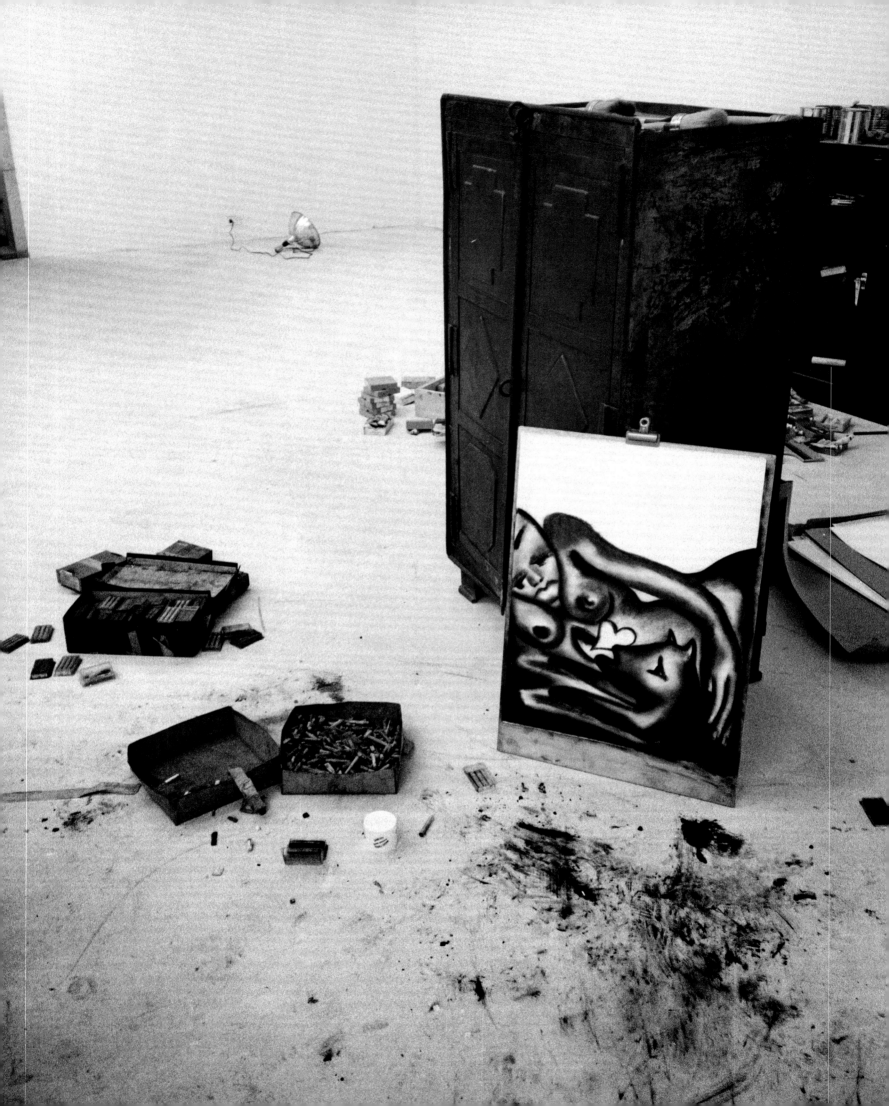

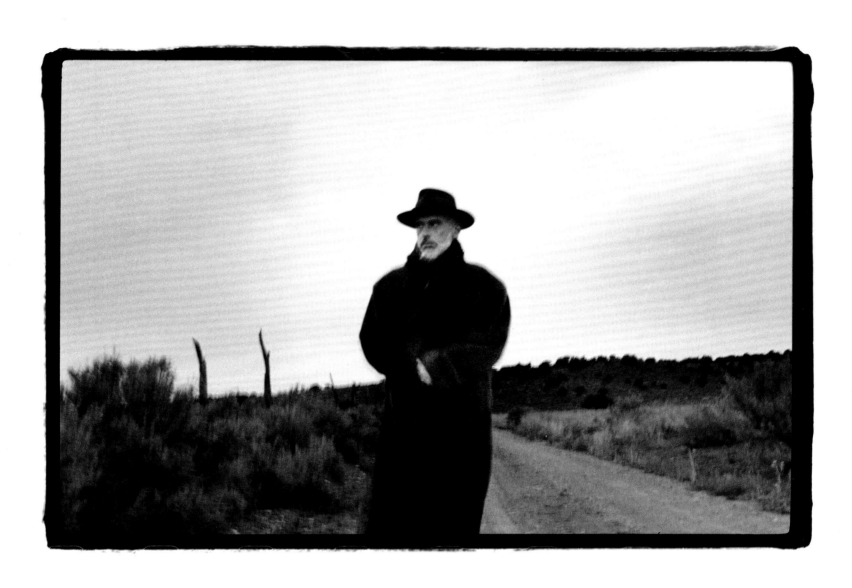

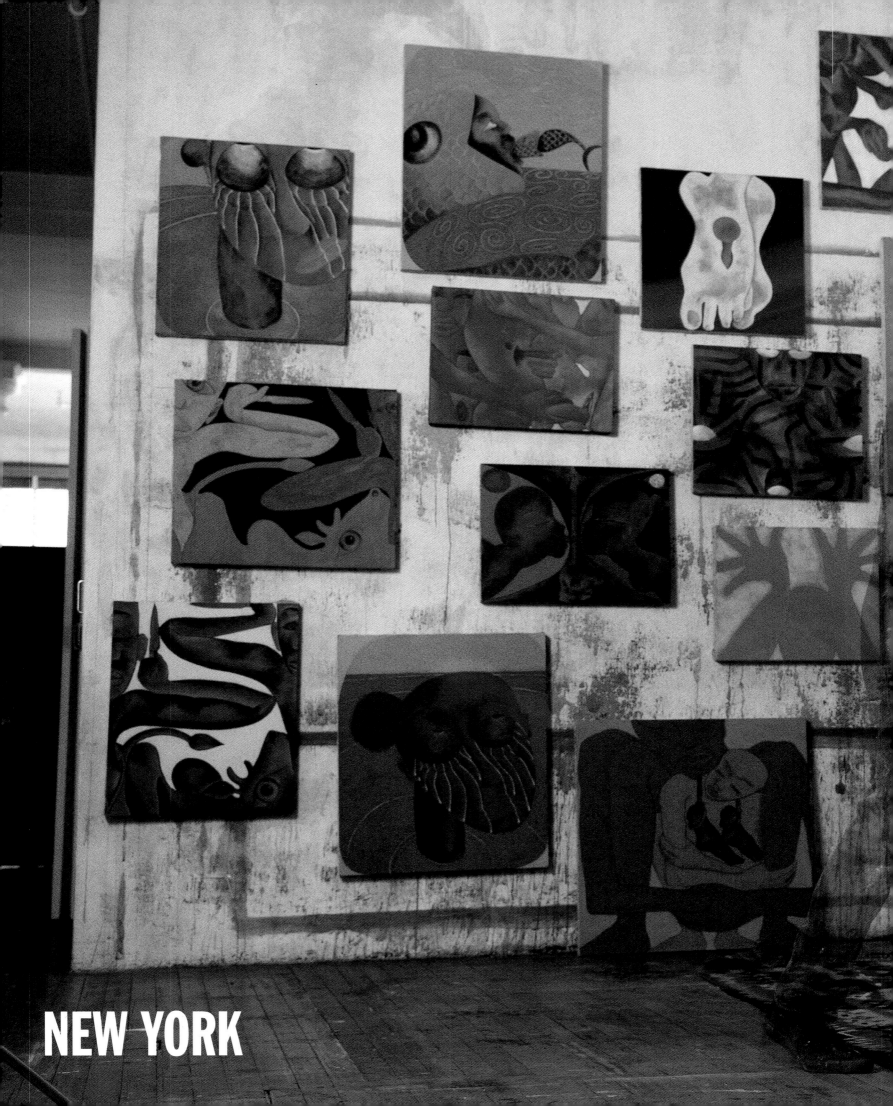

NEW YORK

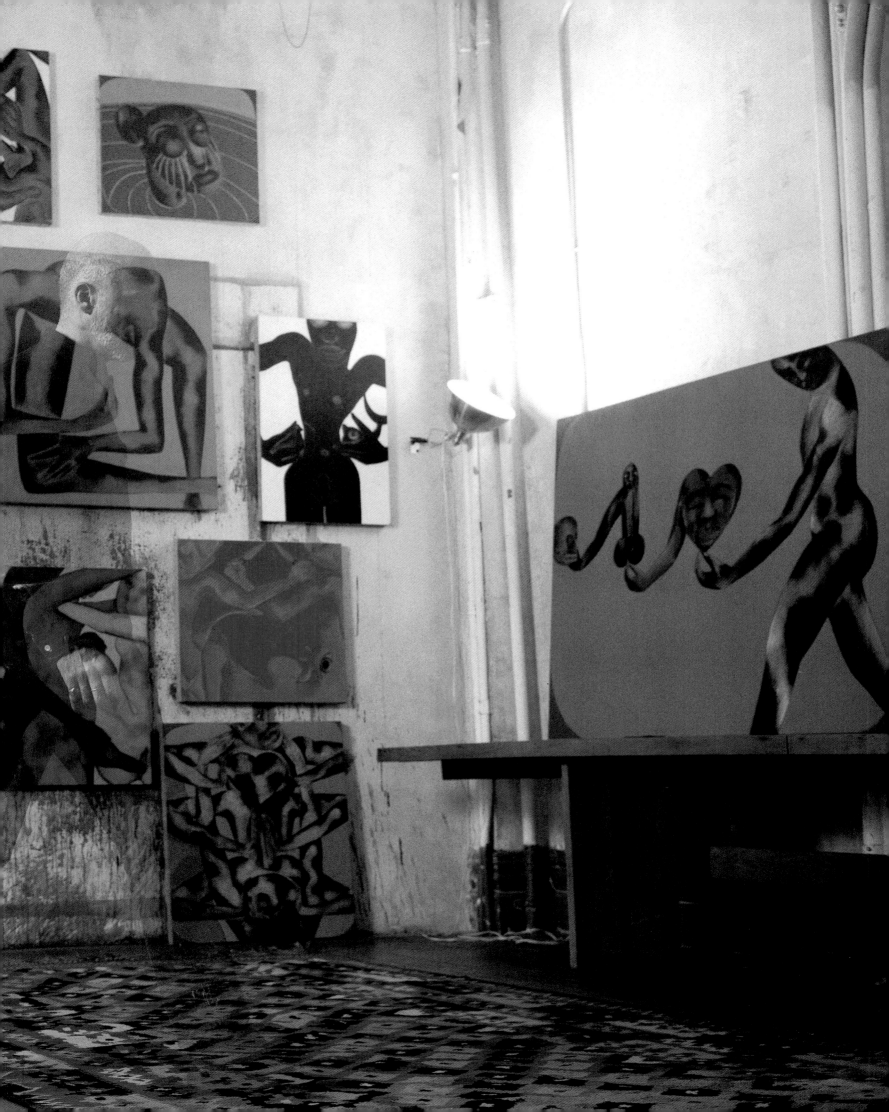

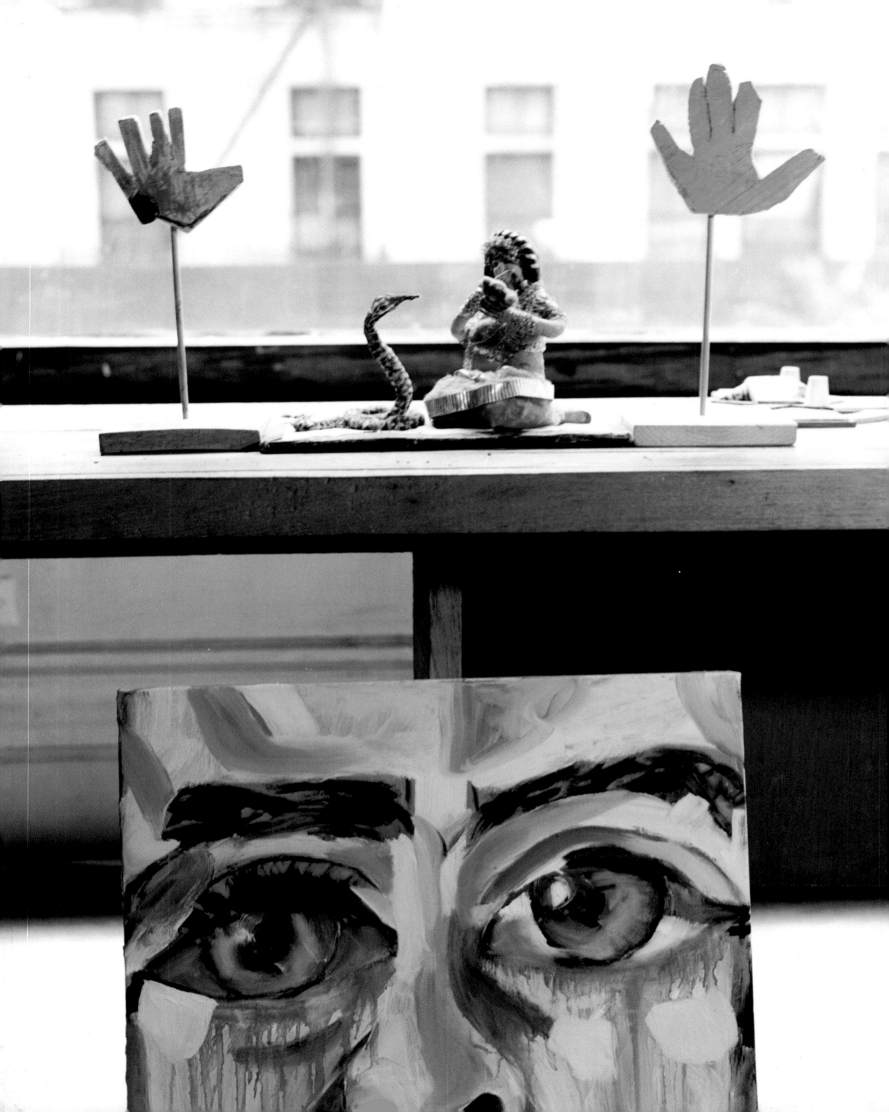

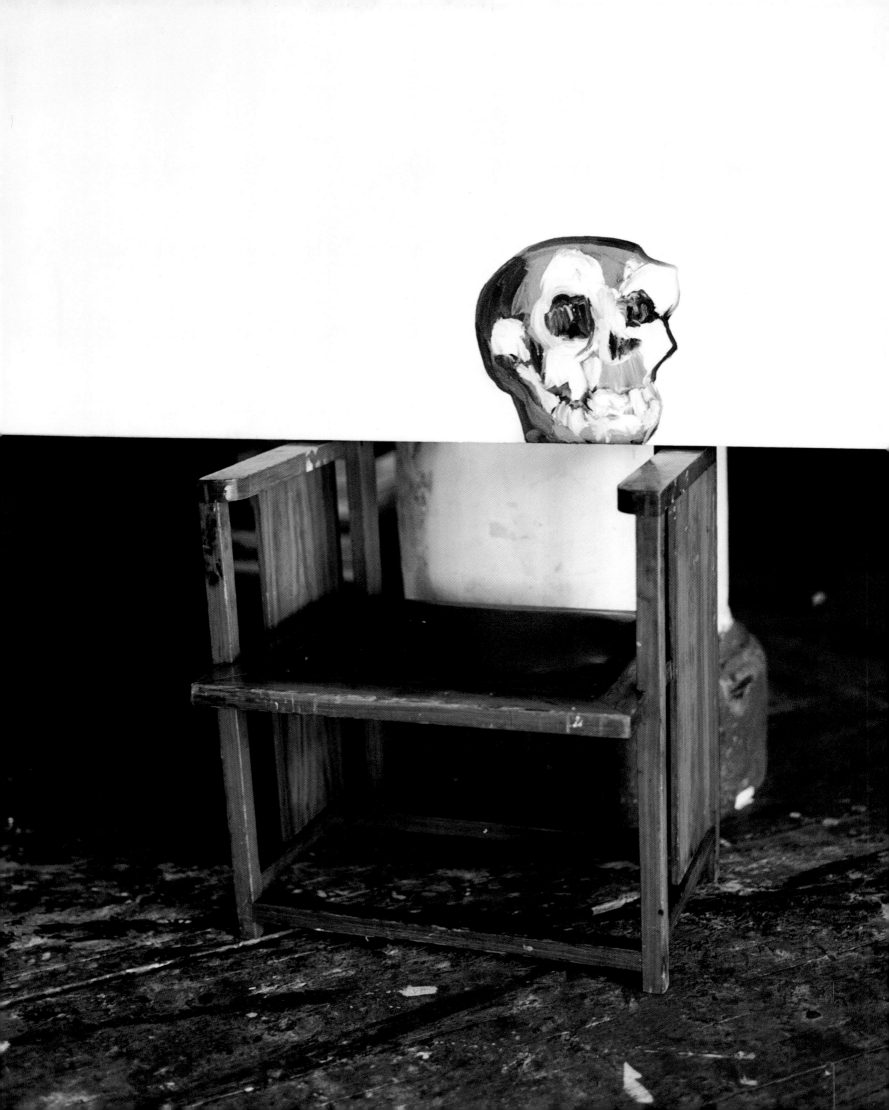

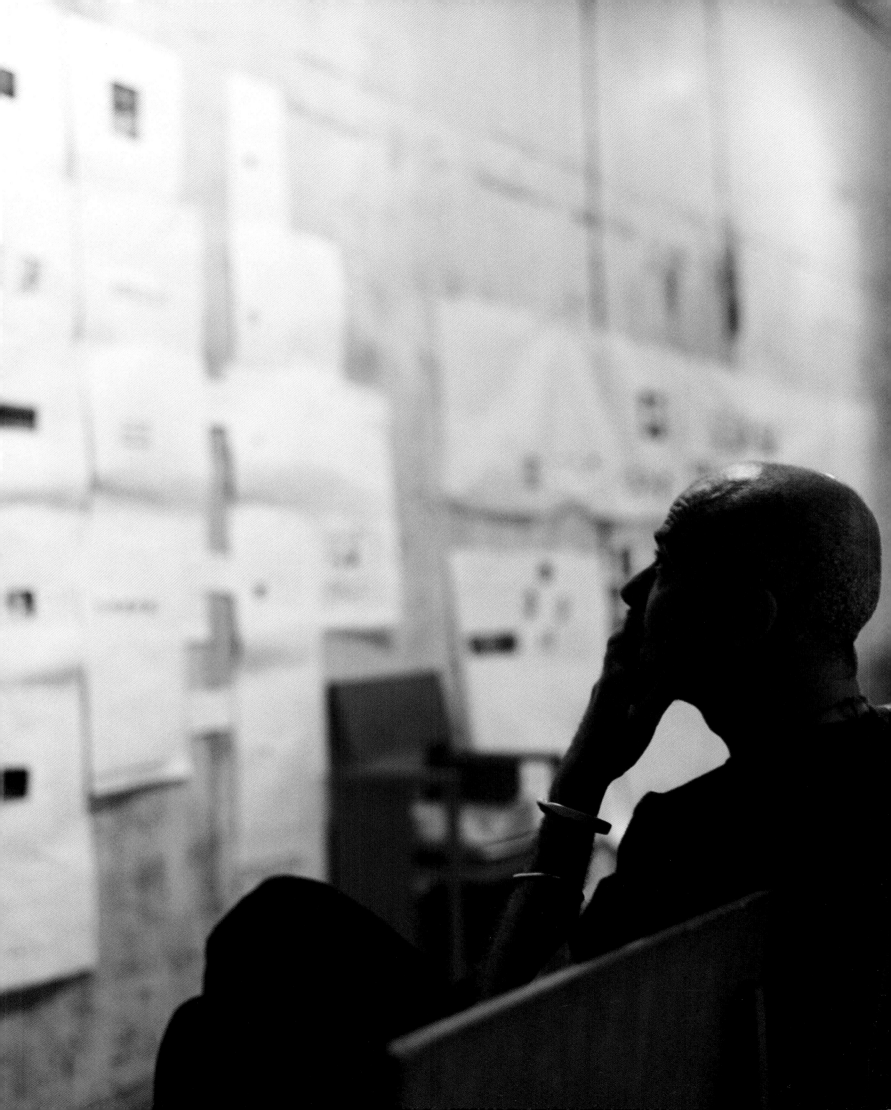

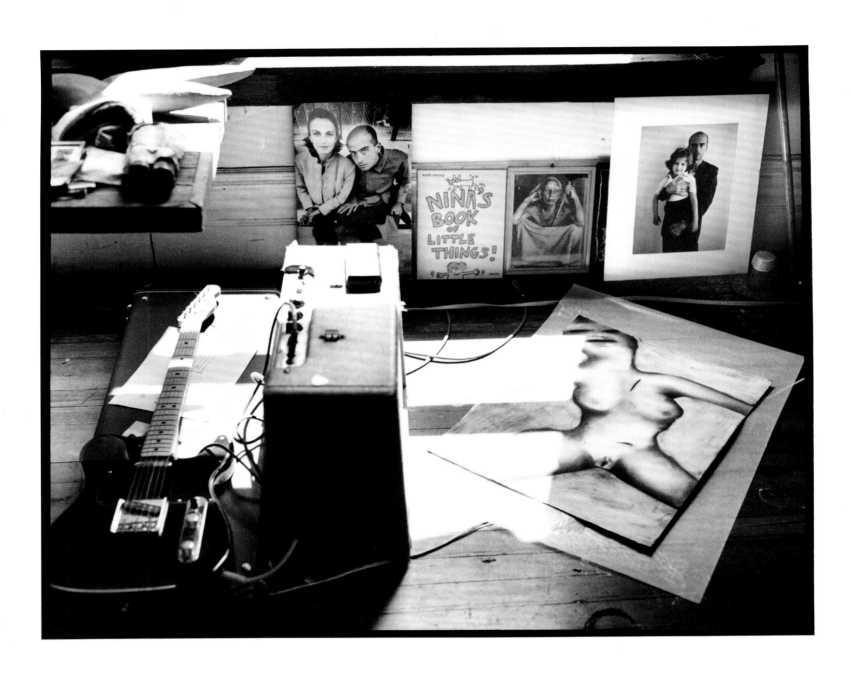

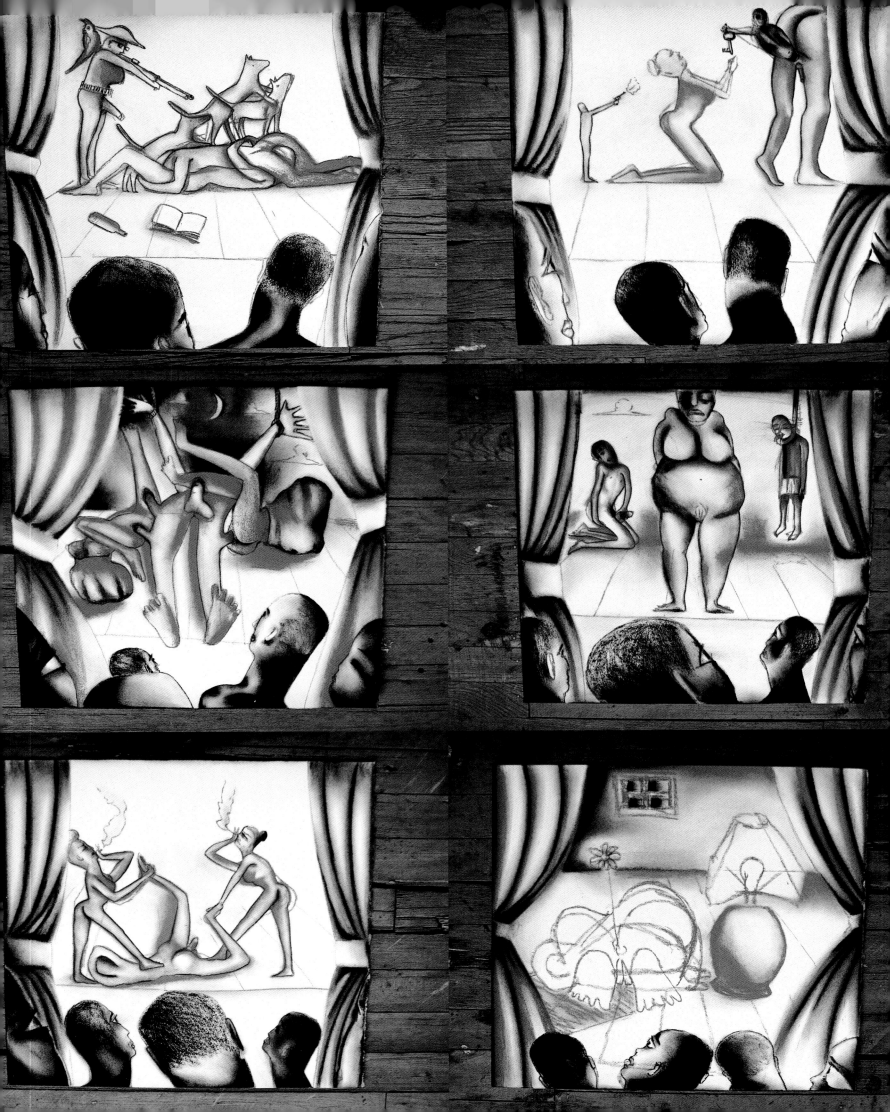

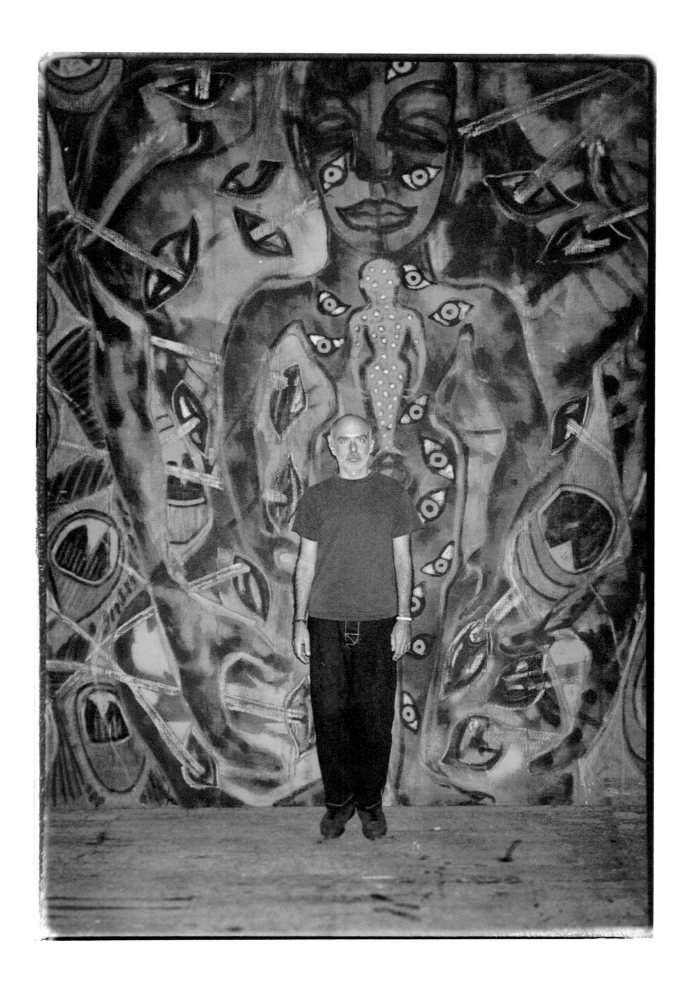

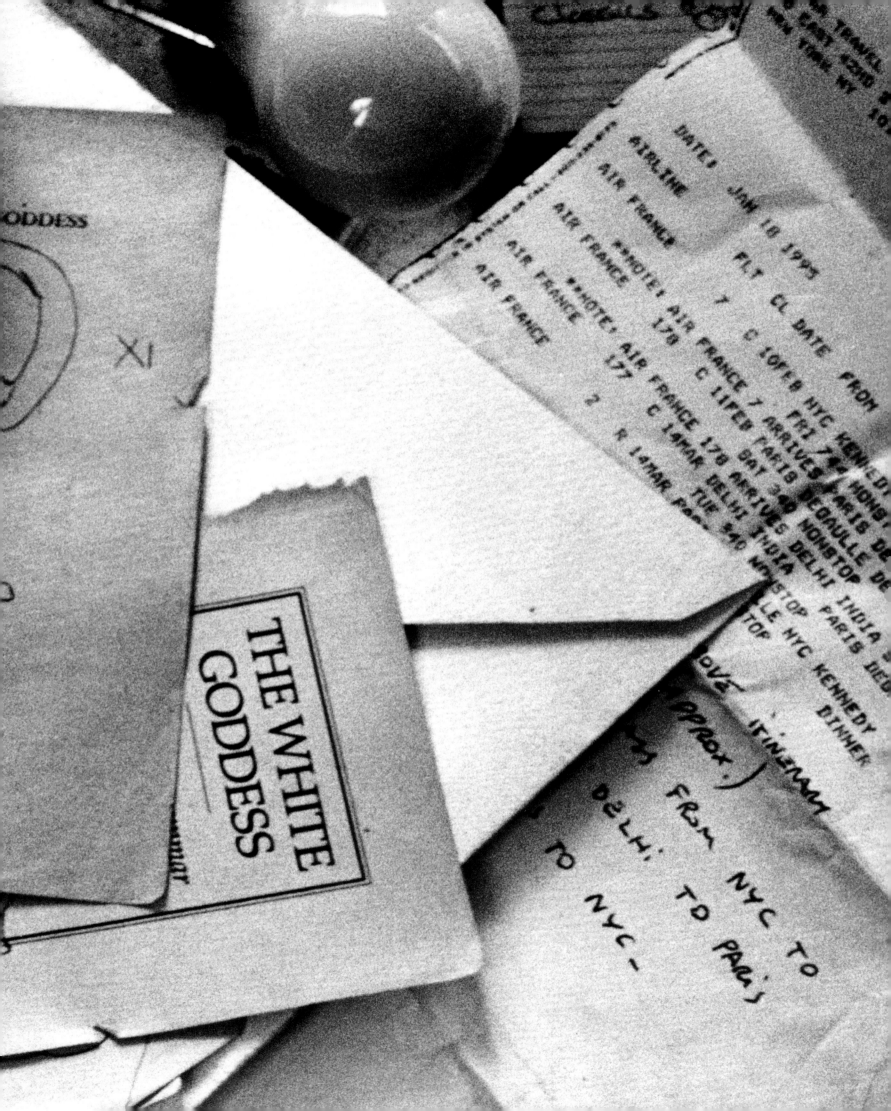

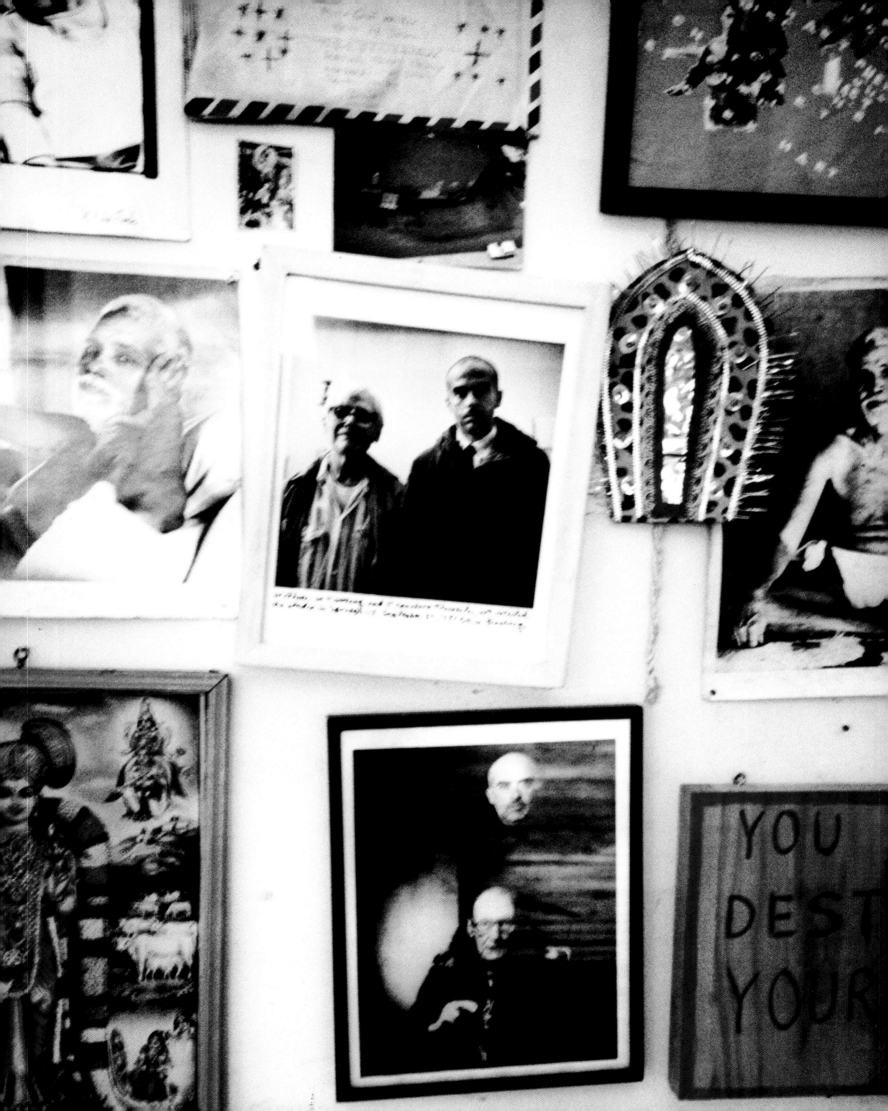

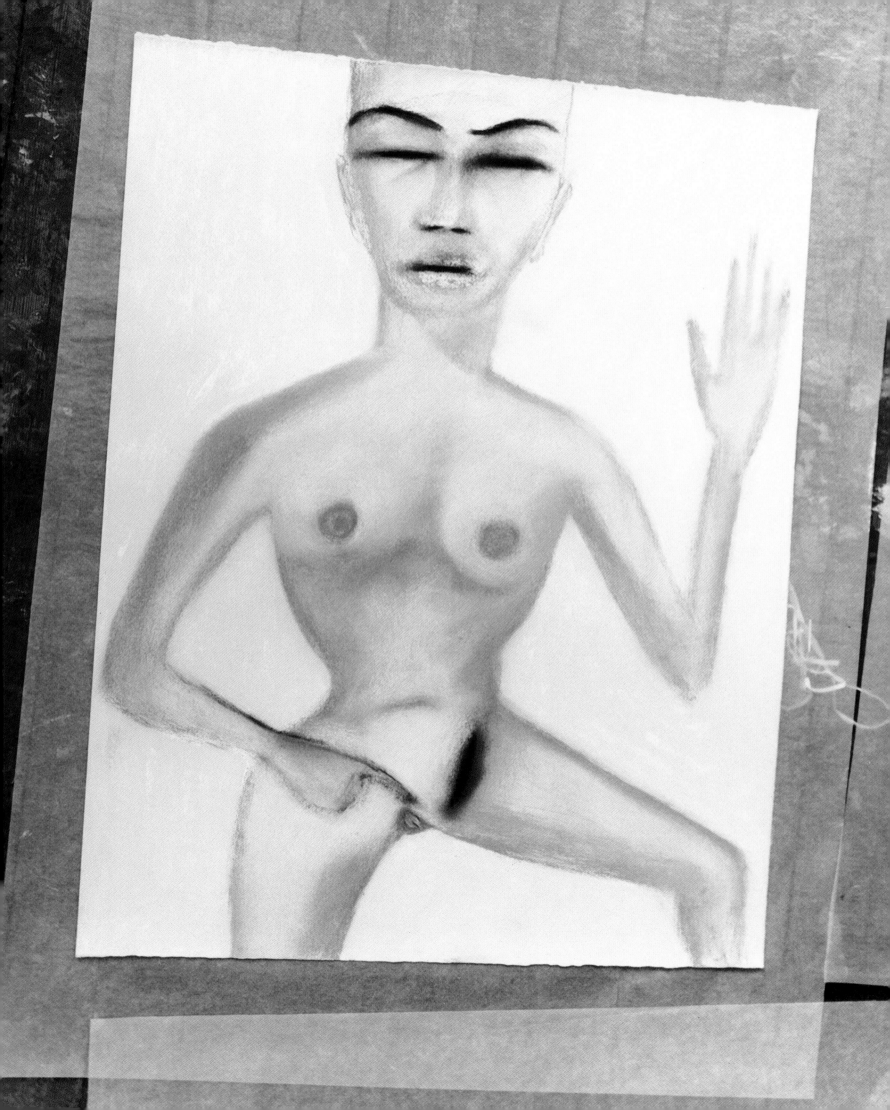

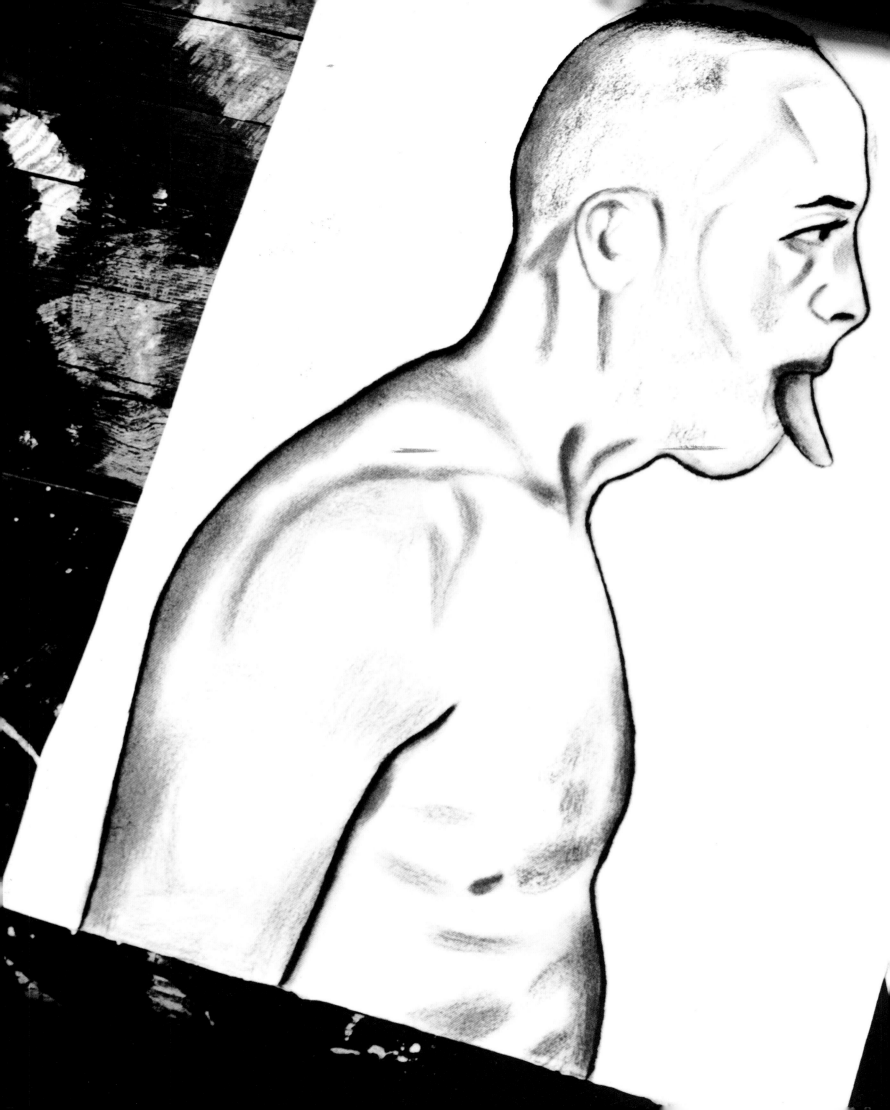

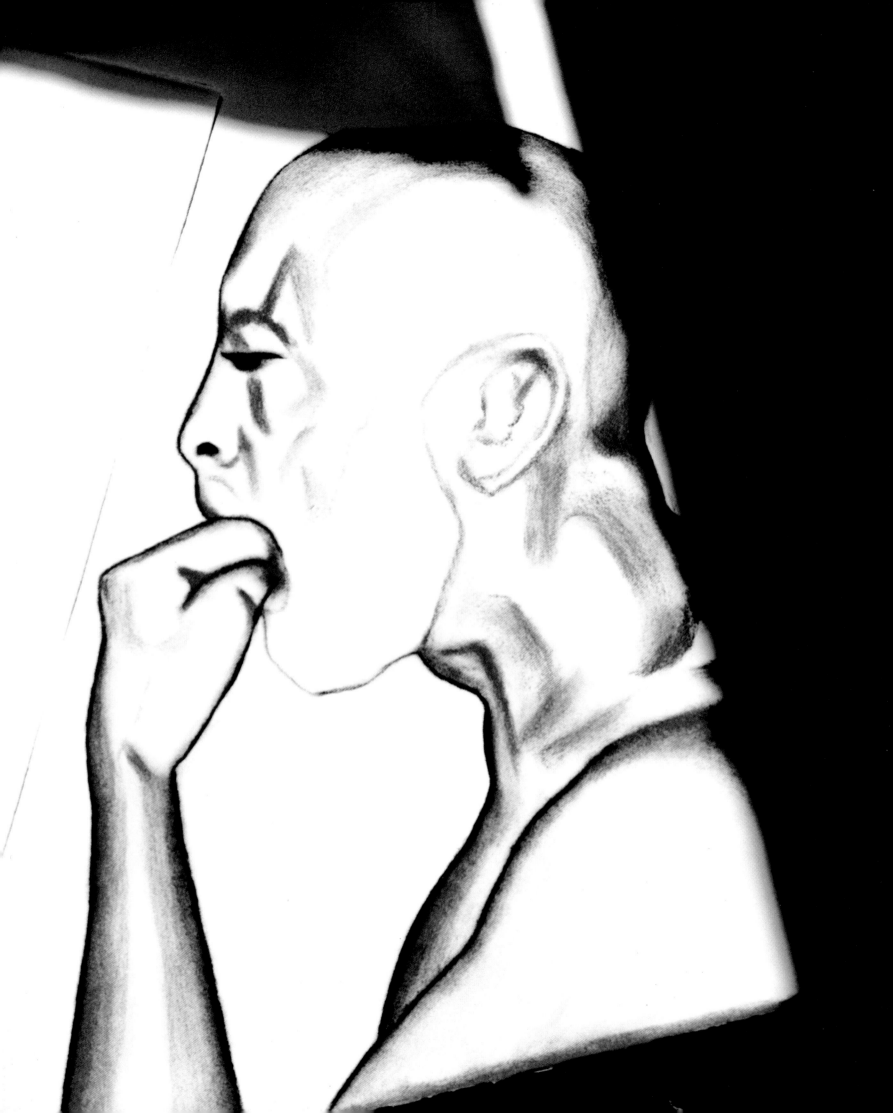

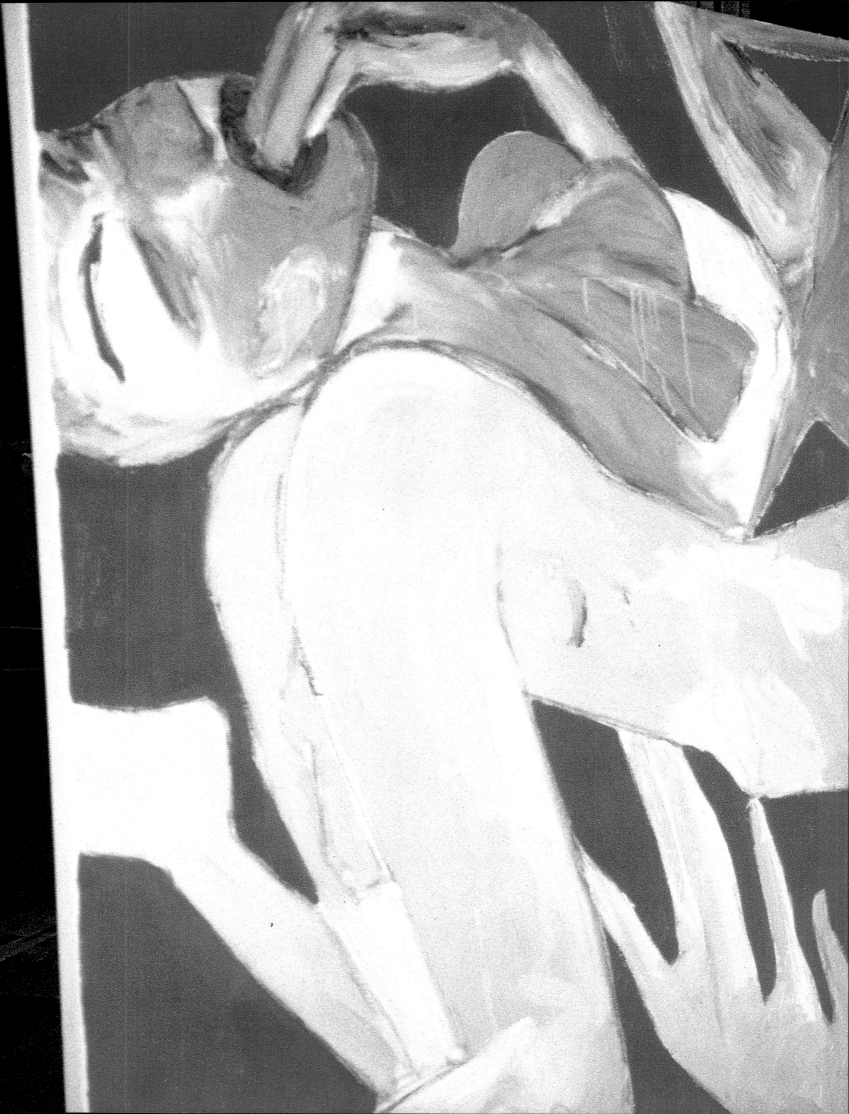

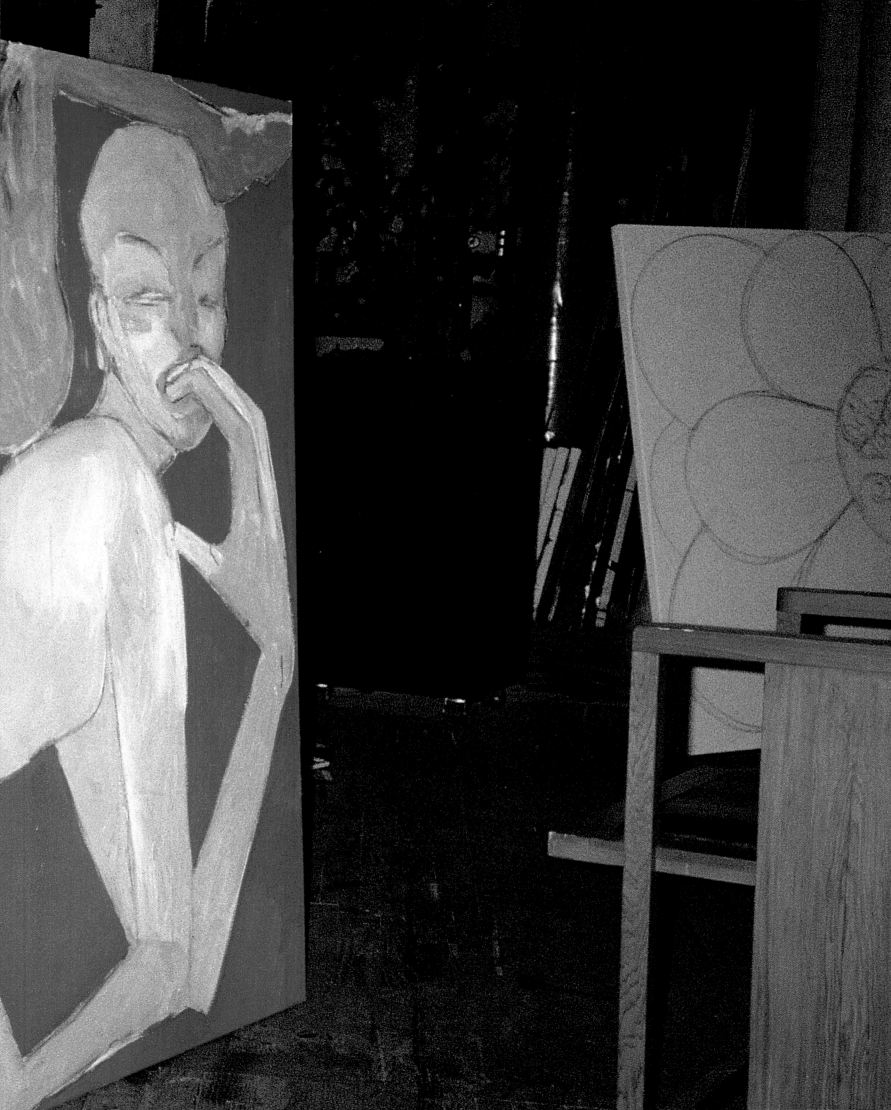

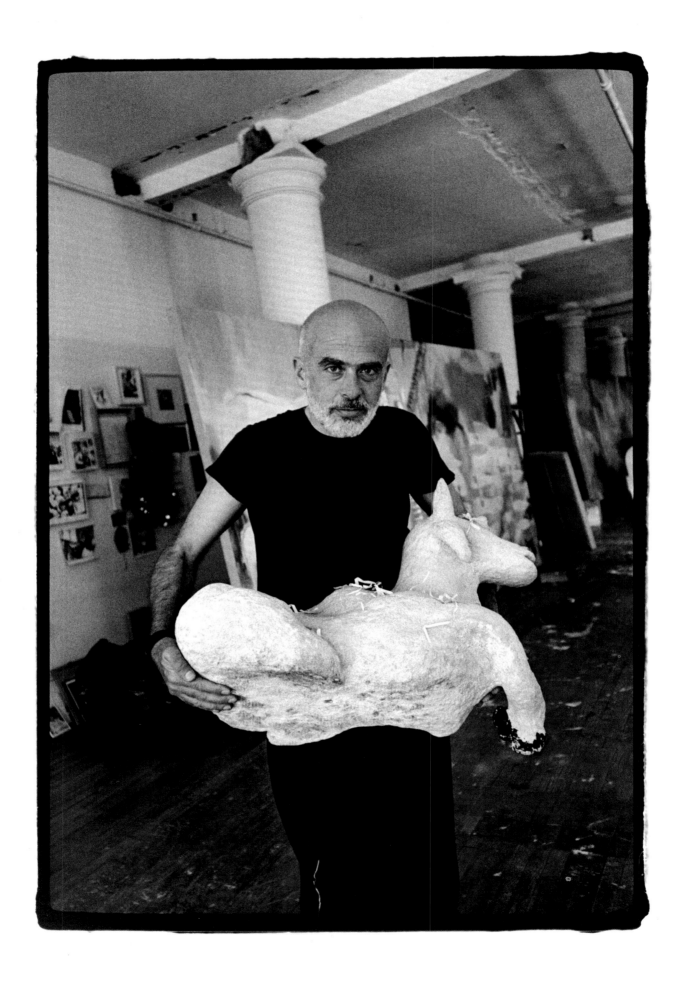

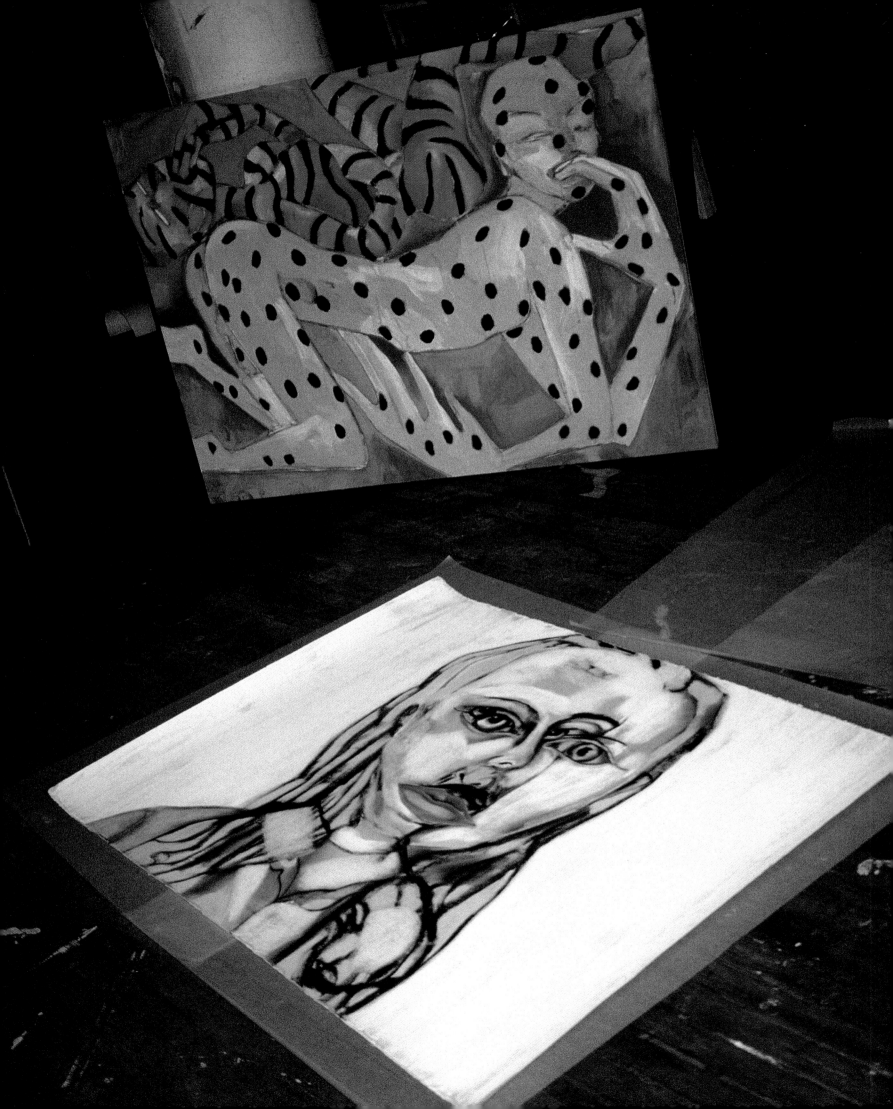

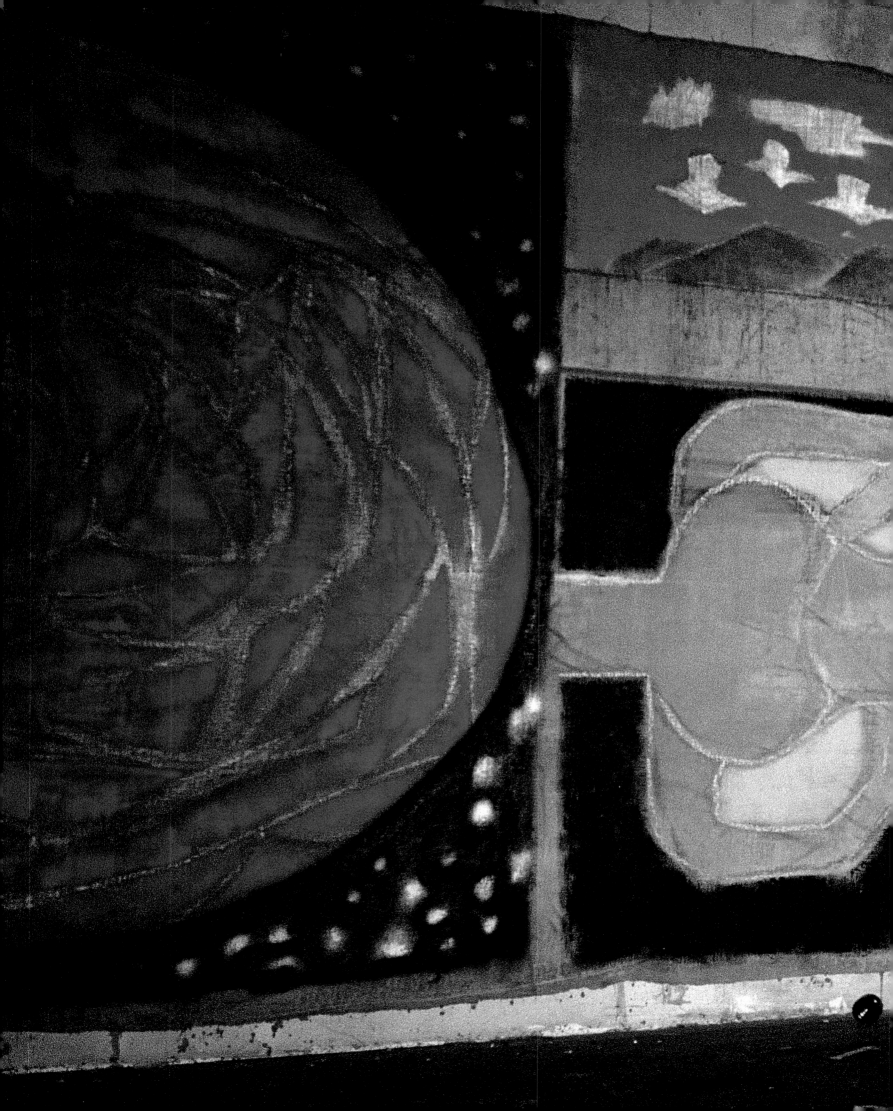

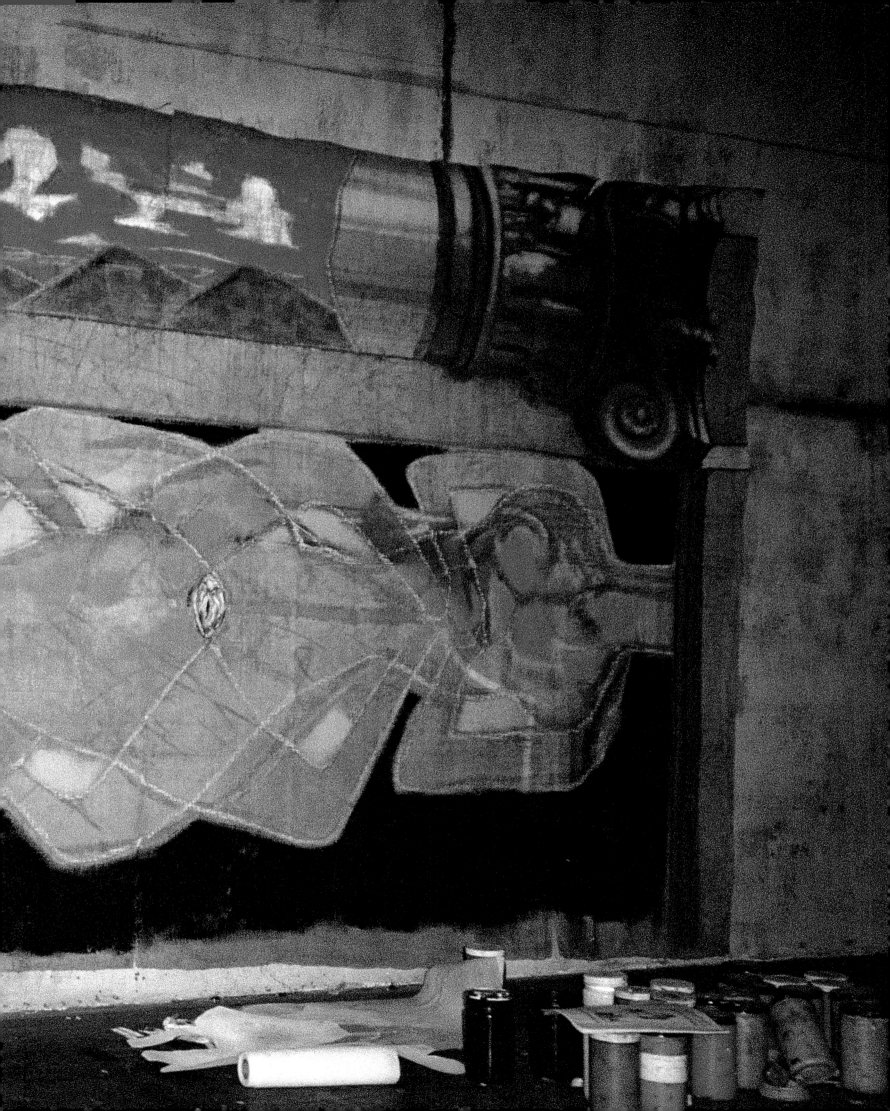

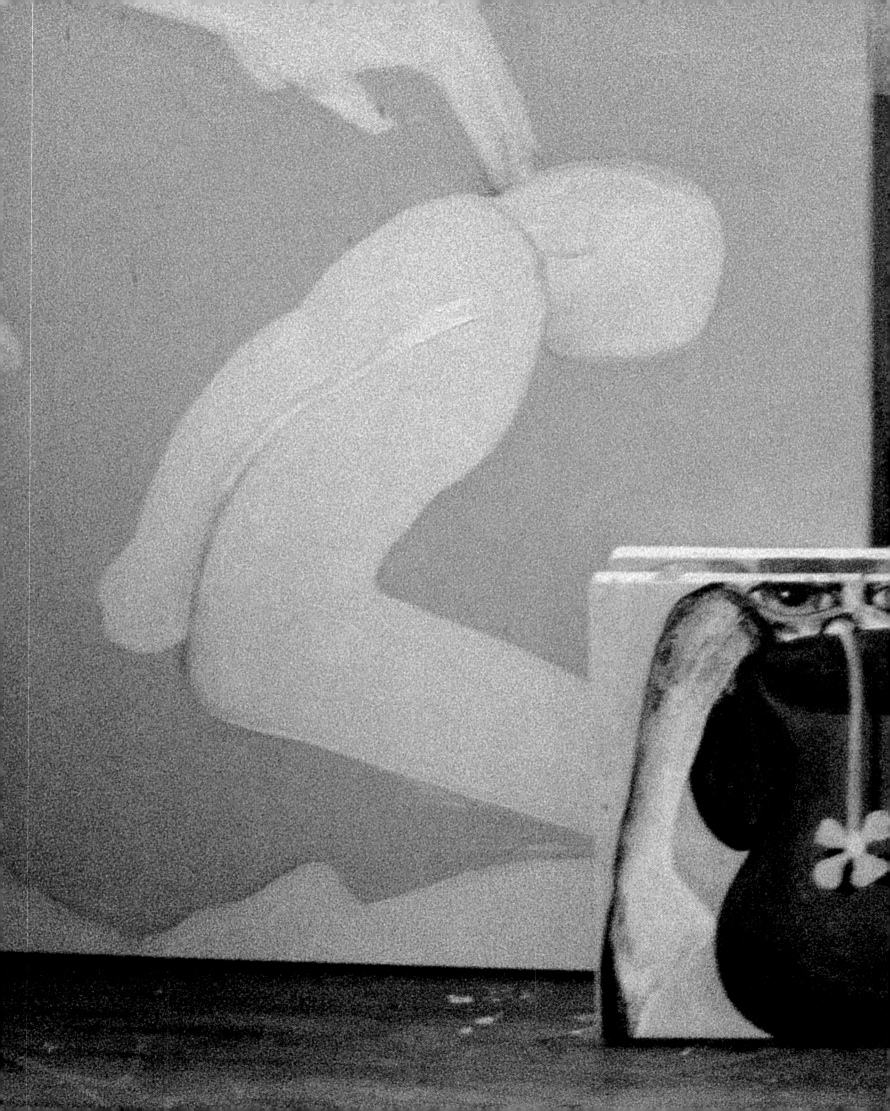

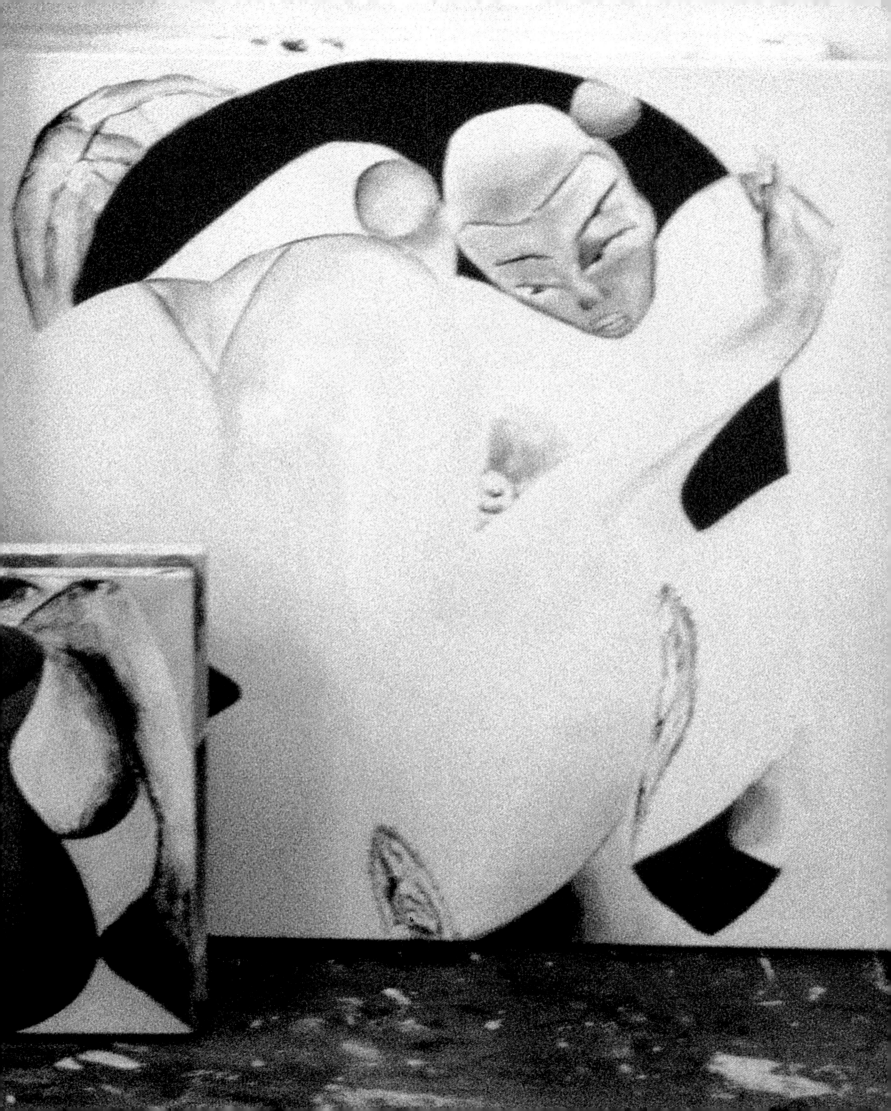

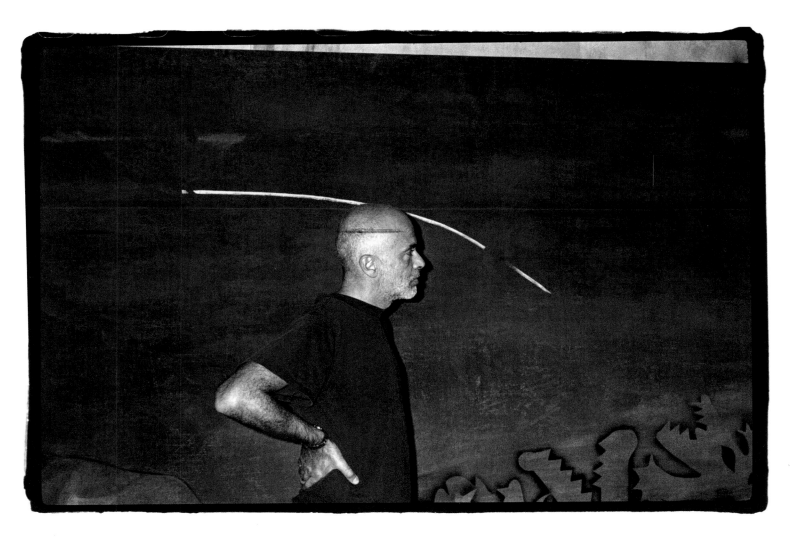

I don't have an optimistic
and democratic idea of images.
Images are rare events, healing enlightenments.
The rest is sentimental illustration.

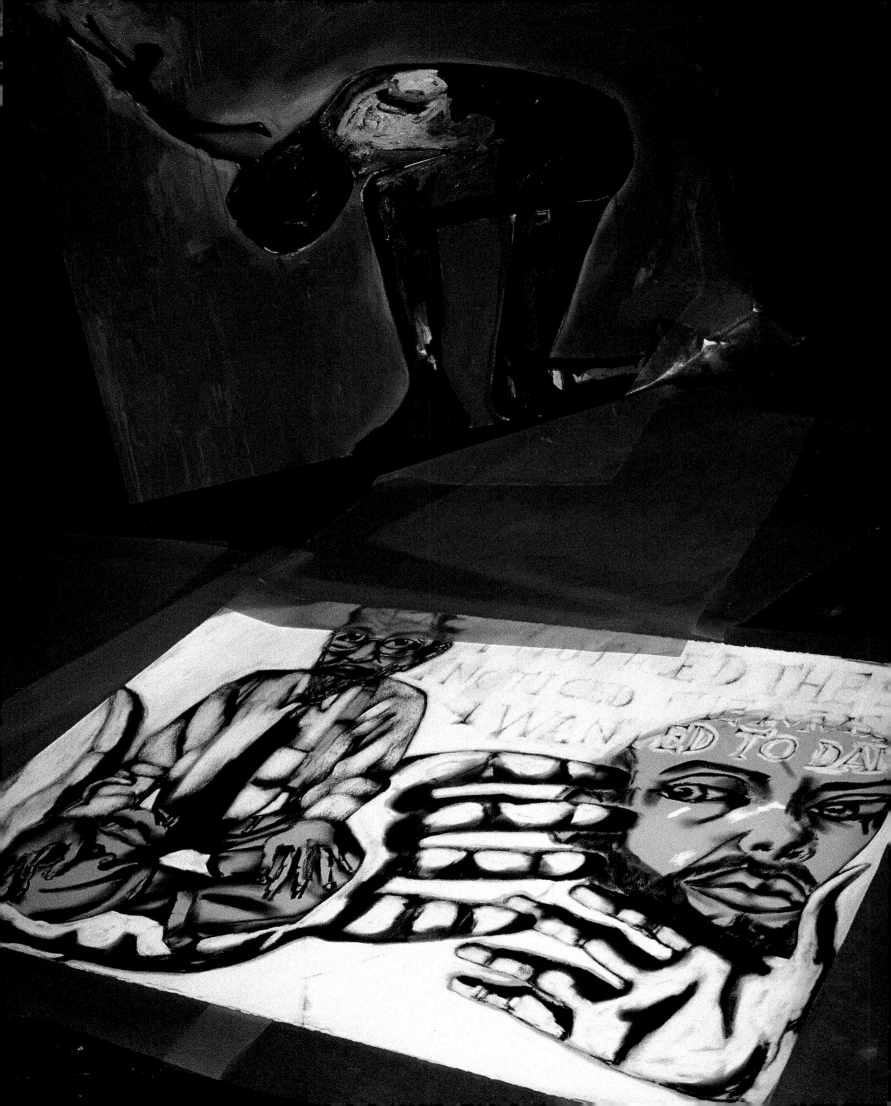

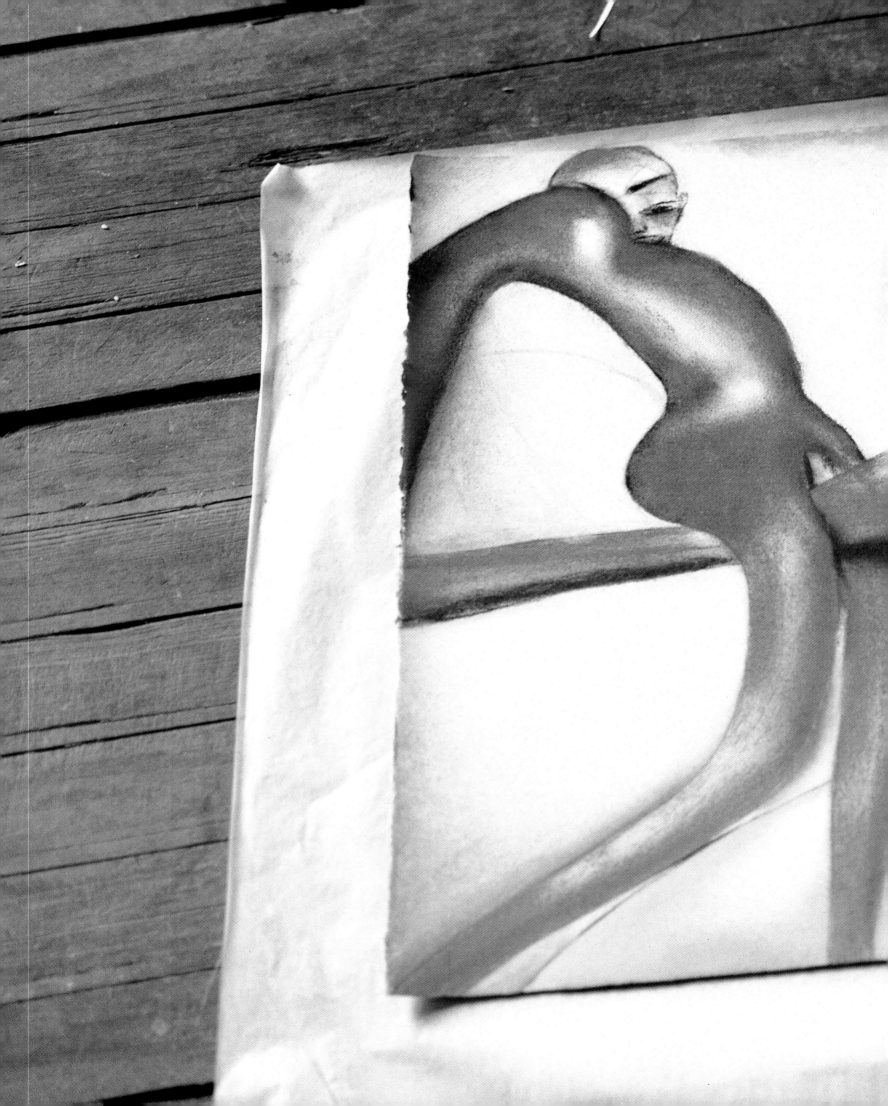

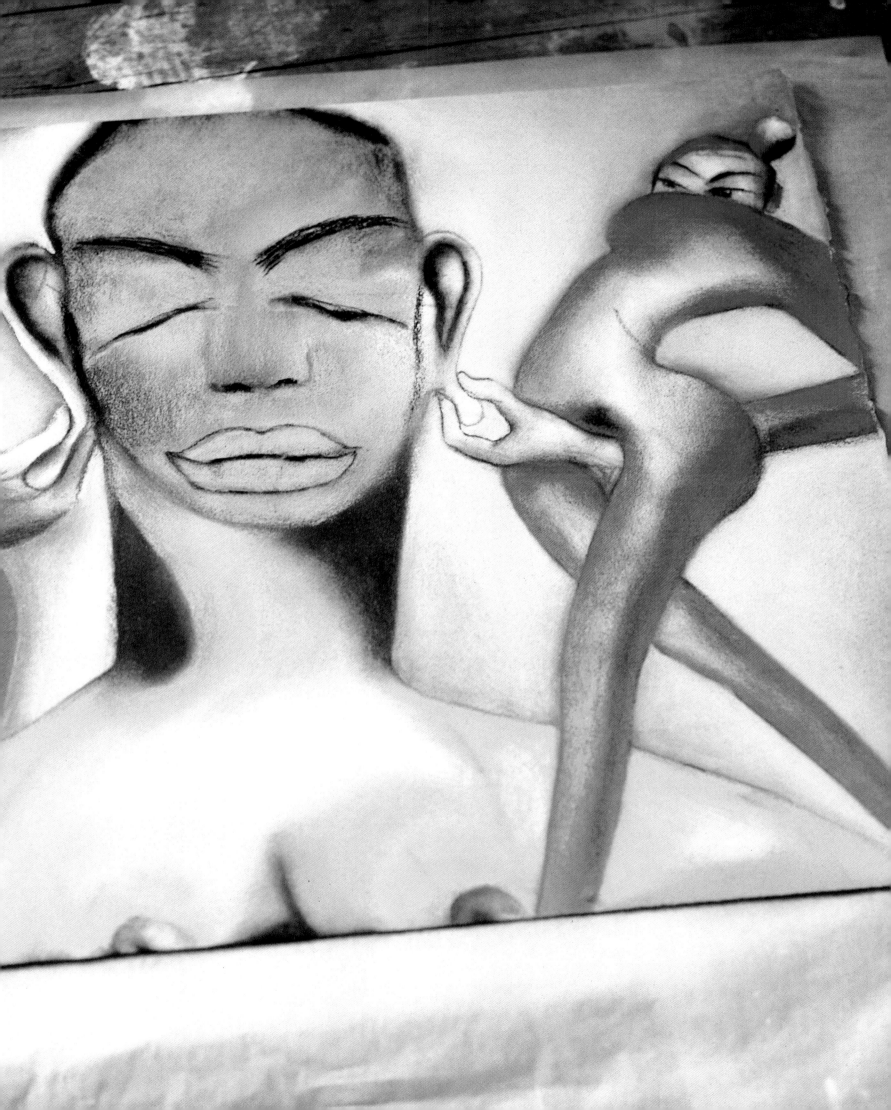

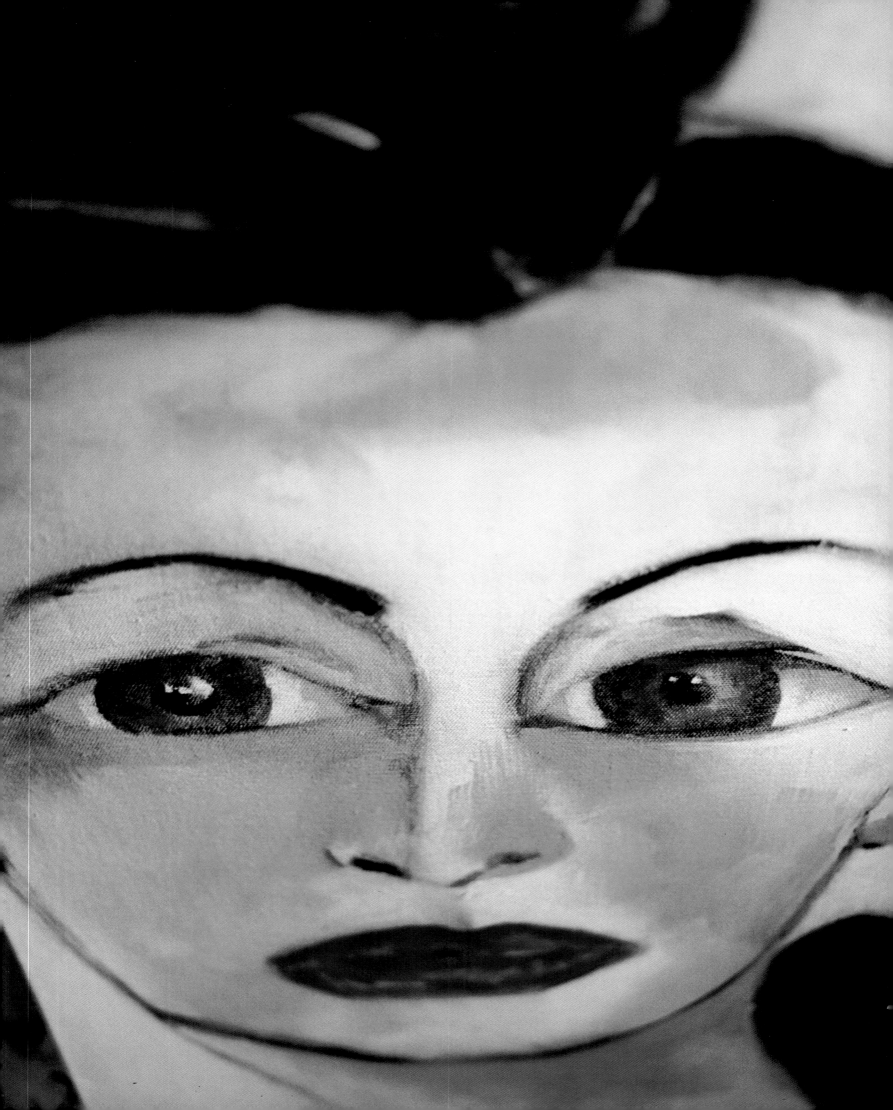

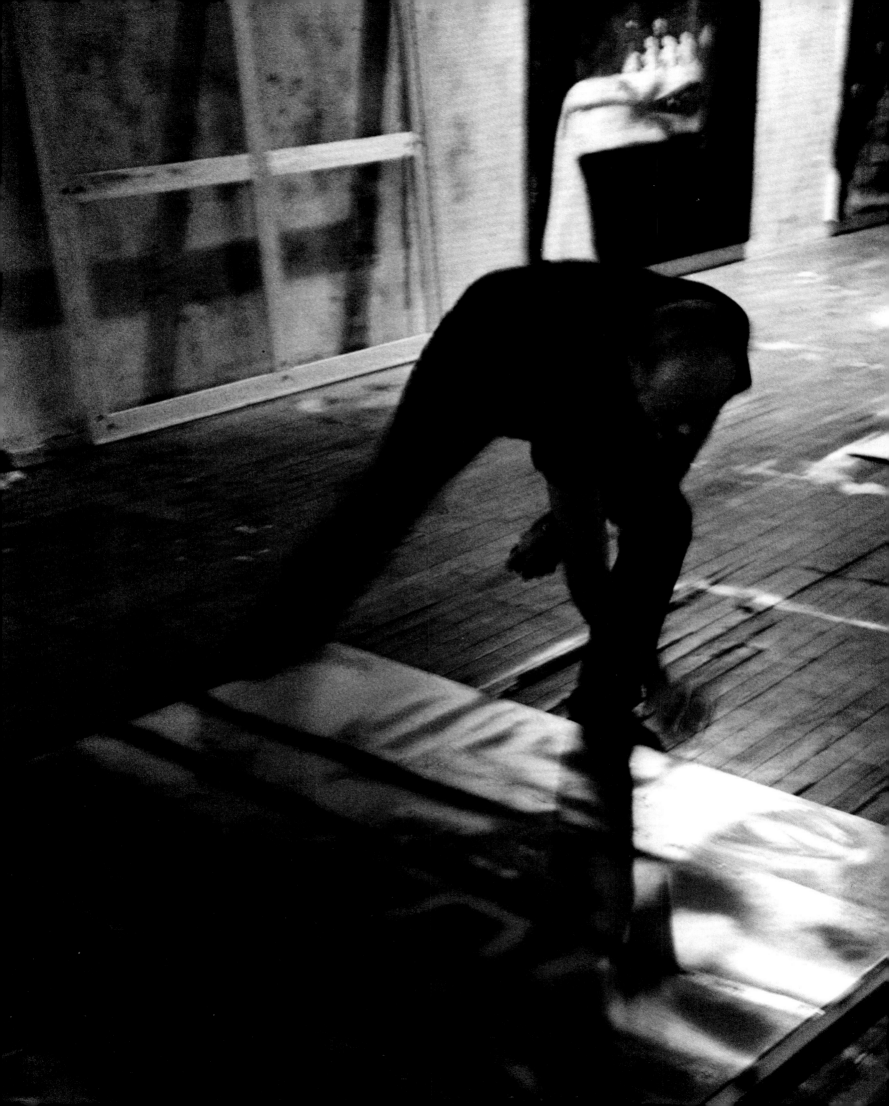

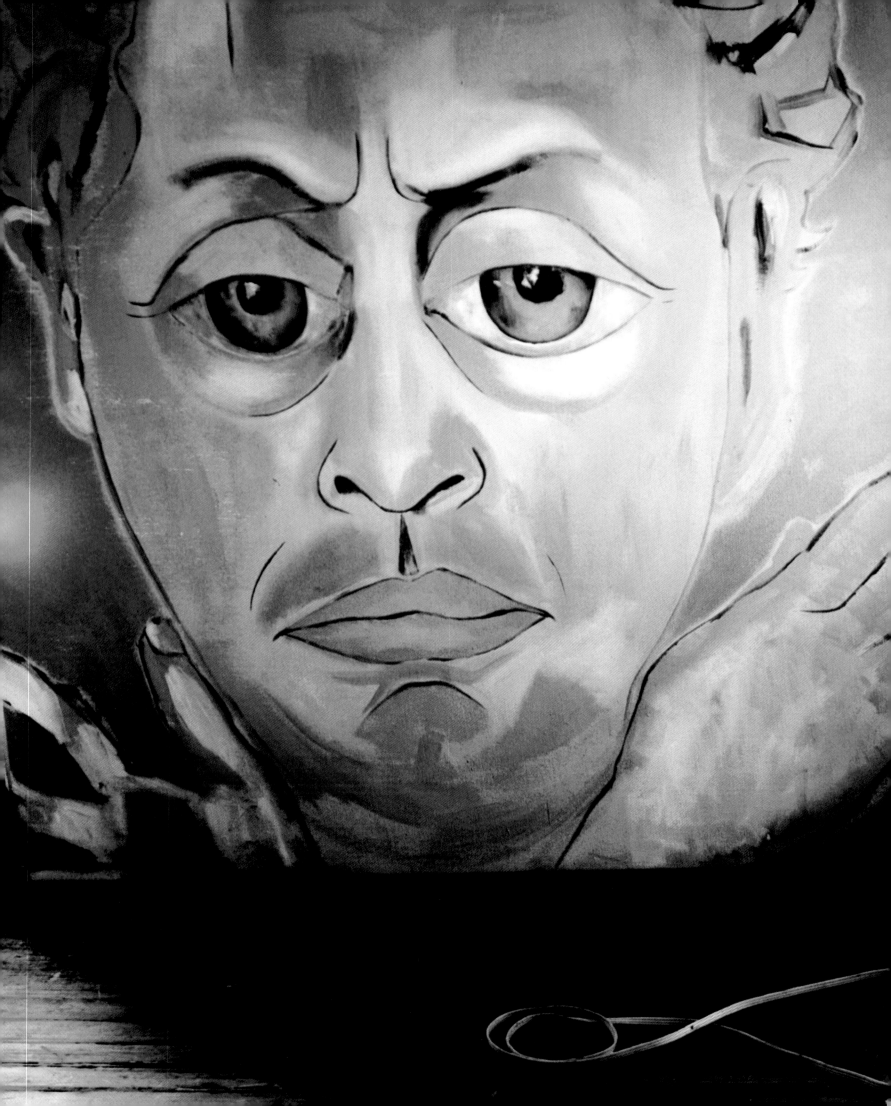

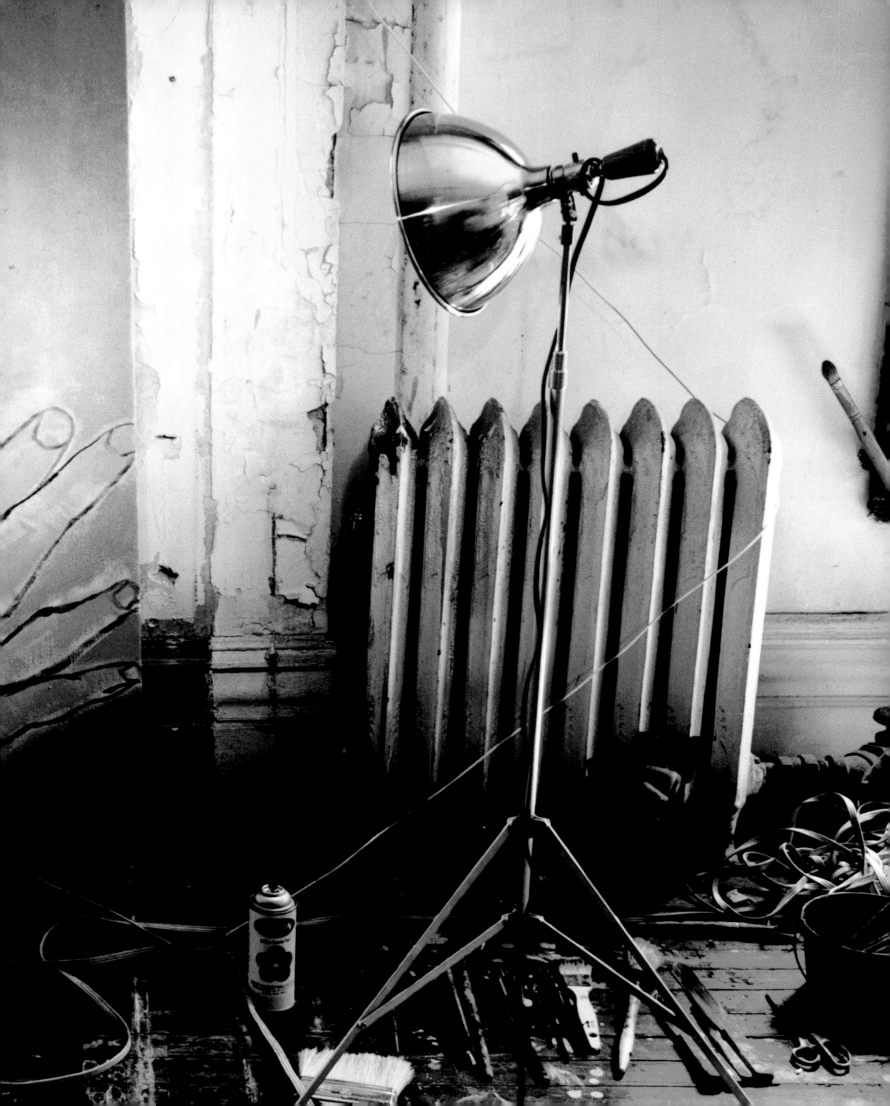

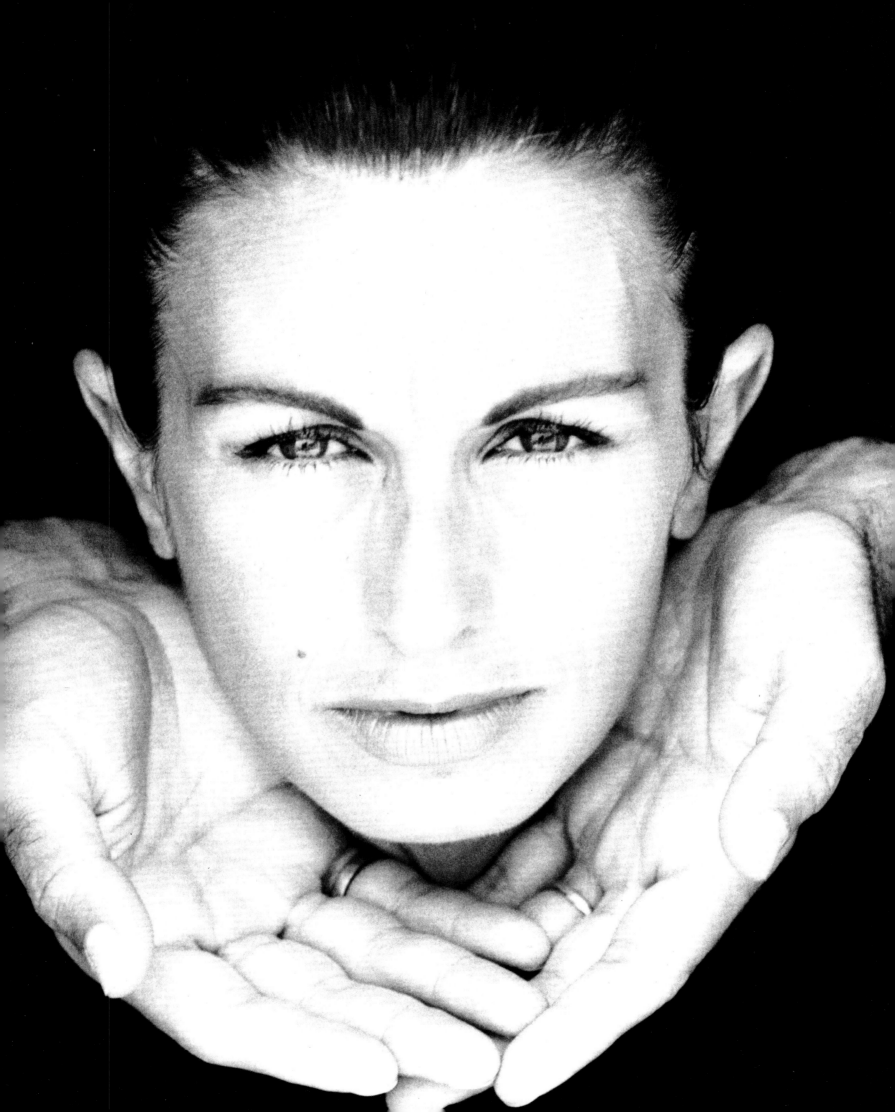

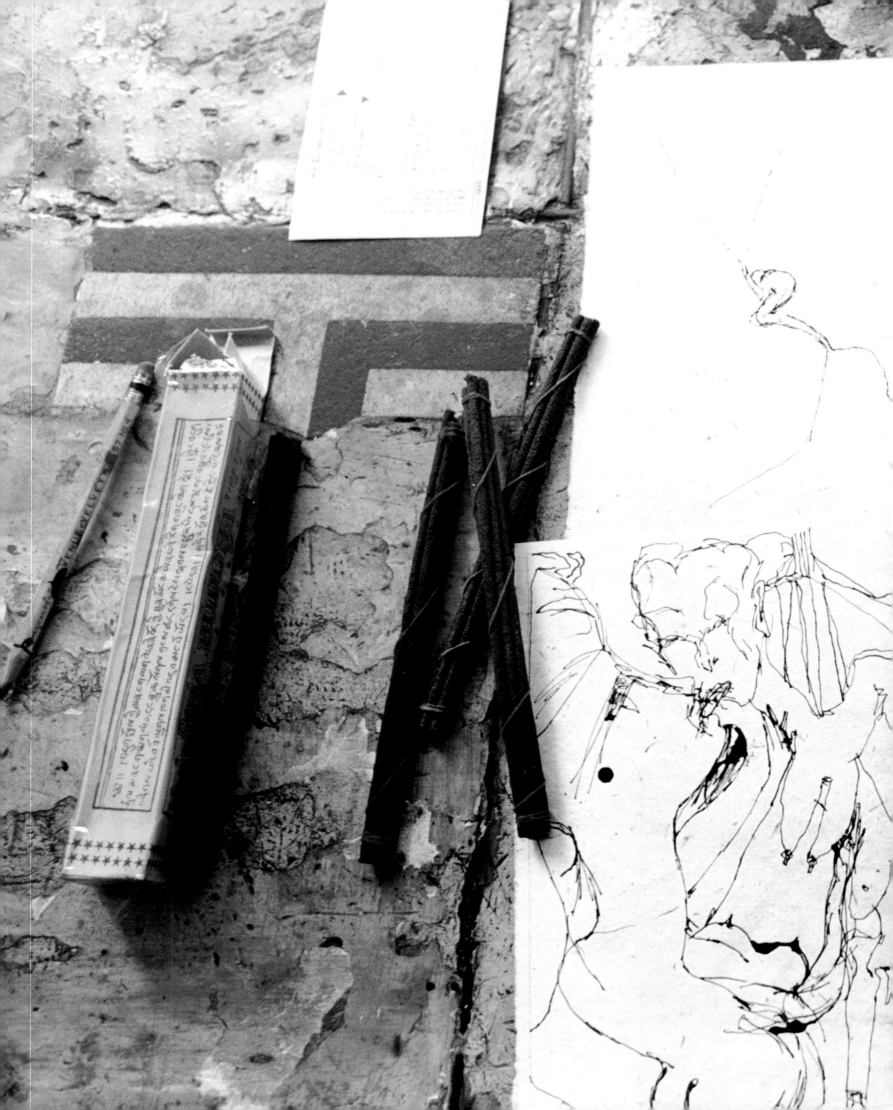

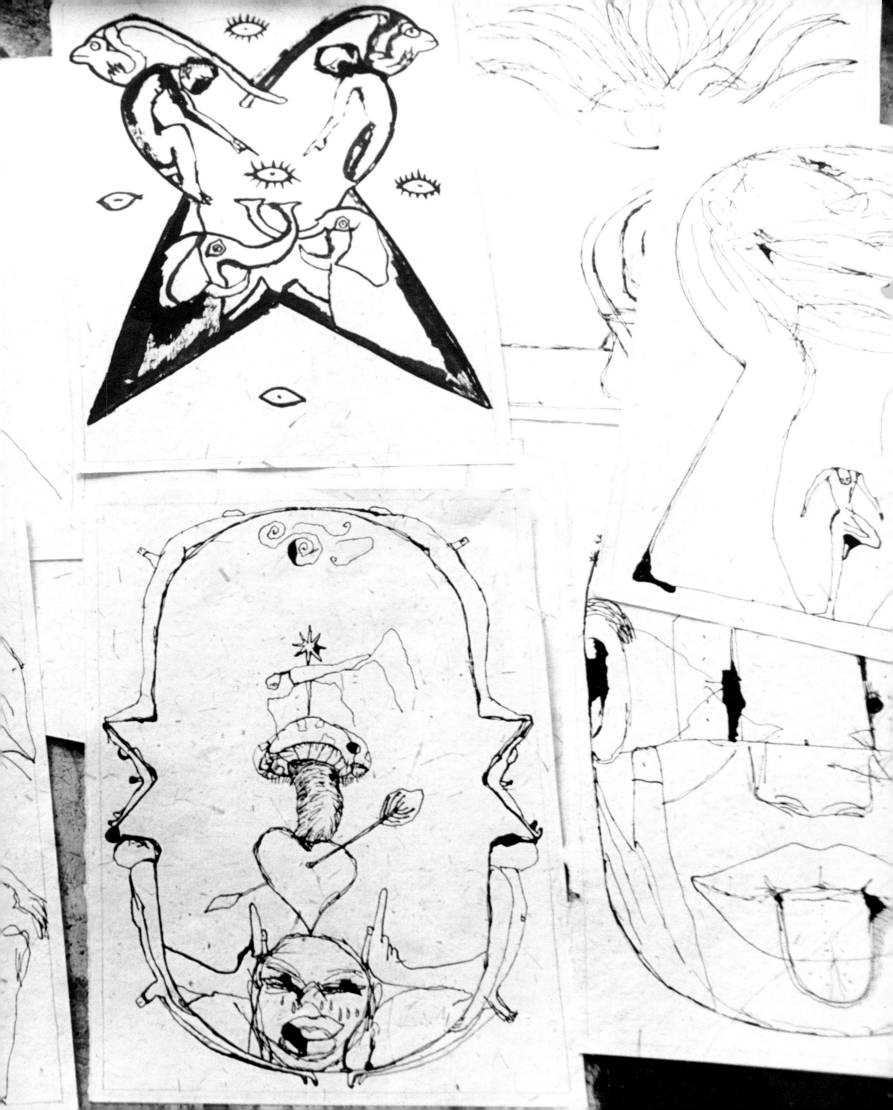

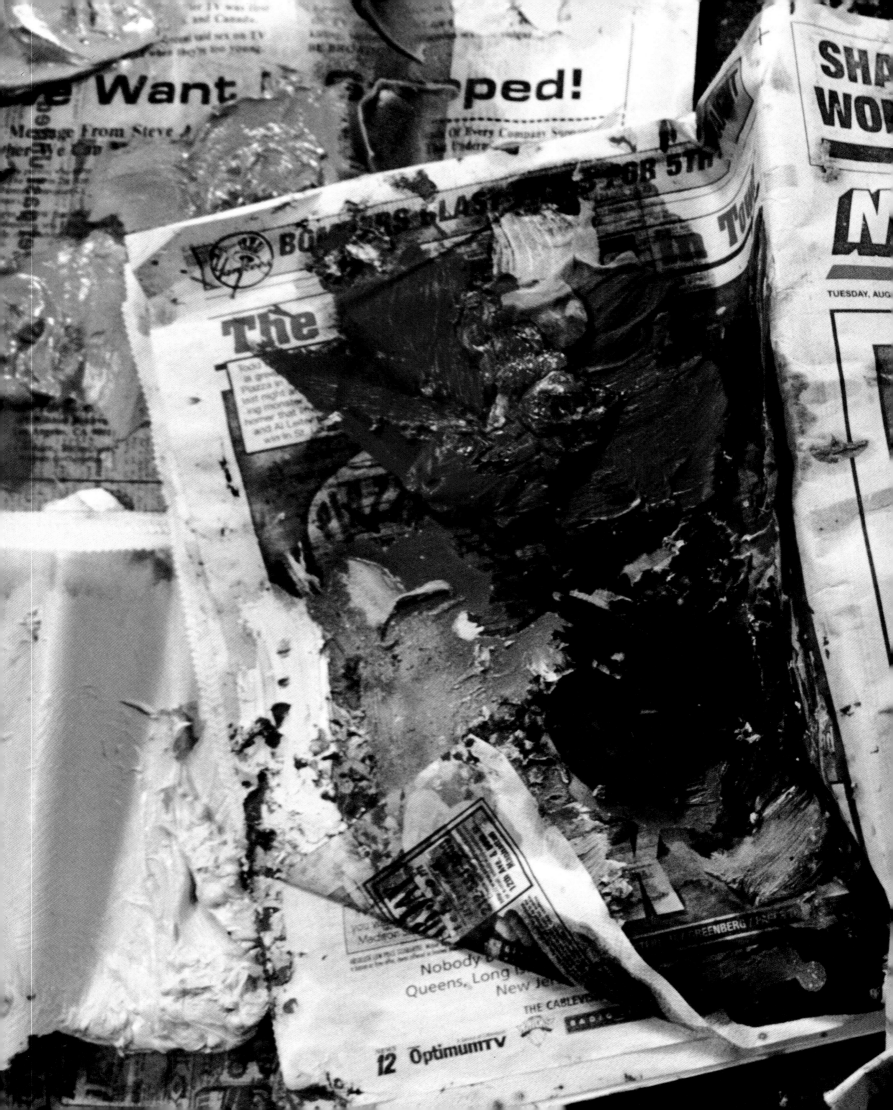

KEUP R
EN'S M
KEITH J. KELLY WITH THE IN
EW YO
, 1996 / Humid, 80-85 / Weather: Page 40 ★

Monday SP
EWS

SCORCHED
EARTH!

July shatters all

Texas cornfields
show the effects
of July's massive
heat wave.

YANKS T

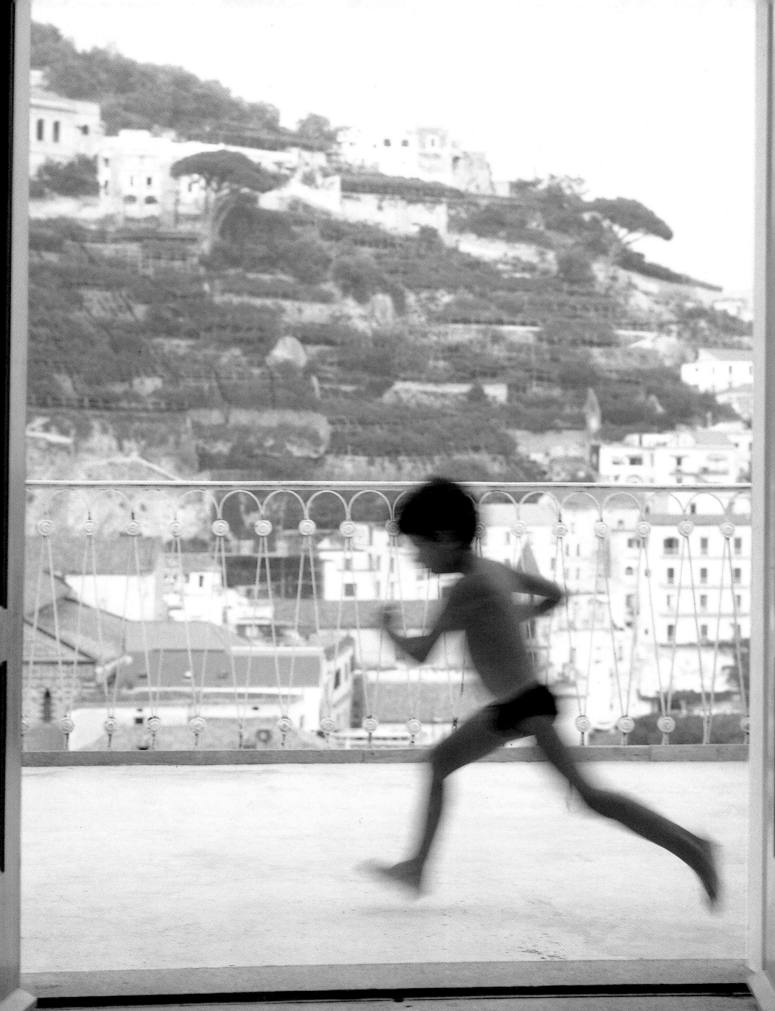

ITALY

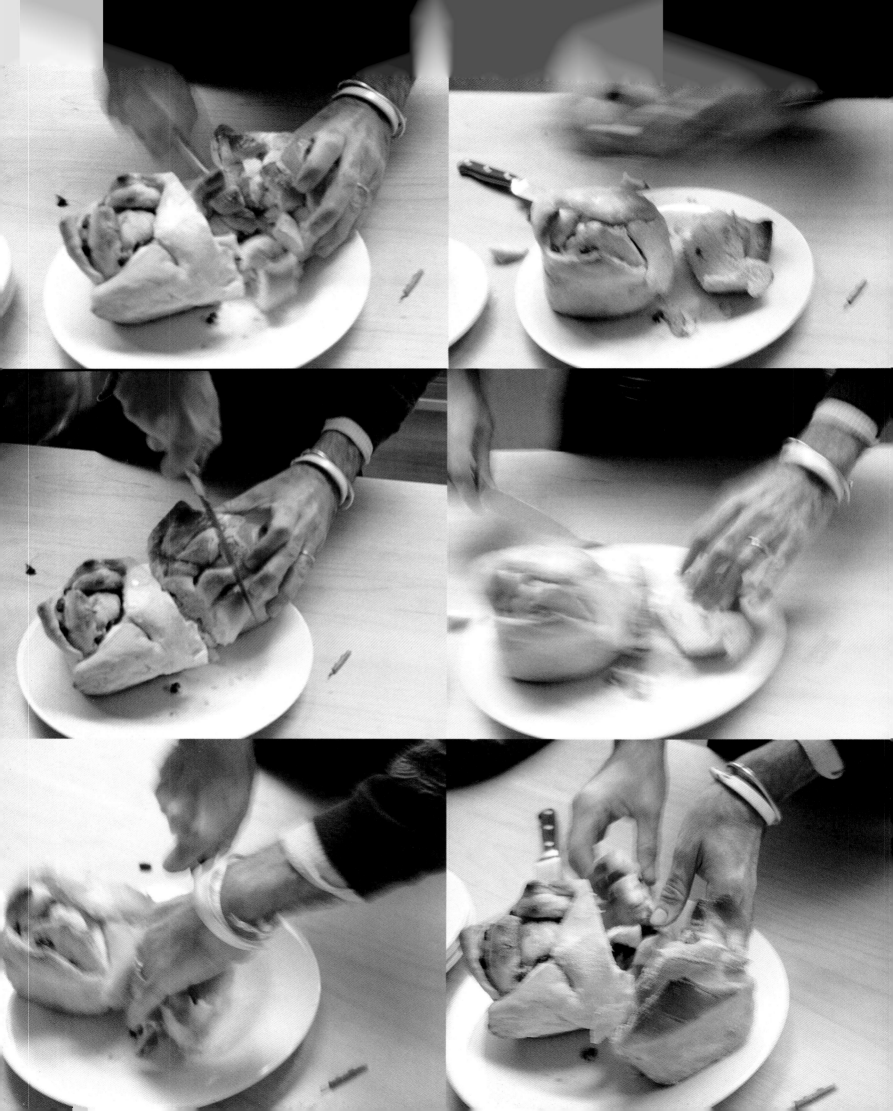

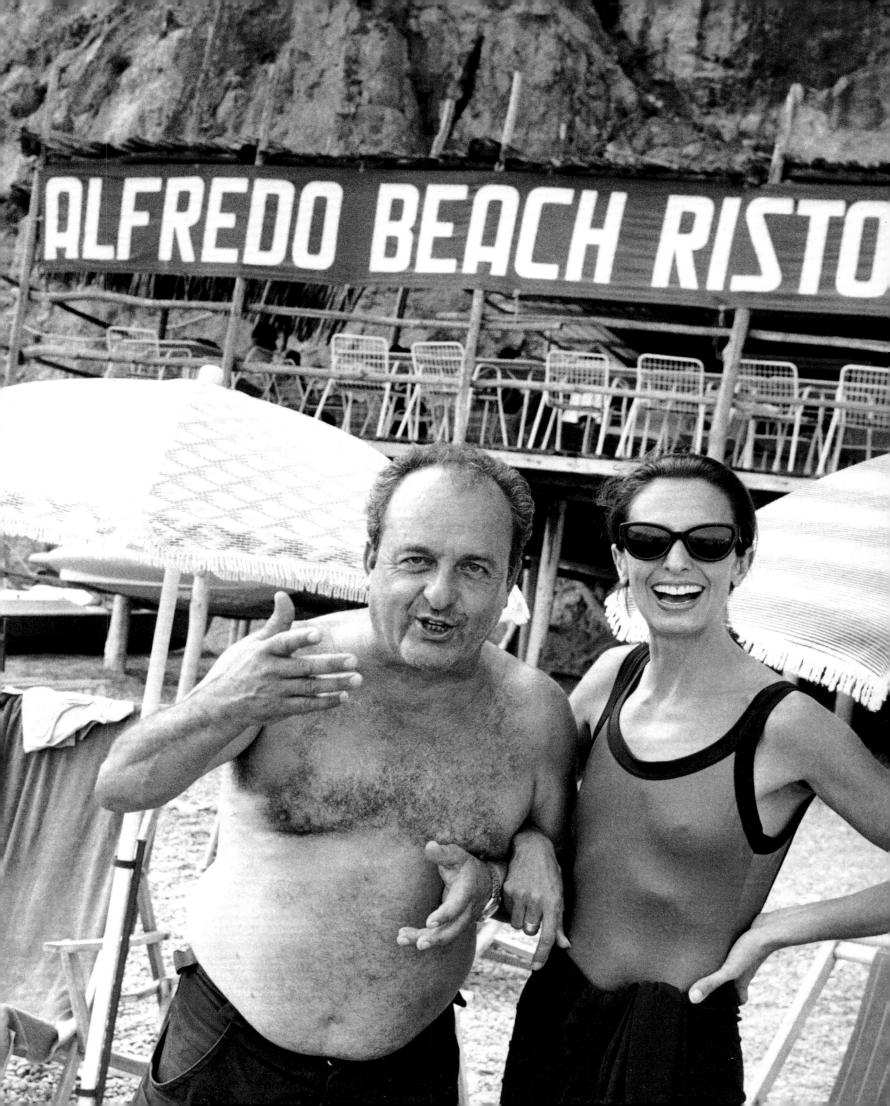

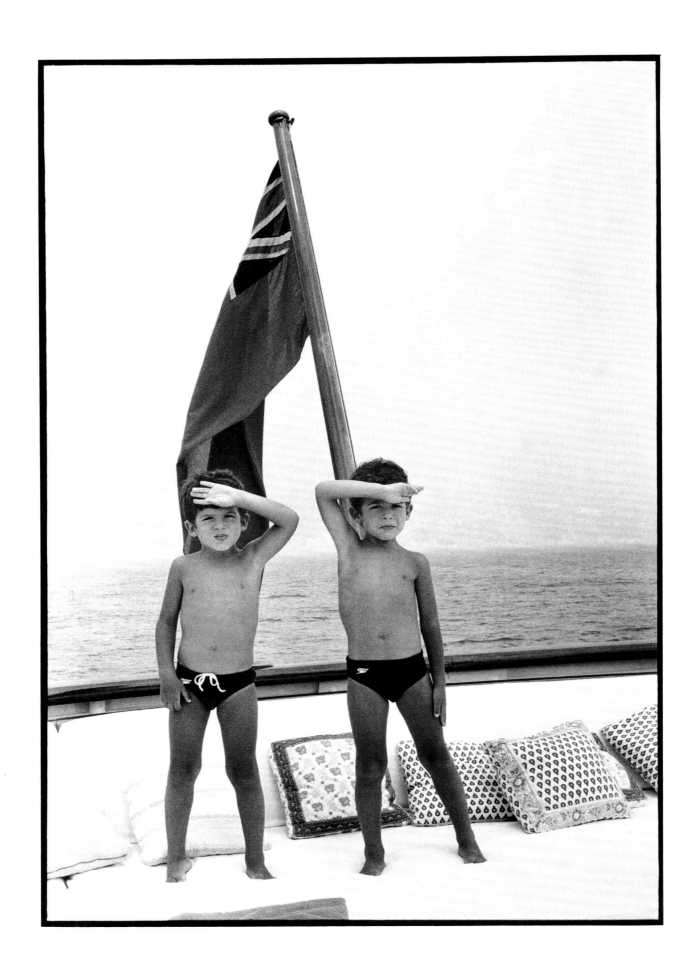

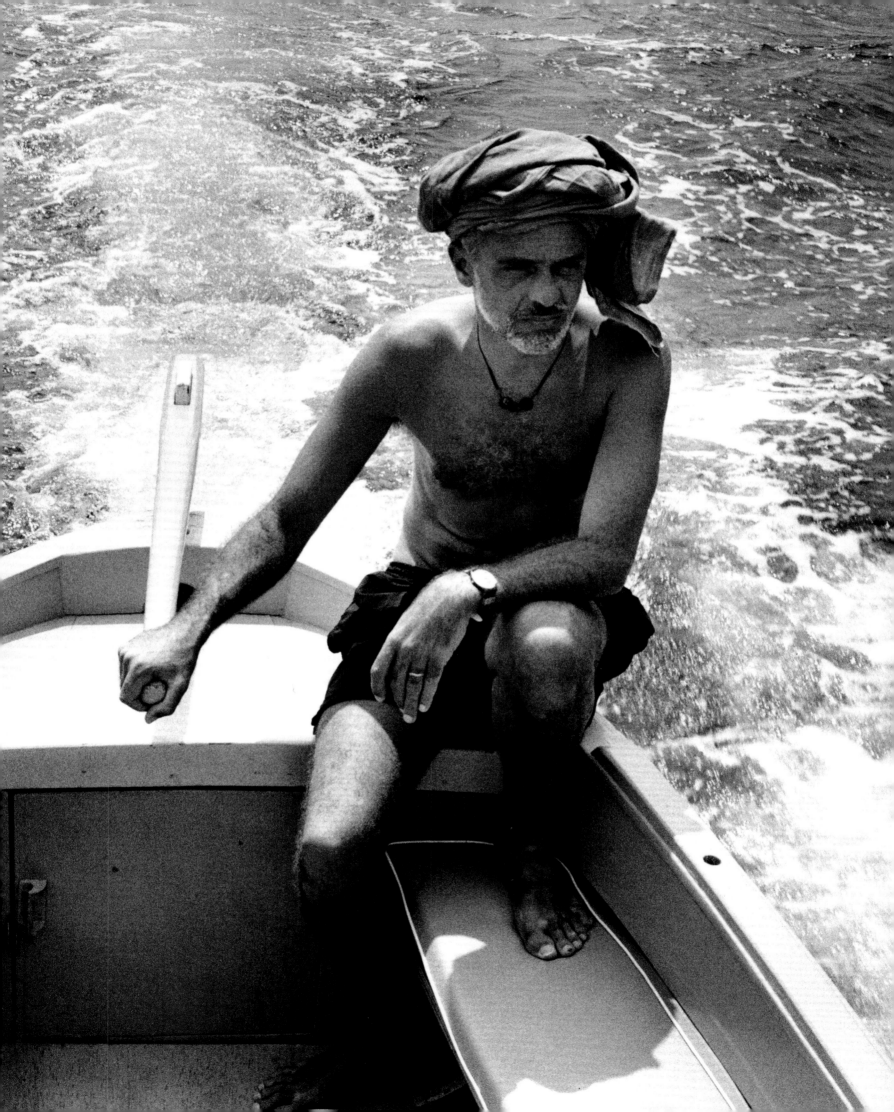

All Neapolitans are shamans.
I'm not very successful at being Neapolitan,
so I have to work real hard at shamanism.

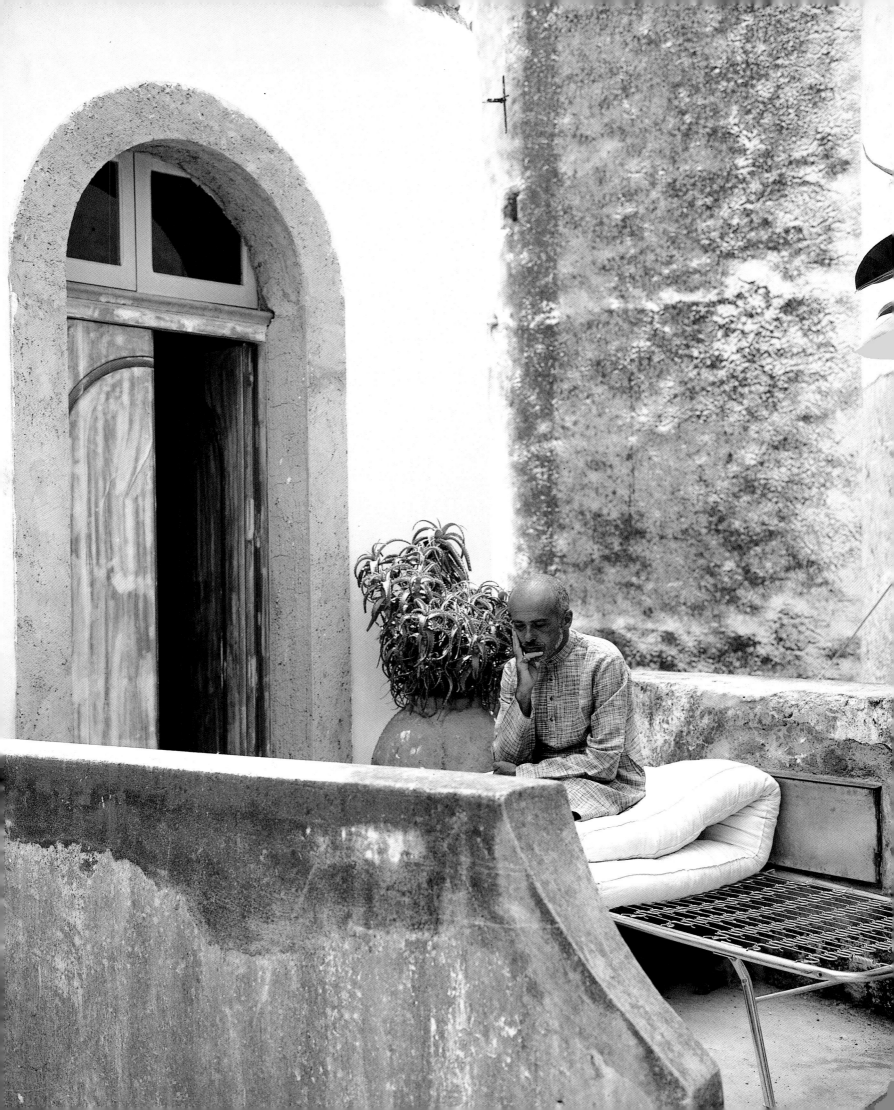

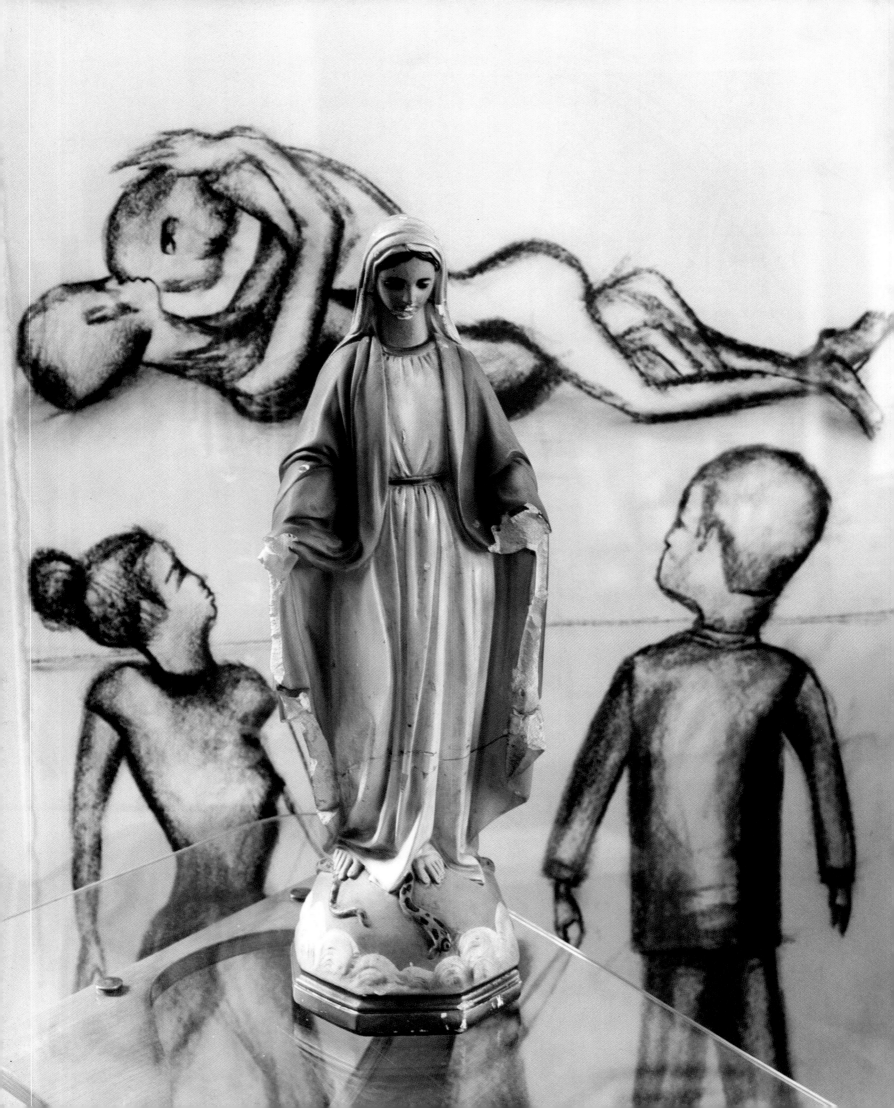

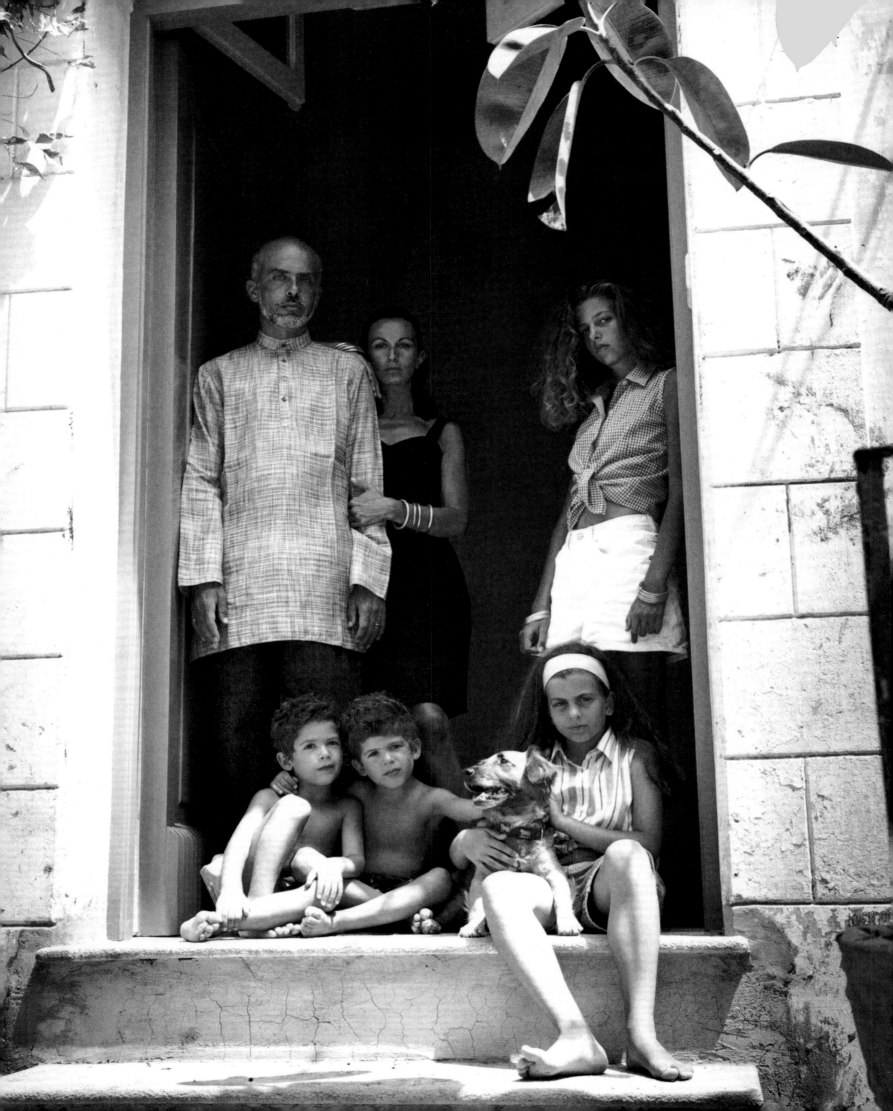

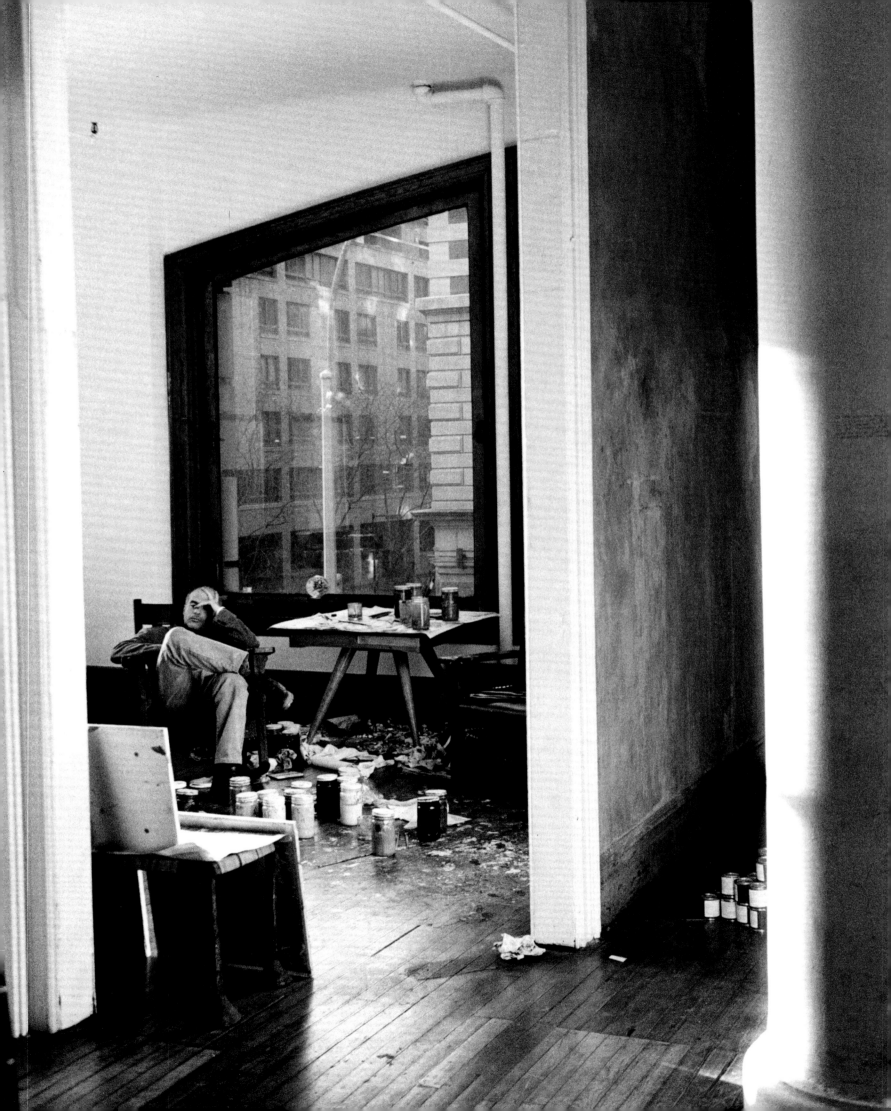

studio visit

BY RENE RICARD

During the Egyptian archaeological season of 1911–12 a team headed by the German Egyptologist Ludwig Borchardt uncovered the oldest-known artist's studio, the workshops and living quarters of Tutmose, sculptor-in-chief to the living god Akhenaton and his consort Nefertiti. The studio was at their court in the royal city of Akhetaten, now known as Tel el-Amarna, on the right bank of the Nile, in the middle of nowhere.

The legend of the discovery of Tel el-Amarna: toward the end of the nineteenth century, cuneiform tablets began to appear on the Cairo antiquities market. All the letters were in the same format, and all the tablets seemed to be of the same date—near the end of the eighteenth dynasty. At the same time, curiously, bits of sculpture and artifacts from the same period, the reign of Akhenaton, were also coming on the market. The combination of Hittite letters and artifacts from the almost mythical pharaoh Akhenaton alerted officials from the Cairo museum who initiated a search, one assumes from palm to palm, that ultimately led to a small community near a low hill that the villagers called Tel el-Amarna.

Apparently, mud from the Euphrates (and also the Tigris) is wonderfully fertile. The letters of the people who lived in Mesopotamia were inscribed on sun-dried mud slabs, resulting in bulky epistles and vast libraries for their recipients. The villagers who farmed around Tel el-Amarna were not pleased to have archaeologists close off their mound; it seems that the ambassadorial library of the royal capital of Akhenaton had seen double service as fertilizer.

One must take most of the history of ancient Egypt on trust, since many kings would cross out the name of their predecessor (*damnatio memoriae*) and usurp his temples. Information survives in the stingiest bits. Written according to a system Ed Sanders claims to be able to read, the records were covered under the sands for millennia. What facts survive are as stable as the future of *shatoosh*.

The complex of buildings Professor Borchardt spent years digging up, for example, was identified as belonging to the sculptor Tutmose because an inscription found on an ivory horse-blinker buried in a pit in a courtyard mentions a man "praised with the perfect god, the chief of works, the sculptor: Tutmose." It could have been a stable, but no, it wasn't a stable, because of the sculpture—masses of it, and all types, even half-finished heads with corrections drawn on. The name "Tutmose" as proprietor, and as actual head sculptor himself rather than just a titular owner, was determined by study and a preponderance of opinion.

The specifics of the abandonment of Tel el-Amarna will probably never be cleared up. The city went on for a few years after Akhenaton's death until one day the remnants of his court seem to have been evicted. In Tutmose's case the process was accomplished with a certain amount of violence and somewhat haphazardly: a quartzite head of Nefertiti found lying in an open courtyard had, of course, her nose broken (this business about broken noses in antique sculpture!). One can get carried away with speculation here: why was this head lying around for its nose to get smashed by whoever smashes the noses on Egyptian stone heads? Tutmose and his shop had gone to a lot of effort to keep the work safe. Perhaps a few pieces were left hanging around so the *damnatio memoriae* crew wouldn't get too suspicious; because in 1912 Borchardt discovered perhaps the greatest example of negative selection in archaeological history. Negative selection is what people leave behind when they move, presumably what they don't want. What Tutmose left behind was the head of Nefertiti, now in Berlin, carefully sealed up in a room with forty or fifty other sculptures—mostly heads of Nefertiti and family.

Borchardt was astonished at the condition of this now famous bust, with its unique toque and only a few minor chips about the ears. You've probably remarked on how, Claudette Colbert–like, Nefertiti is always photographed from one side—the right. The reason is that her right eye is properly inlaid with rock crystal and a painted black iris, but her left eye is blank. The good professor was disturbed that a statue was missing an eye. (It did still have its nose.) He ordered his men to use the finest-gauge sifters but find that eye. He even offered a reward. My sources do not reveal the amount, but it is a moot point anyway, since the eye, as a trip to Berlin will inform you, is still blank.

One of the many explanations for the changes that come over the art of the Amarna interlude around the year seven B.C., I think, is that a new royal sculptor was employed. This would have been Tutmose. He brought a more human, warmer style to Amarna. He probably brought it to Tutankhamen too, because his style is still found in the tomb of the young return-to-normalcy king.

Tutmose had quite a life—swept away, one assumes, under armed guard from one royal capital to another, and leaving behind Nefertiti and King Tut's tomb. That's quite an accomplishment. I wouldn't be suprised if he turns out to be Moses.

If you want to find out anything it'll probably be in Pliny (the Elder). The first existing anecdote about a painter's studio is in his *Historia Naturalis*.

It seems that Alexander the Great was a great fan of the Greek painter Apelles of Cos whom he made his official painter. Like most men who've conquered the known world, Alexander of Macedon was a bit of a know-it-all. You know the type. One day, as he was posing for another official portrait, he started up as usual, expatiating on the subject of painting. This put Apelles in a diplomatically awkward position, but he was able to get Alexander out of earshot to warn him either to keep his voice down or stop talking about art because "the apprentices grinding my pigments are laughing at you."

Not only was Alexander the Great not offended, he offered his mistress to the painter on the spot. Now here's where history becomes inscrutable: Pliny, to show what a great man Alexander was and what a great friend, didn't even bother to ask the girl how she felt. Anyway, from what I know through reading Mary Renault, Alexander would've been grateful for one of the apprentices in exchange.

The scene of Alexander in Apelles's studio was popular with painters in the Rococo period. G. B. Tiepolo

did one where the girl is on Alexander's lap. His son G. D. did one too, a drawing in which all the roles are played by Punchinellos.

Francesco Clemente once said to me, "Do you realize that Gian Domenico Tiepolo [Gian Battista's son] only died in 1807?" It did seem awfully recent. I think we expect the date to be in the 1600s, not the 1800s—in fact he and his father lived in the 1700s. Tiepolo is Rococo not Baroque. Whatever.

Pliny was perhaps the first art reactionary, writing about how art was better in the past. In fact he gives a cut-off date of 280 B.C. (approx.) for the beginning of the end of sculpture. It is a common fallacy of the teaching of art history to claim, for example, that Roman painting is merely the recycling of older Greek painting. This is patently not so, since Pliny bemoans the decadent new-fangledness of painting. In a marvelous accident of history, he died witnessing the end of Pompeii (described in a letter by his nephew Pliny II), so his life is roughly contemporary with the painting excavated in that city.

There doesn't seem to be a consensus, yet, about Roman painting. It's been broken down to four basic styles: I, II, III, IV. Some say this division is roughly chronological but that can't be so. Vitruvius, a real pedant, complains about the terrible neo-painting where columns balance on ribbons; this seems a fairly good description of style IV. Now Vitruvius was writing in about 40 B.C., Pompeii was bombed over a century later (in A.D. 79), and I've read that style IV was the final development in Pompeian wall painting, so there's a discrepancy here. The so called Villa of the Mysteries on the outskirts of Pompeii was supposedly painted around the time Vitruvius was writing his architecture books and it has no style number attached to it (it is style II).

There are problems in the way art history teaches the cult of the masterpiece. We are told, for instance, that no examples of Roman painting that have come down to us are attached to a historically known painter. But Pliny, again, goes on about a certain Famulus, complaining that none of his work can be seen because his entire career was absorbed painting the interiors of the Domus Aurea, the Golden House of Nero. Of course Pliny hated Nero—we all still hate Nero for forcing Seneca to commit suicide, don't you?—but Nero must have loved Famulus. Much to Pliny's chagrin, Nero kept adding on rooms in the Domus Aurea just to get more of the artist's work. We're talking forty rooms here.

Around 1480 the Domus Aurea was unearthed. Raphael and his crew were painting frescoes in the Vatican at the time and did innumerable copies. Vitruvius's description of "columns on ribbons" is truly apposite here, and the entire Golden House was painted in the style, which would come to be called "grotesque" (because the excavations looked like grottoes). Raphael's assistant Giovanni da Udine made a specialty of this style, and starting with Cardinal Bibienna's bathroom most of the papal palaces were painted in grotesque decoration. Therein, I think, lies the problem. The Dormus Aurea does not conform with our ideas about painting—nor with those of Vitruvius nor even I suspect of Pliny. (But at least Pliny has the grace to allow it to be art.) Somehow it doesn't fulfill people's prejudices about what painting should be: it is not isolated squares of subject matter, it is allover decoration. But Raphael knew exactly what to do with it—as did Nero, as, I suspect, does Francesco Clemente. Famulus's paintings, don't forget, were the classical precedents that had perhaps the greatest influence on Renaissance art. Grotesque ornament is a Renaissance ubiquity, and since its discovery it has never been out of style—but I had to piece all of this together myself. Surely you'd think Famulus would be in those thick art history books? He's so famulous.

I remember seeing a room by Francesco at the Philadelphia Museum in 1990, all painted in indigo. It was very Domus Aurea.

Fresco painting is not delicate. When Francesco did frescoes he used to have Claudio di Giambattista come in from Rome. Claudio is a very handsome art restorer who somehow became Francesco's fresco specialist. I miss him. It was always a treat when Francesco was doing a show of frescoes and Claudio would come over and I'd go to the studio and pose. I once posed for an entire fresco cycle of about eight seven-foot-square panels.

Fresco is brutal and hair-raising. First Claudio plasters the panel; this is very butch work. He uses old slaked lime that he brings over from Italy—it's better somehow—then he mixes it up just like any plasterer and scrapes it up onto one of those boards that plasterers use, the kind with the handle. But the way Claudio would slam the plaster onto the panel was shocking—*so* hard—to knock out all the air bubbles. Then he would spread the plaster and that part was a ballet—*so* fast—the whole panel would be covered in a minute. Everyone knows, certainly, that fresco is about speed. It's also, though, about hurry-up-and-wait, because the plaster has to sit for about a half hour to set up right before you can start painting. Then it's fast. Cy Twombly can come to visit but you don't stop posing and painting and plastering. Then Francesco's taking too long. Claudio has to put up wet rags to keep it wet and so on all night. At eight in the morning Francesco says, "You still up to posing? I'd love to finish these four watercolor screens."

Vasari says that Sandro Botticelli's studio was next door to a textile factory, making that famous Florentine wool. Actually most woollen cloth wasn't woven in Florence; it was woven in Flanders and only fullered (whatever that is) in Florence to acquire a luxurious glossy surface. The man next door to Botticelli, though, was a weaver.

According to old sources, Botticelli was neither pleasant nor pleasant looking. He hated his neighbor. It seems the man had looms going at all hours of the day and night. The noise was deafening. Also Botticelli's house was quite old and rickety and would rattle from all the vibration.

The hair on the famous Venus is painted in gold; Botticelli used a lot of gold in his paintings. You can just see him trying to balance a tiny seashell full of gold paint as the neighbor's shuttle flies violently through the warp (weft?) and, well, gold's expensive to spill. One begins to feel bad for the curmudgeonly painter, but Botticelli came up with an ingenious solution: he moved a huge boulder up onto his roof and balanced it on the edge overhanging the weaver's shop and called out "Fire."

The weaver came out and saw that the tiniest vibration would crush his roof.

I don't remember how much farther Vasari goes with this story, if at all. I don't see how this helped matters, but apparently it did. I only mention the story to give an example of a milieu—a craftsman amongst craftsmen—that seemed to be ok with Botticelli. He did produce a great deal of lovely painting.

Now you have a lawyer living above your co-op and a lawyer living below your co-op. An artist never wins.

The artist's-studio system was lost in the twentieth century. In the sixties I still knew painters who could trace their instruction back to the studio of Ingres, but the genealogies of art instruction were disappearing, and with this breakdown in the apprentice-master tradition came the consequent loss of studio lore: the little odd bits of information (often scurrilous) passed down through time, the gossip unsupported by documentation. I don't know where I heard that Dürer's mother was a mulatto, but I know that I haven't been able to find it in any of his biographies. He did wear a lot of wigs.

The loss of the oral tradition of the studios was followed by a general disintegration of connoisseurship, of the kind of knowledge of the physical characteristics of a work of art that is transmitted from master to student or from dealer to worker. That was the way information was passed on more generally before the advent of art books; now, scholarship has replaced connoisseurship. If there is no substantiating document, usually a contract, an inventory, or Vasari, an interesting bit of lore will simply be dropped. I can remember when I was young helping a curator in Cambridge install a case of Benin bronzes. He made me heft these small plaques; they were extraordinarily heavy. The curator told me that the reason they were so heavy was that they contained a large percentage of gold. In fact they usually do contain gold, but it took a scientific test to show that they are also composed of 20 or 30 percent lead.

The worst effect of the loss of the material knowledge of works of art and the emphasis on documents is that experts are losing their ability to see. The appearance of a painting has become secondary to the proof of a document—the reverse order from the past. It is not unusual to find a writer's description of a painting deviating from what is actually present. Today I was reading a description of Caravaggio's *Ecstasy of Saint Francis* in which the writer describes the saint as "pointing to the spot where the stigmata will soon appear." In fact the stigmata, if you look, are clearly visible. This type of mistake is constant in the writing of this author, who is considered an authority on Caravaggio.

Titian knew Vasari. He even tacked ten years onto his age so Vasari would think he was a hundred-year-old prodigy. Titian was such a striver; being a ninety-year-old prodigy wasn't enough. He lived in the age of the tall tale—maps of the period still have mermaids. But there's something not quite quaint about some of his lies.

In the first edition of his *Lives of the Artists*, Vasari gives authorship of a *Mocking of Christ* to Giorgione. By the time of the second edition he had met Titian, so the Titian section is nearly the longest in the book (maybe Michelangelo's is longer; he knew Vasari too), and in this edition Titian claims the *Mocking of Christ* for himself. I'm sure it must've been hard for the young Titian living in Venice under the shadow of Giorgione, who was so beloved and died so young—and all along knowing you're better, as a striver like Titian must have really believed. Titian was such a liar that today's historians give the *Mocking of Christ* to Giorgione *because* Titian claims it. We'll never know. That's what's hateful about liars.

There's a famous story, anyway. One day while Titian was painting a portrait of Charles V Habsburg, the Holy Roman Emperor and the most powerful man in the world, he dropped a paintbrush and Carlos Quint himself stepped over to pick it up and hand it back. The story is in Vasari. But, you know what? The sword cuts two ways; I don't believe it.

The story is supposed to show that Titian was great amongst the great, and that a major class distinction had been breached: the painter has gotten to be courtier, not craftsman. But Venetian artists were always touchy about status. It seems Giorgione could have been taken for a gentlemen.

Titian's friend Pietro Aretino was the first painter's flack—pornographer—artist's agent. He claimed that Titian was ennobled by some crowned head or other. Titian even did a self-portrait wearing a heavy gold chain, the type you get with an order of aristocracy, to publicize the fact. Do you believe it?

Rubens however was the real thing. A true courtier. He must have had a difficult childhood: his nudes look so much like those sausages the French call *boudin blanc* that I'm sure he went hungry as a child.

With a father like his he was lucky not to have been discredited everywhere. The father, after all, while ambassador to William of Orange, had unprotected sex with Anne of Saxony, Princess of Orange (i.e., William's wife), who ended up having his baby. Not very diplomatic. When he escaped from jail his wife took him back. They were Catholic.

When Rubens arrived at the court of Philip IV of Spain the local hidalgos did not accept his cachet. Apparently he was really ill-treated. I'm sure Philip, that strange man, was icily polite—and he certainly liked Rubens's naked ladies. Even after massive fires, whole castles burning down, there are still scores of Rubenses in Spain.

Rubens's studio operated under very particular circumstances. We're used to the Renaissance idea where a little boy, shy and stammering, comes in, is taught to grind colors, and walks out as Leonardo da Vinci. (Strangely enough Verrocchio, in whose studio Leonardo worked as a young painter, has no documented paintings; he apparently got trained teenagers to do the whole thing. In the famous "Verrocchio" *Baptism of Christ* in the Uffizi, Leonardo painted the angel with its back to us. There's another angel right next to it that critics always compare with it to its disadvantage—it's probably by Botticelli, who was apprenticed to Verrocchio at the same time.) In Rubens's studio, Rubens himself only painted the dimples—which kept him busy 24-7. Everything in those giant machines was painted by a specialist: Van Dyke—textiles; Jordans—most things; Frans Snyders—animals; Jan Brueghel—flowers; etc. Yet they all look so Rubens.

At least Rubens only had to suffer Spanish courtiers when he was in Spain. Poor Velázquez lived there.

Philip IV was truly an enigmatic man. From all accounts he was dour and taciturn. There is a tapestry showing him and his court as he presents his daughter Maria Teresa to French courtiers for her marriage to the young Louis XIV: the contrast is grim. The French used the word *gravitas* to describe Philip IV. The singer Nico had enormous *gravitas*, and when I remarked, fascinated, about this quality in her, my friend, who was older and knew her better, said "That's the effect of the abysmally stupid. A lack of agility can look solemn." Was Nico stupid? Was Philip IV?

Philip IV liked paintings. He collected them, commissioned them, and Palamilo said that Velázquez taught him how to paint them. It's a sobering thought, Philip IV with a palette and a little brush standing next to Velázquez before a little easel and a big naked body. Except for his public life we know little about Philip and the little we know seems to point toward Velázquez as his only friend. When the crown prince died, his apartment was turned over to Velázquez as a studio—it's the room in *Las Meninas*. That picture also, famously, shows the painter himself wearing the cross of Santiago—painted in later, when the picture was already dry.

Apparently Velázquez tried to be as arrogant as possible but he could never top the hidalgos themselves. They probably resented the amount of the king's time he got. Not that it did him much good. He'd applied for a patent of nobility—in fact he was from an old well-born family—and the king seconded the request. It looks like someone within the last few hundred years of Velázquez's family had had a job or something because the court herald turned him down. Finally, just before he died, he was granted (the king had probably threatened to quit) the lowest grade of nobility.

One must not look down upon persons at this date trying desperately to be ennobled. It was not social climbing or getting invited to the right parties. It literally allowed you to live in a different world. Nobles

were not held to the same laws. They could not be arrested or tried like other people. They paid almost no taxes. They could carry a sword. Every country had its own set of sumptuary laws that explained who could wear and not wear certain fabrics, colors, etc. We don't know what people who did not belong to one of the seven ranks of Japanese nobility in the Heian period ate; we only know that they were forbidden to eat rice.

The first real studio Francesco had in New York was on North Moore Street. If I'm not mistaken this was where he did a few small paintings in a wax medium. He spent most of his time there, however, working on one enormous painting. I guess the things you first notice in a new town are things that are new to you, or perhaps, actually, it's things that are curiously familiar, or maybe it's a combination of the two—or maybe, literally, it's the first thing you see. As you come in from the airport, in your first view of New York's iconic skyline it hovers *La Dolce Vita*–like over an extensive cemetery. That was in the middle of Francesco's painting. On either side were the second- or third-floor facades of lower-Broadway-type buildings with an overscaled neoclassical woman's face flanking a man on a tightrope suspended between the buildings and over the cemetery. The man had on a long overcoat, two left feet, little dark glasses, and a cane, because of course he was blind.

I have a policy about paintings and artists: don't talk about one to the other. It's a good policy and I should have stuck to it this time, but it was so easy; the painting just wrote about itself in my mind and I was off. Of course he destroyed the painting. I think he probably did some of the wax paintings on the scraps of canvas.

Artists are always drawing themselves. Leonardo is a wonderful example. His drawings, from the beginning of his career, are full of caricatures of an old man with a long hooked nose and a terrific underbite. Uncannily, Leonardo knew what he would look like when he aged. His actual appearance is easily ascertained: he is traditionally accepted as the model for Verocchio's *David*, and his red chalk self-portrait in Turin gives us a good spread of his looks from the age of fifteen to sixty.

Francesco was originally known as a painter of self-portraits. The first work by him that I ever saw in New York, in fact, was a large sumi drawing that contained a self-portrait. Francesco seemed happy to go on for quite a while painting himself or his wife, Alba, often introducing a confusion about who was who. He slowed down the production of self-portraits for a while until a couple of summers ago, when he realized that for many years he'd painted himself the same age while in fact he had gotten much older. This fact struck him with a considerable force. The results of his astonishment can be seen in Luca Babini's photos.

Francesco's face stares out at the viewer in disbelief. There are creases between the painter's eyes; but they are still the big beautiful eyes, and the mouth, a bit nervier, is still that famously sensual mouth. Please don't think this is easy stuff to write. I see Francesco Clemente at least every Sunday; I'm the one who will have to listen to him, with that ironically sharpened edge to his voice, as he says to me one day out of the blue, "*Famously* sensual."

That makes it difficult to take an even marginally distant stand from his work. You see, as Leonardo had a difficult time seeing himself as young, Francesco has the converse problem forcing himself to see his face aging. Rembrandt had the frightening ability to see his face as it changed from day to day, tracing the onslaught of time with barely believable accuracy; but this is unique.

Francesco Clemente in India—well there's a book! For my purposes it's too broad a subject, but in 1981 Francesco did a series of Tarot card–like miniatures in Madras that were painted for him by the studio of

a miniatures painter. He did drawings and gave them to these very young painters to copy onto old paper (paper washed of its previous painting, as is typical in India)—seven or eight baby painters, each specializing in a different element of the picture, balancing their colors in a seashell laid in the paint. It's too bad we don't have a picture of that.

Francesco started out as an architect, and was a devotee of Frank Lloyd Wright. So it is interesting that he's having a retrospective at Wright's Guggenheim Museum—the most impossible space to hang pictures in the world, but he thinks of it as the most wonderful. Scrutinizing the photos in this book, one sees a great deal of Wright furniture. Francesco's studio is furnished almost exclusively in Frank Lloyd Wright furniture, a good part of it, of course, covered in Clemente altars. Every flat surface in the studio is covered with altars devoted to a syncretic religion of objects not so haphazardly collected. The most exquisite *coco de mer* yoni carved out of rock crystal will happily share space with a garishly painted plaster cast purchased at a souvenir shop, the church of a traditionally antipathetic system of belief, but both keeping good company with an ancient bronze bracelet serving double duty as a stand for a well-worn conch. In other words, the studio contains a great deal of material wisdom, because painters, as makers of objects, find themselves in objects. Now how this refers to material or materialism I don't know. There is simply a feeling here of a tremendous amount of intelligent research, of objects becoming repositories for ideas, of still lifes, if one wishes to see them that way, becoming a political rebus. Catholicism and Hinduism are certainly both icon-loving systems. I once asked Francesco to explain what he thought the difference between the two were. I don't think I put it in those words, but anyway he said, "Rather than a dogma, Hinduism is action, a series of gestures performed daily."

In Francesco's first exhibition, a group show in Rome, the young painter showed two pairs of drawings hung against the ceiling, forming brackets at opposite sides of the room. The architecturally determined hanging is rather a constant in his work, and he loves long rows of similar images to follow him around the studio. In Babini's photographs you can see long lines of framed portraits of women. They were not set out like that for the photographer. They accumulated over a not inconsiderable space of time, and the forty or fifty of them were only recently moved out to make way for another series. Francesco's latest paintings of women are two meters long (each). This will be quite a roomful when it's done.

Luca Babini is a handsome young man from Genova, where of all strange things he met the seminally influential American underground filmmaker and photographer Jack Smith, with whom he collaborated on two short films. I am sure that that was quite an education.

Luca arrived in New York twelve years ago or so. He built a boxing ring in his loft. As well as supporting himself as a fashion photographer, he has directed and shot documentaries and shows for American television. As soon as he arrived here he met Francesco, and knowing a good thing when he saw it he began, on an ad hoc basis, to take photographs around the house and studio. He and Francesco would meet up in New Mexico, where Francesco was building a studio and Luca a tepee.

The great appeal of the photos in this book is that they evolved quite naturally over a long period of time. The shots were done in a relaxed atmosphere and came out of the daily life of the photographer and subject; there was no rush to deadline, no pressure to take a great shot. This is the great virtue of the book. Luca has shown Francesco as he developed over about a quarter of his life (sobering thought).

The book began as a black and white book. The color photos have immeasurably expanded the scope of the work, bringing us closer to the subject and adding a degree of intimacy to a group of images that is

naturally about friendship. Without the friendship of Luca Babini and Francesco Clemente a book of this nature could never have been pulled together, and I wouldn't have had access to these evocative photographs. Thank you Luca.

You know that old cartoon format, the artist with his beret and easel and a ripe nude woman posing in front of him, and on the canvas is . . . a still life or a Mondrian? In Courbet's version in the Louvre there is an awfully cute little boy looking up at . . . the model? Well I'm sure I would—a naked lady standing in the middle of a thirty-foot picture with half of Fourth Republic or Third Empire or whatever-period French people overpopulate this canvas. In fact it looks like a line up for *assistance publique*. There's an old codger with a top hat and cane sitting on a cracker barrel telling a story from his youth under the *ancien régime*. There's a lady in a shawl turning importantly from one person to the next; she will be heard. The painting is crammed with people who I'm sure are supposed to represent every condition and station but they all look rather shabby and dense, as if they were posed by the big-shot collectors and experts of the time. The only reason to look at this *pompier* abomination is the sweet depiction all alone on the far right of the very young Baudelaire. He's the only thing in the picture who really seems to be something you'd find in a painter's studio—quietly reading a book with an inkwell set up and ready for him.

This is not the painterly myth Francesco Clemente's studio embodies.

In Boston's Museum of Fine Arts there is a panel by Rembrandt less than a foot square that is among the greatest paintings anywhere and makes an important and new point about the relationship of the painter and his work. This is not a craftsman, this is not a factory, it is the moment of inspiration.

Rembrandt has painted himself far to the left and small. He's standing upright in a darkish room. The viewer has caught his eye for a second; he will immediately turn back to the canvas in front of him. The canvas has its back to us. It is dark except for the leading edge of the panel or canvas, which is a brilliant white. It is reflecting light back on him, and although we of course cannot see what is painted there we have the sense that it is completely blank—that it is waiting to happen, and that Rembrandt is flushed with potential. It's just him and the light. This is the real artist, the modern artist, alone with his work in the studio.

When Francesco first came to New York he stayed for a while with Alba and his four-year-old daughter Chiara in a little studio attached to the Sperone Gallery in SoHo. For his big show that year he wanted to do a suite of large mythological paintings of some of the friends he'd made here. There was to be one person to a painting, so the actual painting time was rather lovely and intimately social, quite charming.

I remember that I was supposed to be standing on a large egg and holding another egg on my head, but Francesco assured me that he could just paint it in. Since I was supposed to be naked in the painting, by the time he'd squeezed out some color I'd taken off all my clothes.

"Oh, Rene, you didn't have to. I just needed the face."

Suddenly he had a naked man in front of him which wasn't at all what he'd planned. He was wearing a suit and yellow tie.

At that moment little Chiara walked in dragging a doll. She had her thumb in her mouth and she looked up at me and it was just like . . . just like . . . the Courbet studio.

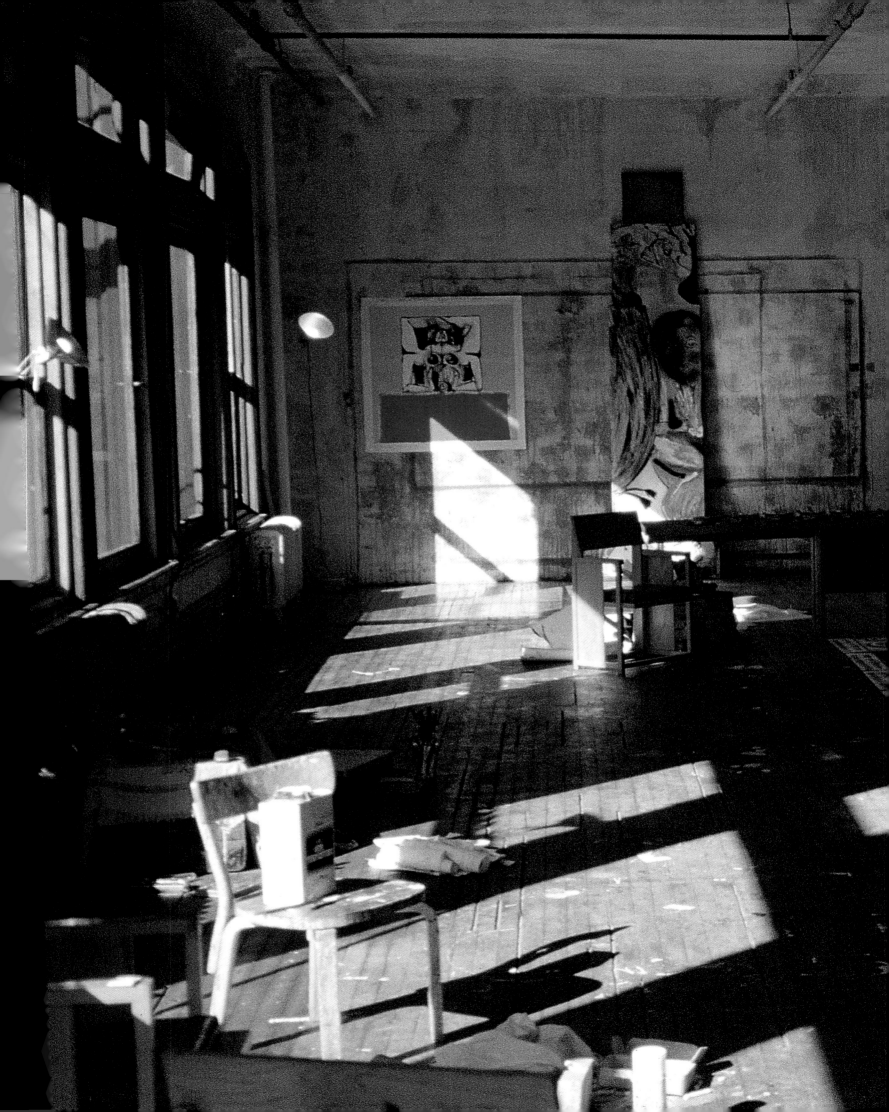

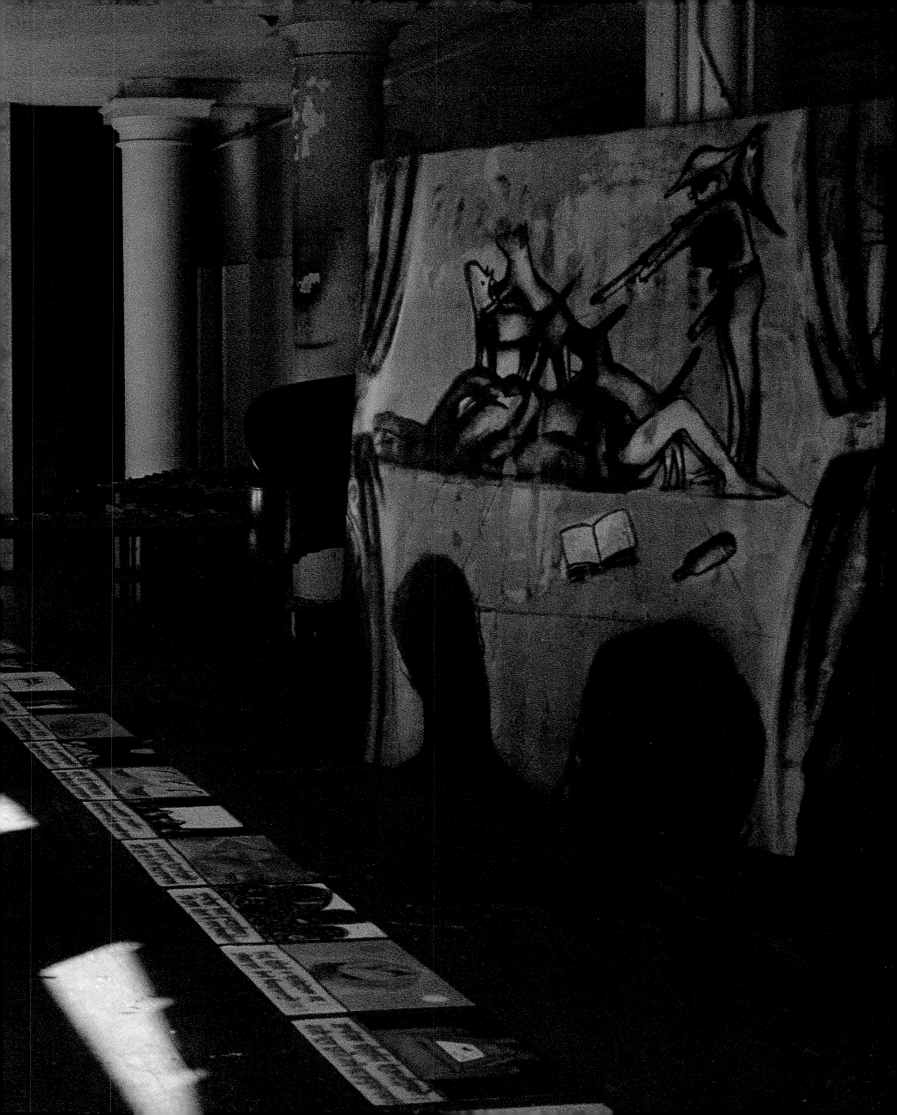

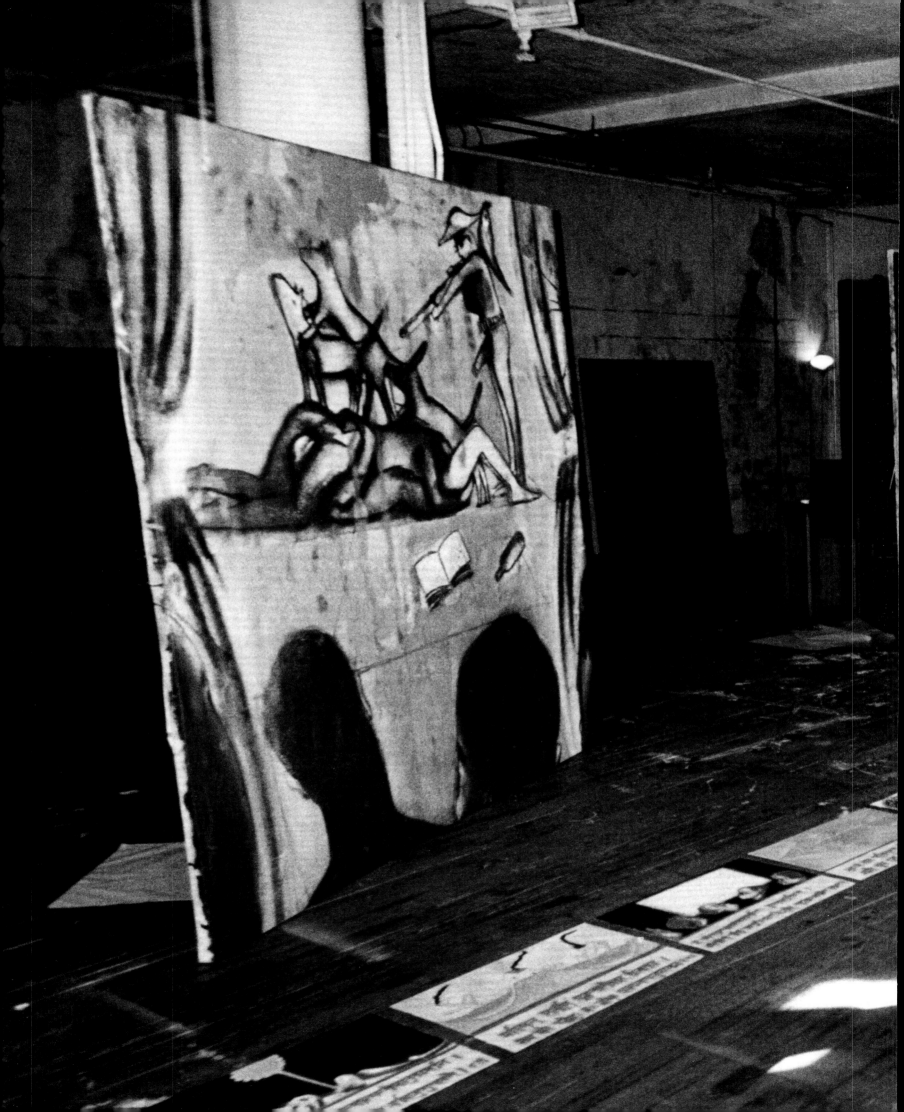

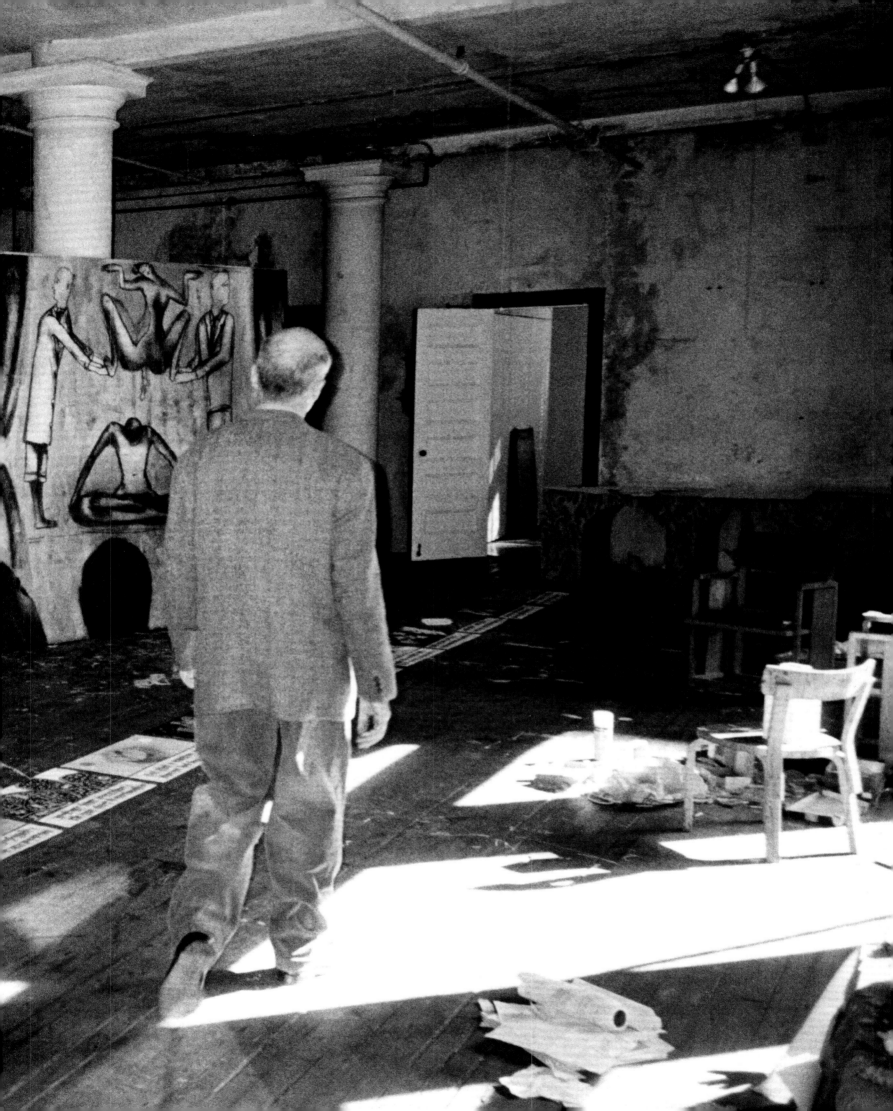

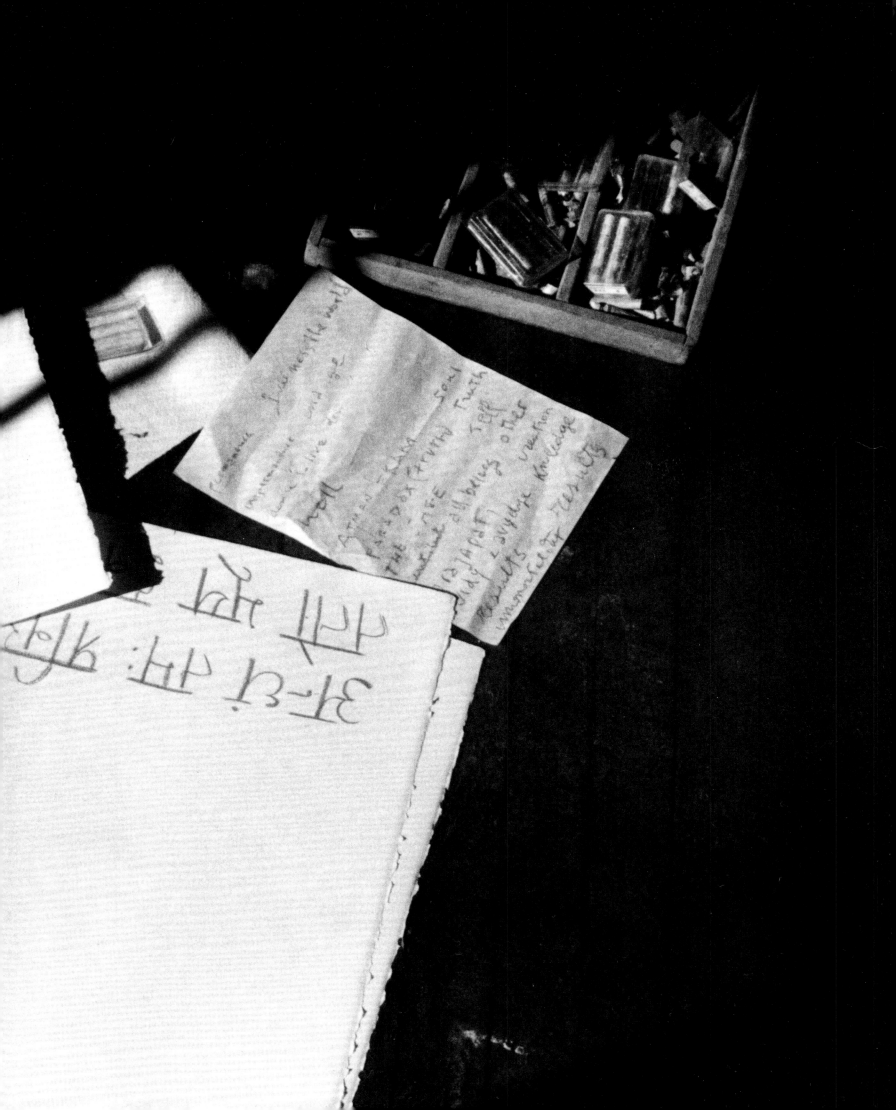

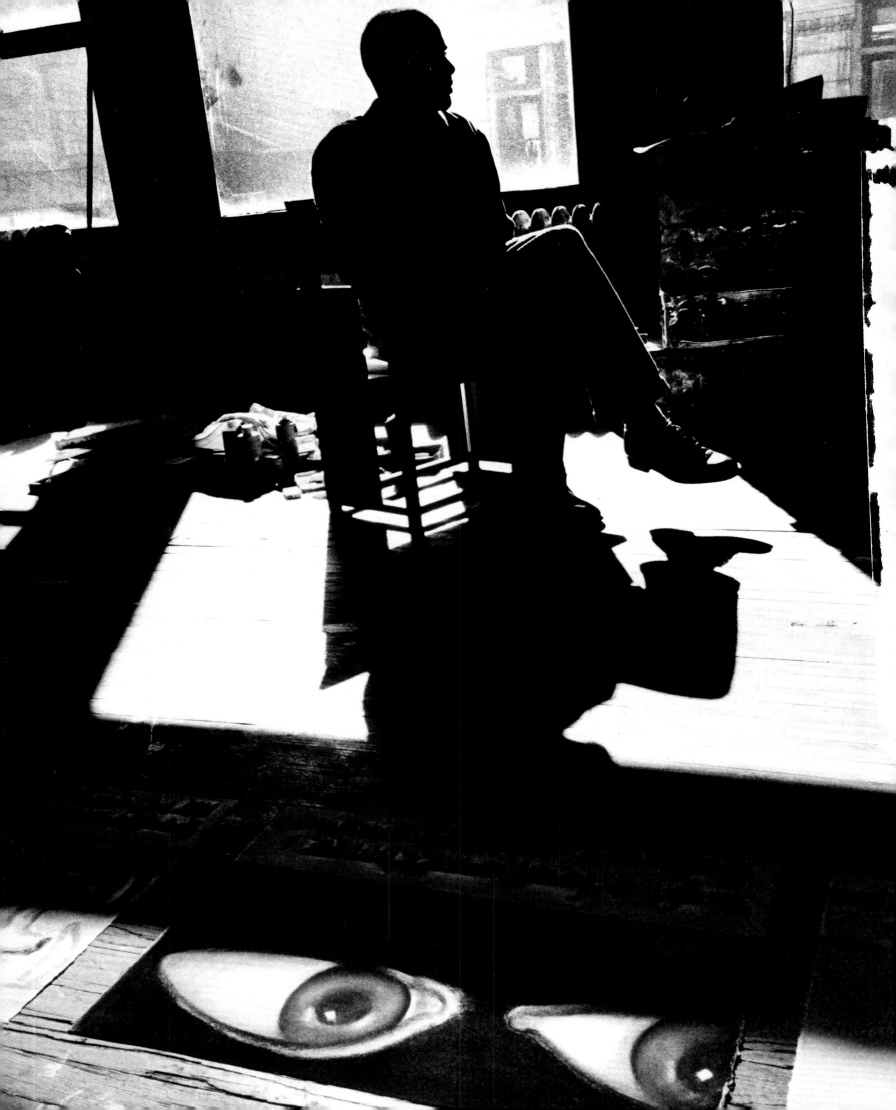

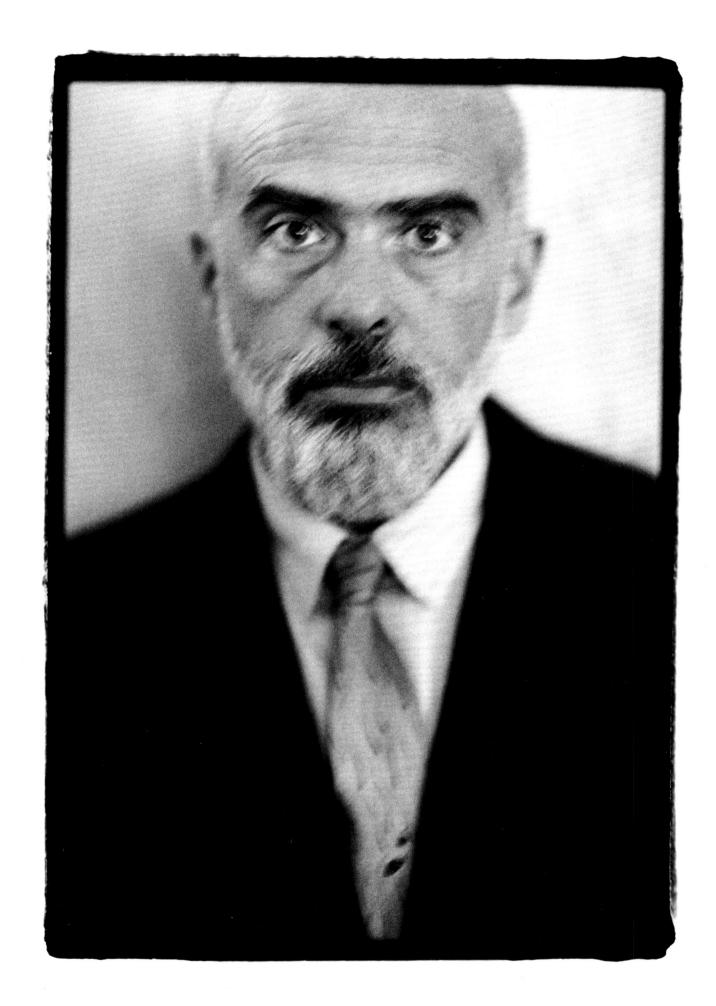

acknowledgements

———

THIS BOOK IS DEDICATED TO MY SON TEO

I wish to thank: FRANCESCO because he keeps on painting. ALBA because she keeps on feeding me. CHIARA, NINA, PIETRO, and ANDREA for their laughter. MICHAEL HOFFMAN for allowing me into the Aperture kingdom. MELISSA HARRIS for teaching me how to survive in the kingdom. LAUREN for setting the wheels in motion. GRAZIA for picking up the pieces (of the wheels) so many times. SANTE for bruising his knees on the floor with my photographs. RENE for the "handsome boy." LESLIE for Teo. LINDA for the oxygen. YOLANDA CUOMO for putting the Sunday dress on my pictures. DOMITILLA for buttoning the dress. JANE for the Eastern winds. NEW YORK because it keeps on bugging me. MATTHEW BOCCACCIO, FRANCESCO PELLIZZI, VICTOR MATTHEWS, FRANK FORTIS, BENJAMIN OLIVER, JANN and JANE WENNER, MARCO MIGNANI, ISABELLA GINANNESCHI, MARIPOL, MASSIMO REDAELLI, DOMINIC CUNNINGHAM REED, CAMILLE PAGLIA, BONNIE YOUNG, PAT MITCHELL, ERIC and TANIA IDLE, RITA AIRAGHI, MONICA FULTON, PEPPY, TOROS, SUZANNE DONALDSON, STEFANO, AMOS POE, ANNICK and CATHERINE, INES BERTON MORENO, VINCENT CARIATI, DEBBIE MARGOLIN, JIM HART, NICOLAS RHODES, JAYNE ROCKMILL, NANCY COOPER, ELINOR MILCHAN, ALBERTO TRUCCO, BRICE and HELEN, SERENA, ROBERT HOWELL, THOM BEERS for saying "Great!" at the right time. Color prints from negatives: MEI TAO. Black and white prints: L&V LABS, INC., New York; TOROSLAB, Paris; MANUEL MAINARDI. Color film processing: DIAPOSITIVE, New York; WEST SIDE COLOR LABS, New York.

APERTURE GRATEFULLY ACKNOWLEDGES THE GENEROUS SUPPORT OF
THE ITALIAN CULTURAL INSTITUTE, NEW YORK
MARION BOULTON STROUD AND THE ELGREBEAD FUND

———

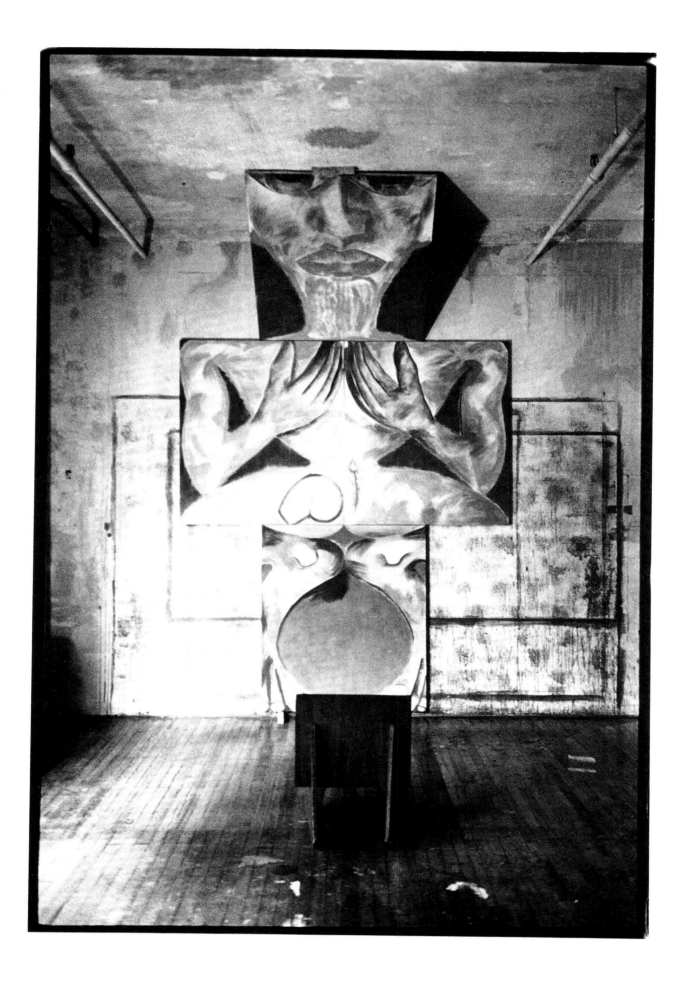

Library of Congress Catalog Card Number: 99-64611
Hardcover ISBN: 0-89381-872-0

Separations by Sele Offset, Torino, Italy
Printed and bound by Sfera Srl., Milan, Italy

The Staff at Aperture for *Francesco Clemente: A Portrait* is:
Michael E. Hoffman, Executive Director
Melissa Harris, Editor
Stevan A. Baron, Production Director
Eileen Max, Associate Production Director
David Frankel, Copy Editor
Lesley A. Martin, Managing Editor
Tamara McCaw, Editorial Assistant
Elaine Schnoor, Production Work-Scholar

Aperture Foundation publishes a periodical, books, and portfolios of fine photography and presents
world-class exhibitions to communicate with serious photographers and creative people everywhere.
Complete catalogs are available upon request. Aperture Book Center and Customer Service:
P.O. Box M, Millerton, NY 12546. Phone: (518) 789-9003. Fax: (518) 789-3394.
Toll-free: (800) 929-2323. E-mail: customerservice@aperture.org. Aperture Foundation, including
bookstore and Burden Gallery: 20 East 23rd Street, New York, NY 10010.
Phone: (212) 505-5555, ext. 300. Fax: (212) 979-7759. E-mail: info@aperture.org

Aperture Foundation books are distributed internationally through:
CANADA: General/Irwin Publishing Co., Ltd., 325 Humber College Blvd., Etobicoke, Ontario,
M9W 7C3, Fax: (416) 213-1917. UNITED KINGDOM, SCANDINAVIA, AND CONTINENTAL EUROPE:
Robert Hale, Ltd., Clerkenwell House, 45–47 Clerkenwell Green, London, United Kingdom, EC1R OHT,
Fax: (44) 171-490-4958. NETHERLANDS, BELGIUM, LUXEMBURG: Nilsson & Lamm, BV, Pampuslaan
212–214, P.O. Box 195, 1382 JS Weesp, Fax: (31) 29-441-5054. AUSTRALIA: Tower Books Pty. Ltd.,
Unit 9/19 Rodborough Road, Frenchs Forest, Sydney, New South Wales, Australia, Fax: (61) 2-9975-5599.
NEW ZEALAND: Southern Publishers Group, 22 Burleigh Street, Grafton, Auckland, New Zealand,
Fax: (64) 9-309-6170. INDIA: TBI Publishers, 46, Housing Project, South Extension Part-I,
New Delhi 110049, India, Fax: (91) 11-461-0576.

For international magazine subscription orders to the periodical *Aperture*, contact
Aperture International Subscription Service, P.O. Box 14, Harold Hill, Romford, RM3 8EQ,
United Kingdom. One year: $50.00. Price subject to change.
To subscribe to the periodical *Aperture* in the U.S.A. write Aperture, P.O. Box 3000, Denville, NJ 07834.
Toll-free: (800) 783-4903. One year: $40.00. Two years: $66.00.

First edition
10 9 8 7 6 5 4 3 2 1

DESIGN BY YOLANDA CUOMO AND DOMITILLA SARTOGO